FANTASY & SCI-FI DIGITAL ART
**ImagineFX**

# SCI-FI

## The Ultimate Guide to Mastering Digital Painting Techniques

First published in the United Kingdom in 2012 by
Collins & Brown
10 Southcombe Street
London
W14 0RA

An imprint of Anova Books Company Ltd

Copyright © Future Publishing Limited and
Collins & Brown, 2012

Distributed in the United States and Canada by Sterling
Publishing Co, 387 Park Avenue South, New York,
NY 10016-8810, USA

Front cover illustration by Marek Okon
Back cover illustration by Joe Vinton

ISBN 9781843406761

A CIP catalogue for this book is available from the British Library.

10 9 8 7 6 5 4 3 2 1

Reproduction by Rival Colour Ltd, UK
Printed by Toppan Leefung Printing Ltd, China

This book can be ordered direct from the publisher at
www.anovabooks.com

For more information on *ImagineFX* please visit
www.imaginefx.com

FANTASY & SCI-FI DIGITAL ART
# ImagineFX
# SCI-FI
## The Ultimate Guide to Mastering Digital Painting Techniques

COLLINS & BROWN

# CONTENTS

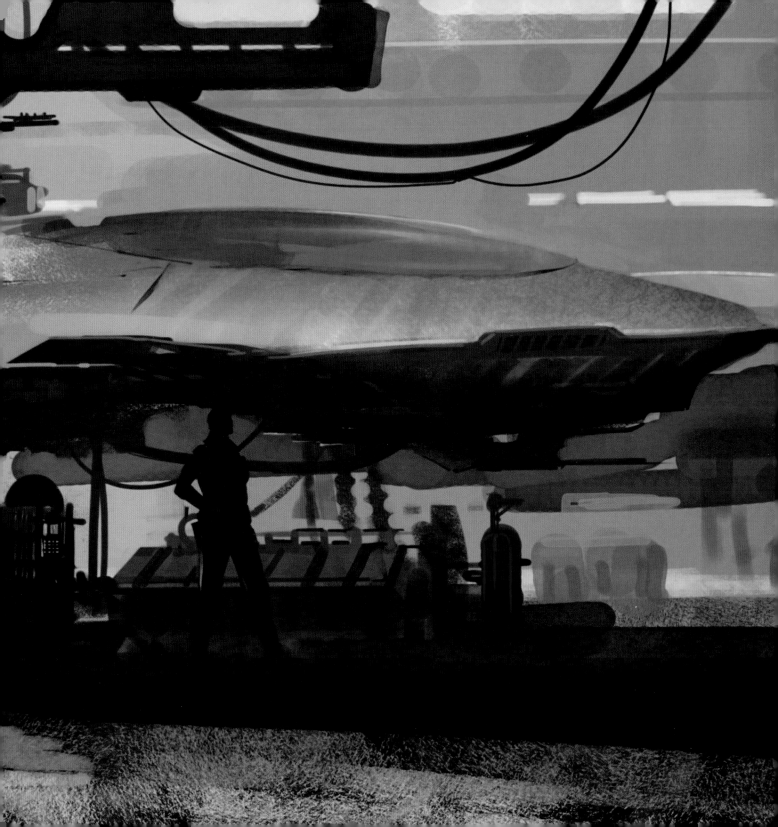

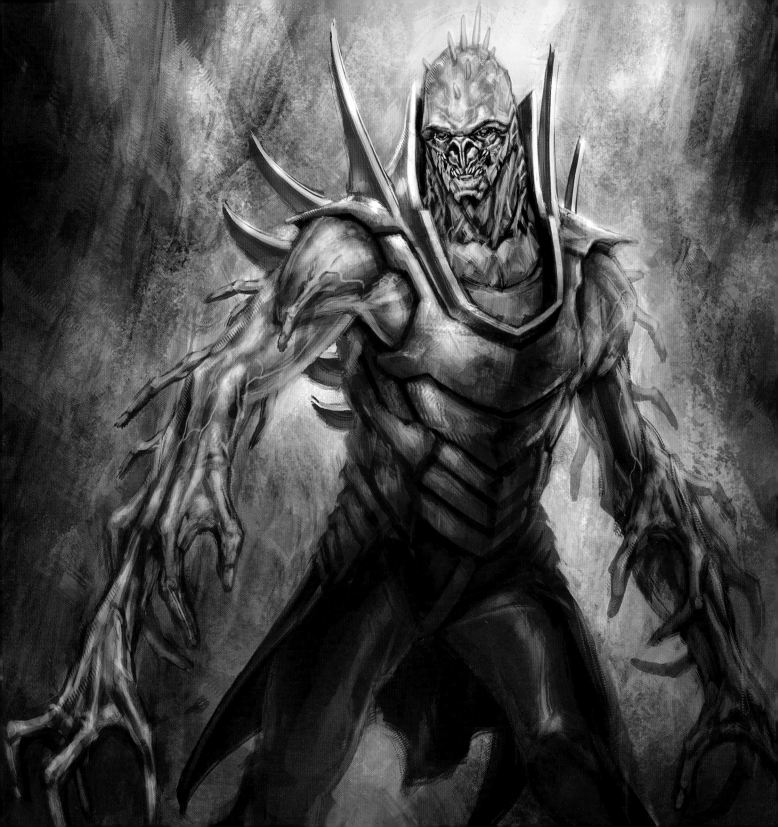

# INTRODUCTION

**W**elcome to this fourth book of our digital art painting series. In this edition, we showcase the work and creative prowess of the foremost artists currently working in the art entertainment and illustration industries. They have been handpicked from ImagineFX to offer guidance, inspiration and step-by-step techniques on how to create better art.

The aim of science fiction art, sci-fi or SF – or whatever your preferred term is – is to use your imagination to create and depict believable visions of the future. Dreams and visions that could in time become science fact.

The workshops here aim to offer a solid grounding in the art skills needed to bring your imagination to life. There are demonstrations on painting creatures, characters, environments robots, weapons and vehicles. The leading digital artists of our time are on hand over the next 200 pages to help you discover new skills: Aly Fell shows you how to create a Barbarella-style sci-fi female, Chee Ming Wong recreates a Tron-inspired lightcycle, John Kearney demonstrates how to create an alien creature and Christian Alzmann reveals his 25 tips for designing robots, and much more.

Whether you're a proficient digital painter, a beginner, or even paint traditionally or use 3D software there's something here that will ignite your desire to pick up a pencil and start realising your own visions.

Remember that whatever your level, everybody as to start somewhere. The more mistakes you make, the better you will become and the more you'll start to like what you draw and paint.

Each generation of sci-fi artists has imagined and created new definitions and ideas of what the future will look like – and now it's your turn. So flick over the page and get started on creating the future!

*Claire Howlett, Editor,*
*ImagineFX magazine*

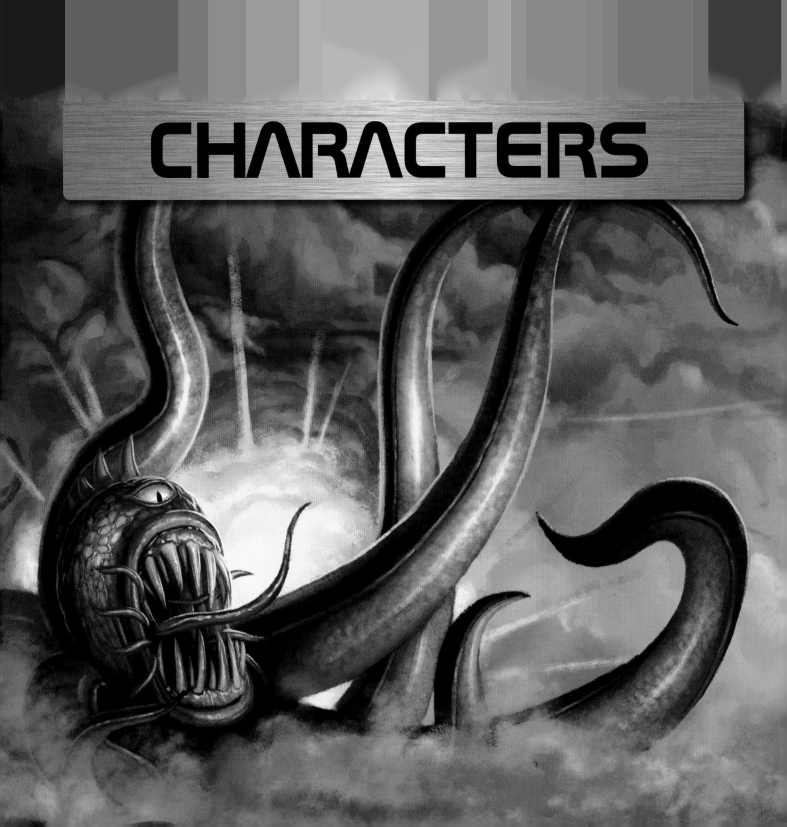

# CHARACTERS

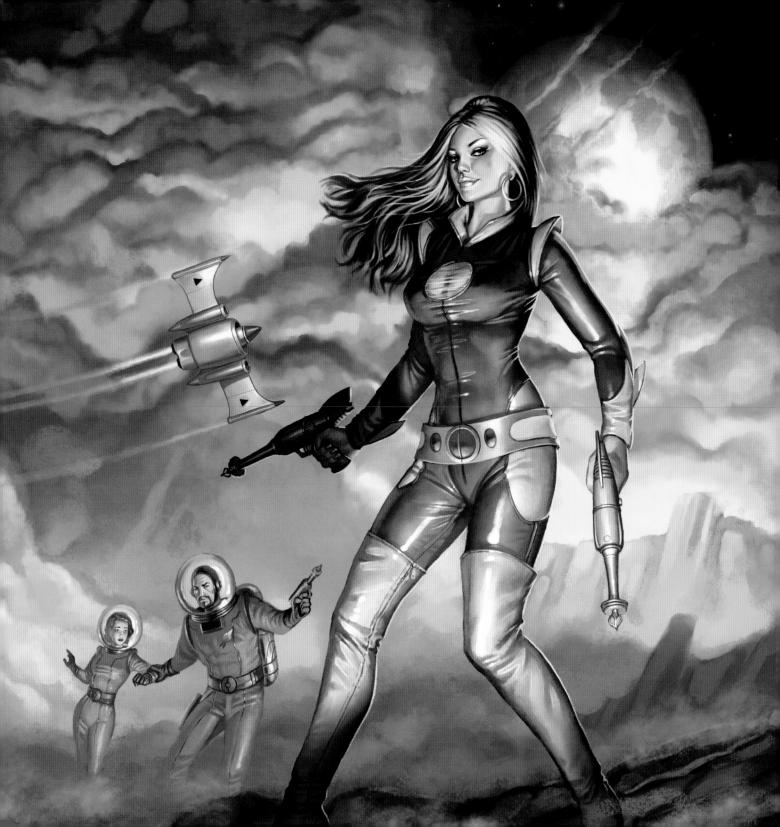

## ARTIST PROFILE

### Marek Okon

**COUNTRY:** Poland

Marek is a freelance illustrator and concept artist who's been in the industry for over five years. He's most famous for his work for Games Workshop, LucasArts and Crytek.

**WEB:** www.okonart.com

# TAP INTO A SCI-FI CLASSIC

**Taking the seminal film TRON as his launch point, Marek Okon ups the ante and paints a vivid science-fiction image**

From the outset I want to create an image that's unmistakably science fiction, with some loose references to the classic film TRON. I'm also aiming for a vibrant, strong, almost unreal colour palette, combined with light effects that will dazzle the eye.

I start with my heroine's pose. I imagine her as a strong, determined-looking woman wearing some kind of techno suit, standing in front of a data stream and becoming a human computer terminal. I want her to almost taunt the viewer, as if she's saying, 'Bring it on' while the light flows through her body.

The techno suit is a little project of its very own. It's a combination of various materials, from skin-tight synthetics that bring out her feminine curves, to metallic parts suggesting technological elements, and glassy armour that disperses the data stream in a fierce light show.

Using vivid colours means that I find painting a suitable background a little tricky. I'm aware that if I don't keep the background fairly simple, it will draw attention away from the subject of the image. If I make the data streams overcomplicated then all the light effects will become hard to read.

Working outside my usual colour palette is a challenge, especially because I'm also rendering different surfaces under extreme light conditions. But overall it turns out to be an educational experience and best of all, a lot of fun!

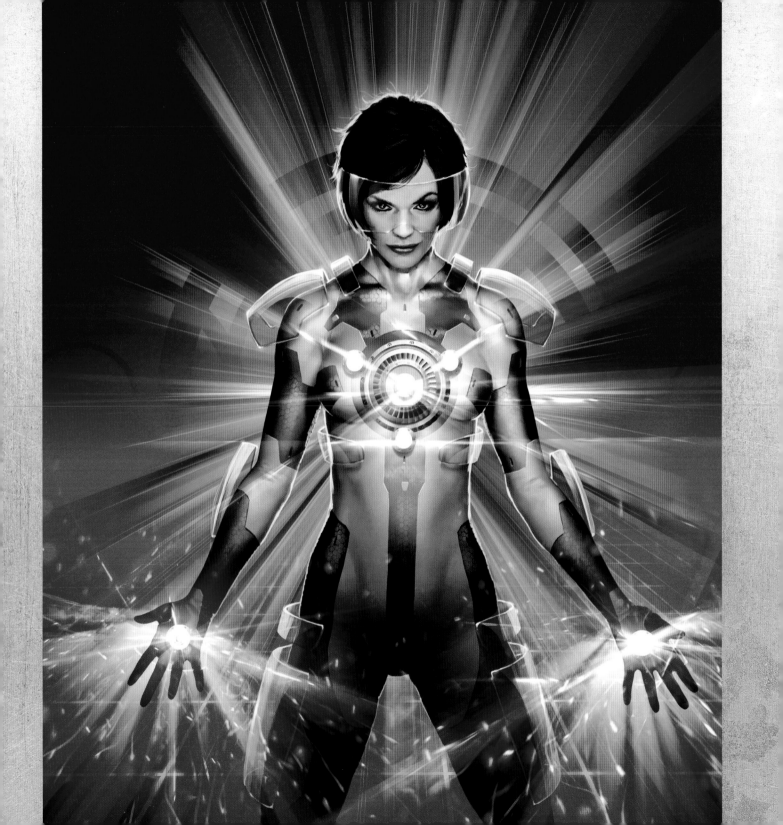

# Keep it subtle

If you want to make a surface appear interesting, try modifying its specular reflection. Just check out this part of the suit. Breaking the glossy areas into hexagons suggests that the suit's surface looks like this. This is a great technique to use if you want to hint at a material's qualities, rather than applying a heavy texture over the whole surface area.

# A time to reflect

Glass is always fun to paint. Just keep in mind that it reflects every light source around it, and transforms the shape of that light source to the shape of its surface. So here the straight lines hit the heroine's visor and are reflected as smooth curvy lines. The best way to represent a glassy surface is to put it in front of a dark background, which makes all those reflections more visible.

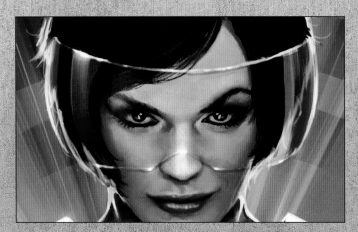

# Light and shade

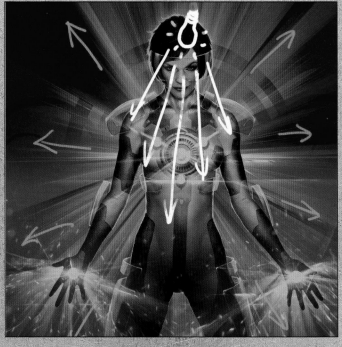

When posing a character in front of a bright background it's helpful to use a directional light source just in front of the subject. This will result in the edges of the subject becoming shaded and dark, contrasting nicely with lighter tones of the background.

# HOW I CREATE...
## A CHARACTER INTERACTING WITH LIGHT

###  1 Early days

Choosing an engaging composition is the key to a successful image. That's why I always start with a few sketches. I try to vary them in certain ways so the client can choose which one works best for them. I avoid putting too much detail into these sketches because everything can change at this point.

###  2 Light up

I introduce more vivid colours and contrast within the data stream and experiment with light effects. It's important to keep the image consistent with the colour palette, so any effect I use should be as vibrant as the rest of the composition. The same goes for skin tones, the suit's surface or any extra details I paint on the heroine.

###  3 Colour draft

Just as with the initial sketch, the first value or colour draft shouldn't be too complex. However, it should contain all the elements that will appear in the final image, or at least an indication of them. I might have to rethink my choice of colours, but because I haven't included a lot of details here, any changes can easily be made.

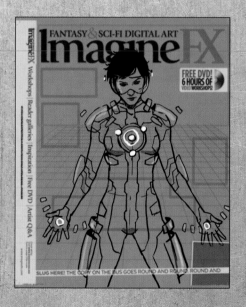

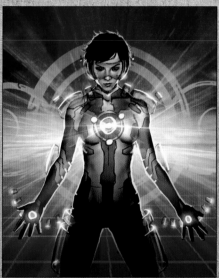

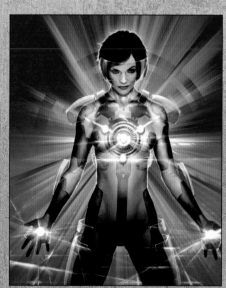

## ARTIST PROFILE
### Aly Fell

**COUNTRY:** England

Aly Fell is a 3D artist and modeller from Derbyshire. He's a character art specialist, and has worked on gems such as Count Duckula, Dangermouse, Avenger Penguins and Discworld.

**WEB:** www.darkrising.co.uk

# IT CAME FROM BEYOND SPACE

## Girls in shiny catsuits, square-jawed heroes, tentacled monsters...
## Aly Fell reveals how pulp sci-fi has it all

Something I love in character art is personality. A raised eyebrow, sly grin or sideways glance can speak volumes and draw you in where blank intensity can leave you cold. Even if the world that the artist depicts is unreal and fantastical, a knowing glance can involve you, the viewer, in the unreality. I hope that most of the characters I draw have personality – a knowing quality in the same way that Sid James in a *Carry On* film would look to the camera and suddenly be speaking directly at you. It makes you involved.

Pulp fiction covers, particularly sci-fi ones, have little self-awareness in retrospect, but we can impose that on them ourselves if we provide them with some retrospective irony. Looking through any collection of 40s or 50s covers, it is amazing to see how seriously some of them take themselves, in much the same way that the sci-fi movies of the same period did.

There always had to be a morality tale there somewhere. But then, they were obviously different times with very different fears. Spaceships offered a means of escape from the Cold War fears that dominated the news of the time, and yet it was often nuclear energy that powered these craft to the stars.

Barbarella changed a lot of that with its pop culture kitsch. What I would like to do here is to create a Barbarella-type character in a typical pulp fiction world – dramatic landscape, spaceships, toothy monsters and so on. My inspiration is going to be Barbarella, of course, Frank Frazetta and the wonderful covers of artists like Frank Kelly Freas. All in the wonder of Photoshop!

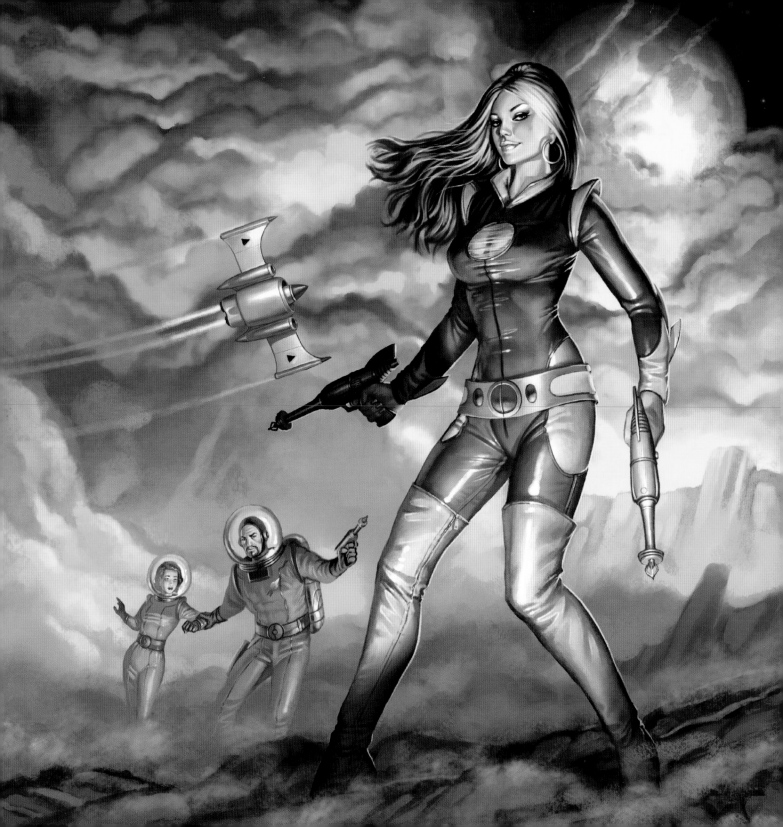

## Sketching it out

As the image is for a cover for ImagineFX magazine, it has to be a wrap around. Emails to the art editor provide me with the template, so I know the compositional layout that I have to work to. Essentially it's double a single page. I sketch up a few versions, changing the pose, and a final is decided upon.

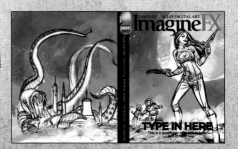

## Deciding an approach

I usually start with a line drawing. In this case, I try a technique that I've rarely used, which is to paint in greyscale first and then apply colour on top of it using Overlay, Multiply and Colour Mode painting options in Photoshop. I first lay down a simple mid-tone underneath the sketch, which is on a separate layer.

Then, on a new layer over the sketch, I start to paint in tone, as I would colour. I always start with the face, the eyes being the first brushstroke. As I'm working on the outfit, I get a new instruction – an earlier sketch fits better with the intended layout and the cover text. So it's back to a previous version. I actually preferred this one anyway.

## Cutting and pasting

As I was really happy with the face that I was producing for the first version of the image, I decide to cut it into the new version to save some time. A bit of tweaking with the Transform tool and I get it right. I also clean up the rough composite sketch I received back from ImagineFX on the same Photoshop level.

I decide not to follow the tonal path I was intending, and instead start applying body colour over the quick greys I have laid down. At this point I've essentially cut the image in half so I can work on just the front, making sure I have a back-up of the full composition. This cuts down on the work that Photoshop has to do and stops your computer being sluggish.

## Working over tone

I'm a bit of a layer nut. I use them too much and keep attempting to cut down a bit – but if you've got 'em I think you should use 'em! I create a new layer and set the blending mode to Multiply.

The overall colour stipulated is orange, so I put down a basic orange. Using Multiply means that I can still see the line and tone underneath. It also provides a ground over which I can paint further.

I keep the girl separate. She's going to be blue. Realising that my layers are already starting to get untidy I put her working layers into a group in the Layer Box drop-down menu. This is a way of keeping your separate elements neat if you use a lot of layers.

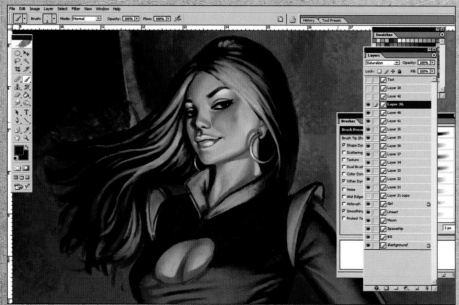

 ## Painting body colour

I start on the spacesuit. There will be two major light sources in the image: a strong up-light from the front for dramatic effect, and a diffused, ambient light from behind. As the main light source is from below, I must take this into account. Bright light flattens form if projected from the front, so I use the hard line of my original sketch as the darkest element of shadow and paint up to and over it.

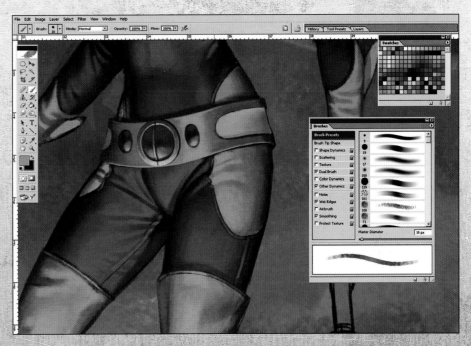

## SHORTCUTS

### HUE/SATURATION
### CTRL+U

I find that this shortcut is extremely useful for all those little colour tweaks that you need to do.

## PROSECRETS

### SAVING FILES

Always save, that's the golden rule. It's so frustrating to lose something you're really happy with, and even more so to have someone tell you, 'you should have saved!' The thing to do is to save as a new file intermittently. Try to develop a numbering system that makes sense and is easy to remember, like Pulp Cover 01, Pulp Cover 02 and so on. Never call it Final, because the chances are it won't be, and then you end up with New Final, New Final 2.

## Getting on with it!

I now need to paint the girl. I don't use a lot of custom brushes in Photoshop, just a few each time I start an image. I like a simple, flat, round with Wet Edges checked, and a similar brush with a simple Dual Brush option for texture.

If I need something specific, I create it. For sketching out I use the Conté Pencil, which is a Photoshop brush, for a thick and thin result. It's quite naturalistic in its pencil feel. The look of the girl is very 60s, but also very now. For her skin, I use the flat, round brush. I'm not a huge fan of too much soft brush work, so I'll maybe just use it for a bit of occasional blending.

## 7 The moon and sky

I turn my attention to the moon, using ours as the base inspiration and trawling the Internet for reference images. I paint it in a separate file in monotone, using the two simple brushes I described earlier. I save it and copy and paste the moon into my working file, and scale it to fit (Ctrl+T).

Now I look at the background. As the girl and the moon are on their own levels, I can hide them. Using the two brushes, I create a cloudy sky for an imposing, operatic feel, with some hidden light, and some cliffs as a compositional element.

The clouds are lit from underneath, so they will fade off from light to dark, with a secondary colour in the darkest areas.

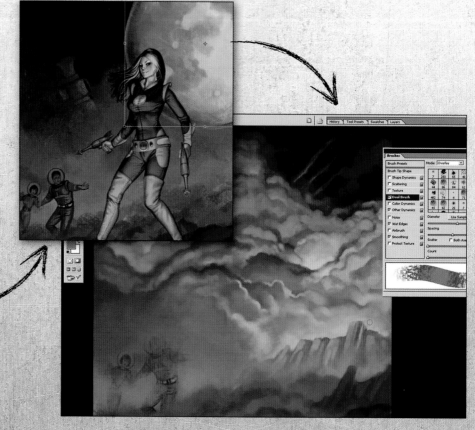

### SHORTCUTS

**SCREEN MODE – F**
For screen display options, toggle through Standard Screen Mode, Full Screen with Menu Bar and Full Screen Mode.

## 8 Always check things out!

I check with the ImagineFX cover template. It's working fine but the moon pulls the viewer off to the right, so I reduce its size and start blending it with the clouds. Duplicating it onto another layer and playing with layer modes can produce some serendipitous results, so I do that here. In the end, I brighten one of the duplicated moons.

## 9 Canvas Size

To increase canvas size you can use the
Crop tool – great for making images bigger
and smaller – or use the Canvas Size option,
which is in the Image drop-down menu.
I double the size, but extend it to take
account of the spine as well. I then paste in
the original sketch of the corny tentacled
monster. Also, to give myself a base colour
wise, I paste under the sketch the artwork
from the front page.

## 10 Clouds, clouds, clouds!

I like clouds. Good job really, as there are lots to do here. Remember to
treat them the same way as I did in step 7. I cover up the duplicated
half of the image with lots of clouds. As I'm not sure how I'm going to
treat the monster, I just fill in space that I know may be obscured later.

It's also time to create the secondary characters that I obscured
earlier with cloud. I decide upon a bearded baddie, with a slight feel
of Doctor Who's arch nemesis The Master.

I also include a woman with a more retro haircut to fit in with the
pulp feel of the whole thing. I then add highlights to the main girl's
outfit and tidy up the hair and other details, like the guns.

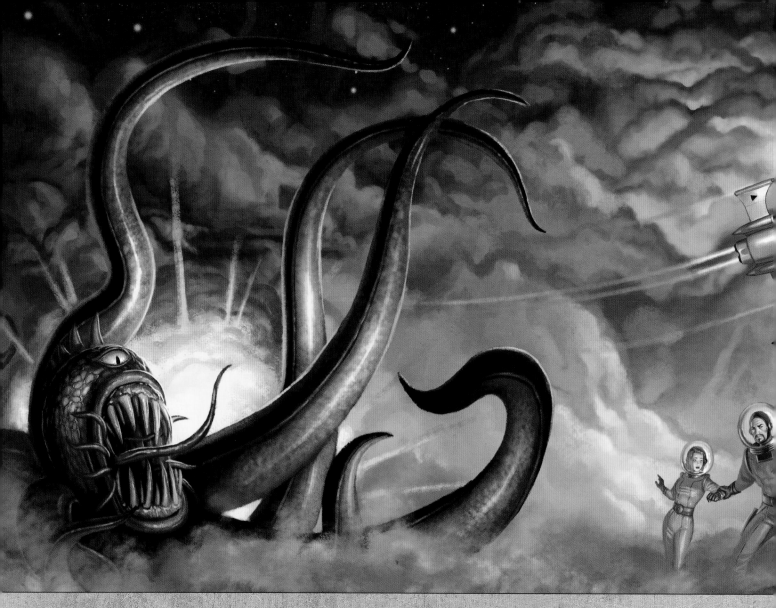

##  11 Flatten those layers

It is wise to intermittently merge the layers you have finished working on. As I finish on the girl, I flatten her layers and reduce the working file size. This is very important when working on large images, as Photoshop is an application that likes to use a lot of your computer's resources. Keeping working file sizes down just helps those 'it's all frozen-up' moments from occurring quite as often. If there is something that you feel like changing and it needs a layer that you flattened earlier, you can always paste into the working image from an earlier work-in-progress. Ensure that you're saving the work as a new file as you go along, and not just overwriting the first one!

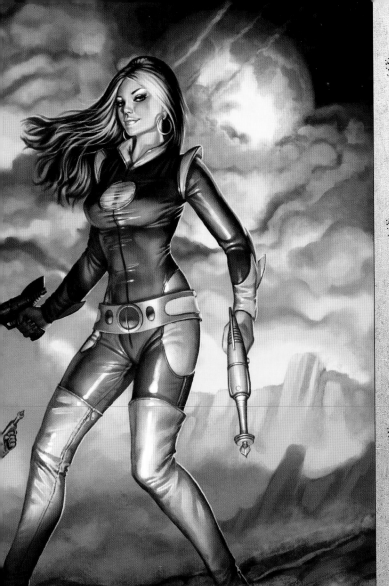

 ## Spaceships

A further item to balance out the composition and create a bit more narrative is a spacecraft. I'd roughed out a couple in my original sketch, so being inspired by Frazetta and *The Trigan Empire*, a silver dart felt appropriate. Painting it almost flat on I thought I might be able to duplicate it later and have a squadron attacking the monster. In the end I think this may look too obvious, but I'll decide later.

 ## Monsters

My monster is fairly generic. One of the wonderful things about old pulp fiction covers is how naïve the monster designs felt. With all the anatomically perfect, ultra-designed aliens we are accustomed to seeing in movies and on TV, it's rather nice to look at the old images and just say to yourself, 'No way would that work!' They were often just humans with insect or monster heads, a claw or a tentacle. Mine will be a space octopus with big pointy teeth. I paint him rising up out of the dust of the planet's surface, with the explosion from a spacecraft silhouetting him.

 ## Final tweaks on the main character

I go back to the girl, and with a fine brush just touch up those little details and generally tweak until I'm happy.

It's at this point that it becomes difficult to let an image go. I start to question whether there is still something needed. Now it's time to walk away from it. Have a cup of tea and a biscuit – put it down and come back to it in a bit. Any error will be much more apparent when looking at the image fresh.

 ## The end...?

I realised it needed lightening a bit, so I created a new layer over the final flattened image, set the layer mode to Colour Dodge and filled it with black. Using a very soft brush with opacity down to 50 per cent and flow right down to 10 per cent, I select a soft pale yellow and gently brush it over the lighter areas of the background and areas that require added highlighting. Flatten it, make a final adjustment using the Photo Filter and the Brightness/Contrast settings, and it's done.

---

## SHORTCUTS

**SHORTCUTS – FIT ON SCREEN – CTRL+0**
When constantly zooming in and out, getting an overview of the whole image is essential.

## ARTIST PROFILE
### Marek Okon

**COUNTRY:** Poland

Marek moved into digital painting from web design two years ago. His main love is painting sci-fi and fantasy subjects, and he mostly works on book covers and illustration.

**WEB:** www.okonart.com

# CREATING EPIC SCI-FI

## Marek Okon reveals his thought and design processes behind this stunning sci-fi image

Whether you're an established illustrator or just starting out in the concept art world, after you've done a few images and spent a bit of time on illustrations you're sure to reach the same conclusion – knowing *how* to paint is not the only thing that matters: it's important that you know *what* to paint as well.

That may sound obvious, but it's not as easy as it seems. While some clients will give you the freedom to paint whatever you want without interfering with the subject matter, the vast majority will want you to paint specific subjects and themes.

It's down to you, as an artist, to get the job done, to put on the canvas or the screen elements that will define without a doubt the idea behind the brushstrokes, and sell the image to the client or viewer.

In this workshop I will break down the thinking and design process behind every element that goes into painting a successful sci-fi image.

I use pretty much the same method with every big picture I do, so you can follow the same steps for many different types of image. I'll also discuss how to create a successful sci-fi environment, and what painting techniques I use to best present my image.

This workshop will be more about *why* than *how* I paint certain things in the way that I do. As Syd Mead once said in an interview with ImagineFX, 'idea trumps technique every time', so let me show you the thought process behind my pictures, supported with some tips on how you can most effectively present your idea.

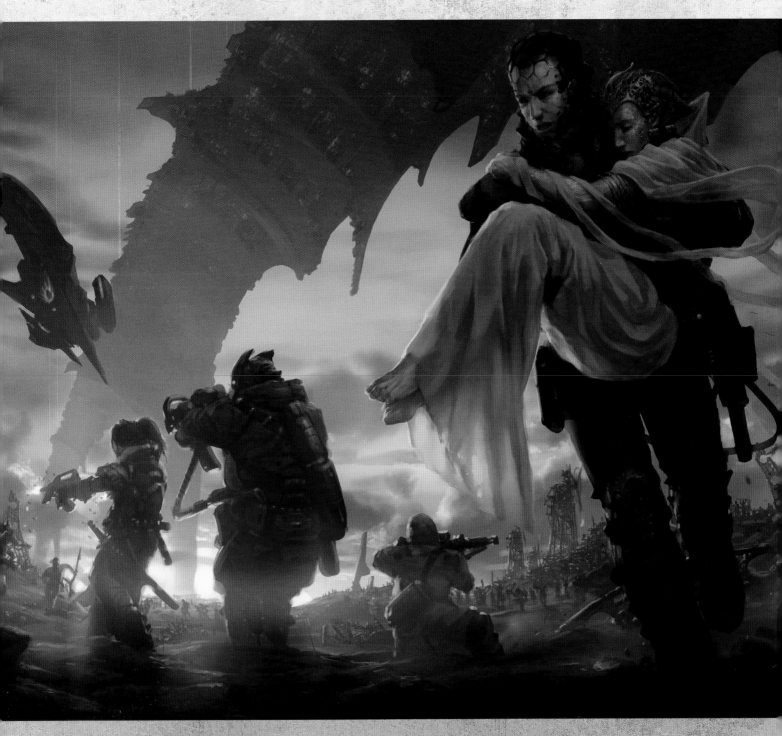

# ❶ Subject

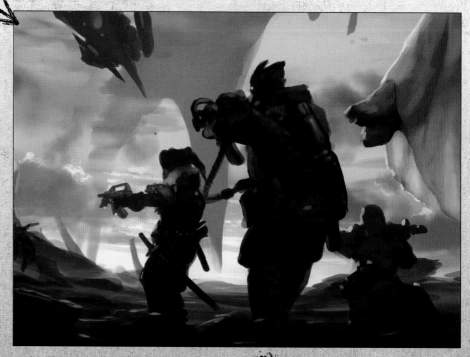

Sci-fi is one of my favourite subjects. It enables you to show off your imagination, your technical thinking and design skills. That's especially true if you're painting something that has a purpose in the world presented. It's important to keep checking with yourself what the purpose is of the object you're painting, and to consider how someone might use it, or why it looks the way it does. This helps add sense to your world.

In general, you can divide sci-fi into two categories – technology and characters. You can show a character operating a technological device, but your illustration must focus on one specific topic. I often see illustrations that want to show too much at one time. Remember what it is that you want to show, then show it in the best way that you can.

# ❷ The elements of good sci-fi

In my mind, I start collecting the elements of traditional sci-fi paintings: massive megastructures, a spaceship, its crew, a strange alien world...personally I prefer images that focus on characters, because it's easier for viewers to connect with the scene. Characters also help you to tell a story with your image. So I

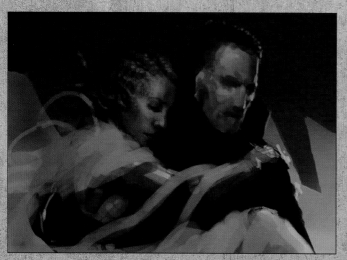

imagine up a young, dashing space captain with an alien queen in his arms, waiting for his ship to pick him up. That's the core idea around which I base my image. While elements may change, that core idea should remain intact, otherwise you're just painting a different picture.

# ❸ Developing your idea

I've got the core idea nailed, so the next thing to do is to embellish it. I've got the central figures for the image – the space captain and the alien queen in his arms. I've got the backdrop of the strange alien world, the massive megastructure, the spaceship and its crew. But I need to add more life to it. So I decide the space captain and his crew should be waiting for the spaceship to land and pick them up. Landing spaceships always make a bit of a mess, which will make the image less static, but I'm still not happy. I think some of this will appear forced – why's the alien queen there in the first place? Then I realise what I need – natives! My story is complete. The space captain has rescued the alien queen from the natives and is running to the meeting point for his ship. His crew is covering his back.

## Why bother?

You might be asking yourself, does the story really matter? That's a lot of time spent procrastinating before really getting into the painting process. Many artists might think 'why can't I just draw a great big spaceship in space, where it belongs?' Of course, there's nothing to stop you doing that. You can still create a great picture that way, but without a story to back it up, people will forget about your image all too quickly.

What's more, if a client has commissioned you, they may have a story already, and they'll want you to add in all the elements of their story. The better you piece these together, the more likely you are to get hired by them in the future.

## Environment setup

I start by painting the environment, then the background and finally characters, keeping everything fast and loose. The setup of the environment is essential to define the mood of the whole picture. If you want a sad feel, make it grey and rainy, or if you want it to be scary, set your image at night time. For this image, I go with a sunset scenario, which is one of my favourite settings to paint and is good for the energetic battle feel that I am trying to convey.

Next I add the background to the image. I start this by drawing a horizon line, then add some initial terrain. I'm trying to shape it in a way that will create a nice composition.

## Megastructure

As you can see here, a strong composition element is the curvature of the megastructure, which is practically dragging viewers into the centre of the image. I paint in the main characters – space captain with the queen in his arms, his crew behind him, and the spaceship trying to land. Finally I add natives attacking wildly from behind, trying to get the queen back.

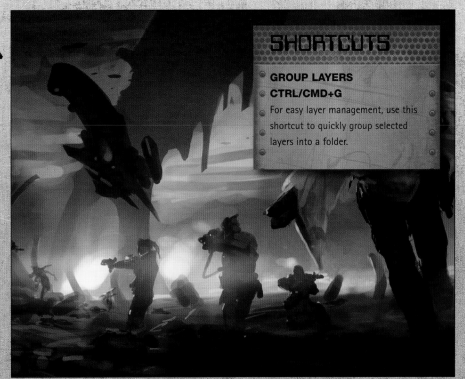

**SHORTCUTS**

**GROUP LAYERS**
**CTRL/CMD+G**
For easy layer management, use this shortcut to quickly group selected layers into a folder.

## Real life reference

The human eye is far better than a camera is at compensating for large contrasts in light. For example, think of when you walk into a dark room on a sunny day. Everything outside the window appears very bright as your eyes adjust. This is called High Dynamic Range. So, when encountering a light source as strong as the sun, cameras can't get enough information about other light sources present during sunset.

That's why, when you photograph a sunset, you get a nice, colourful sky, and everything around it is pretty much black. But the human eye can deal with this much more efficiently, so even during sunset you can still see everything around you clearly.

## Painting the sky

I start with some gradients to fill out the sky. First there's pale orange at the horizon, next is saturated orange mixed with stripes of red, and finally pale blue sky that gets darker the higher it goes. Be sure not to make it too dark, though – it's still one of the main light sources in the image. On top of that I add in some clouds of varying shapes and sizes. Some are more transparent and light, some thicker and heavier. Don't worry if your colour picks seem a bit awry at this stage – they can be easily corrected by applying a nice, orange gradient in Overlay mode to the image.

## PRO**SECRETS**

### CHECK YOUR VALUES

It's important to constantly check the values in your image to make sure you don't mess up hierarchy and composition. I use a simple black layer in Colour mode on top of my whole picture, and turn it off and on when I need it. This way you can quickly spot any mistakes and fix them accordingly.

## 10 Polishing the captain's helmet

Here I pay particular attention to the space captain and alien queen designs, which I think need a bit of polish. They go through a variety of changes as I play around with the concepts a little. I was concerned that my initial ideas were too simple and generic-looking – they just didn't have the out-of-this-world sci-fi appearance I was looking for to suit my story. So, after some experimenting, I came up with this, which I think is much more suitable. I particularly like the captain's suit design and his weird, partially organic helmet.

## Characters

I like to paint my characters after I have established the environment they will inhabit. That way, all light sources and ambient influences are already taken into account. The shading of the characters is pretty simple, with the sky dome lighting them from above and the sun casting a strong backlight over them.

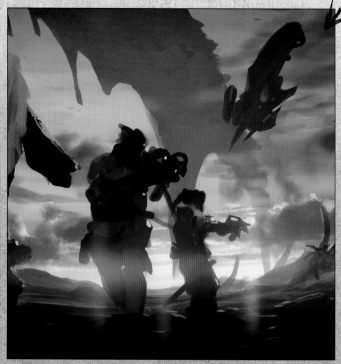

 **A further note on characters and light**

An important thing you must consider while painting the characters is to remember that the sky dome is all around them, and so is the light it emits. So there's a bluish light not just in front of them, but also at the sides. There are also subsurface scattering effects (that's light shining through objects), which are particularly noticeable on the queen's semi-transparent dress and veil.

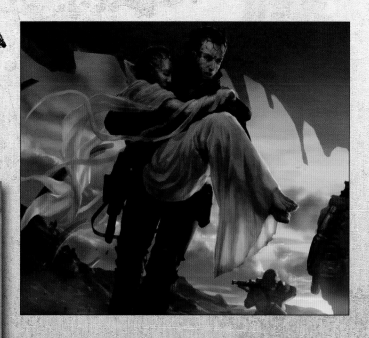

## PRO**SECRETS**

 **COLOUR AND CONTRAST CORRECTORS**

To add some different perspectives to the image, I use a folder of adjustment layers that can be easily modified as needed. In this folder you can keep a few colour correction layers and some contrast adjusters, and use them to enrich your colour palette. When you're done you just hide the whole folder and quickly get back to work.

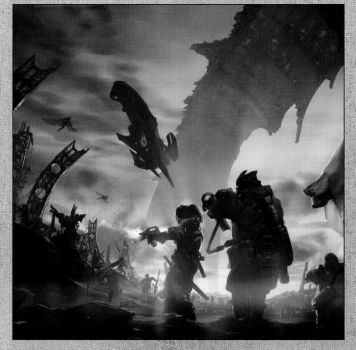

 **Finalising the background**

I want to make the megastructure in the background of the image really big and inaccessible from the surface. To indicate its size I apply strong air perspective (an indicator of great distance), use very low contrast just to hint the details, and cast a strong, atmospheric, bluish haze to show how high and far this structure goes. As with previous elements, I use an orange overlay on one end of the structure to melt it into the sunset.

## SHORTCUTS

**COLOUR BALANCE**
**CTRL/CMD+B**

This is a quick way of opening the Colour Balance palette to help adjust colours in your image.

## 13 The spaceship

I follow a very similar technique to the one I used on the megastructure to finalise the spaceship, which is trying to land to collect the captain and his crew.

Notice how details disappear further into horizon: that's due to the effect of air perspective, which I previously mentioned. I can apply this, on a smaller scale, for the spaceship. I add a colour overlay effect to easily adjust the amount of air perspective on the ship, thus placing it correctly in the image.

## 14 The natives

When I first thought up these characters I just wanted them to be a bunch of primitive, blood-thirsty mutants. Then the idea of a crazy bishop leading them into battle popped into my mind. I liked it so I utilised it, but it meant I had to change the environment slightly. Instead of the deserted wasteland, I made it a huge garbage dumping ground, polluted by the civilisation that lives within the megastructure. So I paint in a few bigger metallic structures, distant houses, wind-powered electricity generators. All of this makes it a place where you could believe something lived, instead of just a barren land of rocks.

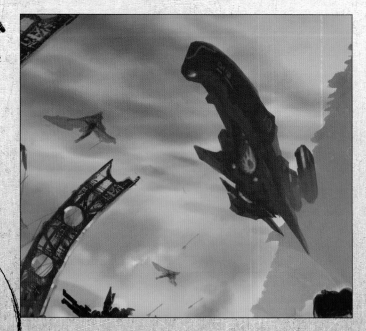

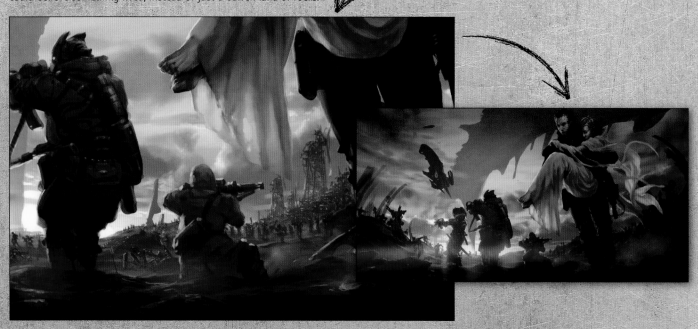

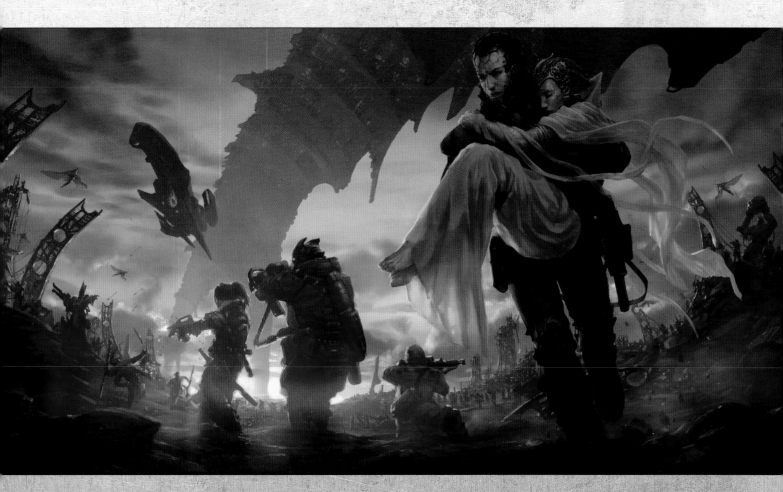

 ## Final tweaks

I use a few Overlay and Colour Balance layers just to make sure that everything goes well with the setting sun. With sunset environments its crucial that you keep your values right, otherwise your lighting will look fake and unnatural. A final tip if you're thinking about creating future technology designs is to make them original, yet recognisable. All the elements you put in a picture should lead to the goal you set yourself at the beginning of the painting process. In this case, it's an epic sci-fi story.

## ARTISTPROFILE

### Francis Tsai

**COUNTRY:** USA

Francis is a freelance illustrator and concept artist living and working in southern California. A roundabout career path beginning with degrees in physical chemistry and architecture eventually led to jobs in the video games industry. He currently works full time on a freelance basis for the games, comics, TV and film industries.

**WEB:** www.teamgt.com

# PAINT LIKE SYD MEAD

## Francis Tsai takes his cues from Syd Mead's work on *Blade Runner* to produce a cover-worthy painting

For me, as for many others in the entertainment design community, Syd Mead's work on *Blade Runner* has always been a huge source of inspiration. The designs for the sets, vehicles and props have a high-tech, sci-fi vibe, but at the same time feel very rooted in reality. This is no doubt due to his training and earlier career as an industrial designer (including designing cars for Ford), in which real-world concerns like budgetary and engineering constraints inform the design process.

For this workshop I'll be borrowing heavily from Syd's catalogue of designs and illustrations for the movie *Blade Runner*, and also bringing in some other influences from the movie itself, in terms of mood, lighting and character. I'll combine those elements with some of my own techniques in digital painting to create an illustration that pays homage to both the designer and movie.

My process isn't really as orderly as it probably could be. I have a definite end point in mind, and a few strategies along the way that have helped me in the past with other illustrations – but there will be some back and forth in the process.

The overall look and feel of the world, and a significant prop design or two will come from Syd's work, while some of the mood and lighting will reference Ridley Scott's vision of the movie. Layered on top of that will be a bit of my own take on the *Blade Runner* world, along with my scattershot painting technique, which will hopefully tie all those elements together.

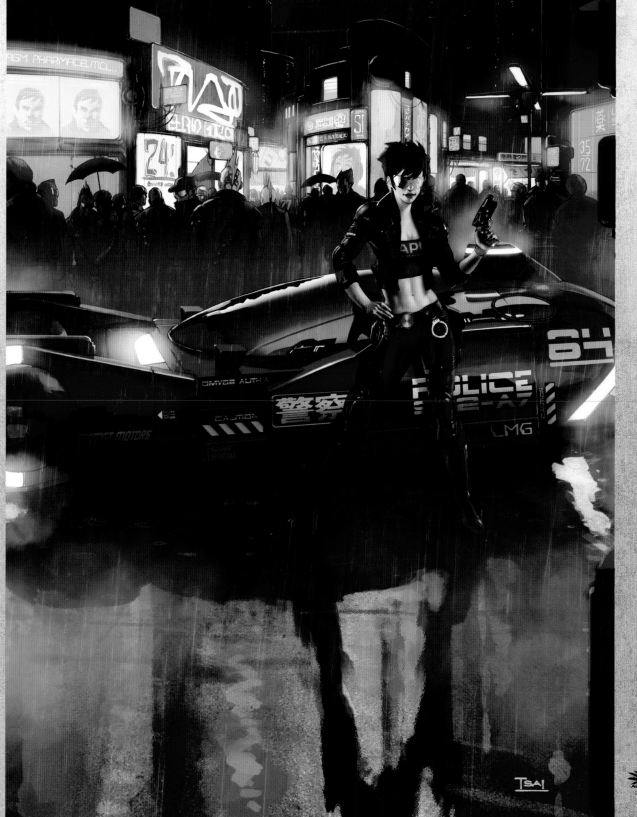

## 1. Initial thoughts

When Paul Tysall, ImagineFX's art editor, contacted me about doing a piece paying homage to the design work of Syd Mead to go on the magazine's cover, he had a few suggestions in terms of subject matter. Signature elements like the retro-fitted architecture of 2019 Los Angeles, specific vehicle designs like the Spinner police car, the pervasive neon lighting, rain – these were just some of the things he mentioned that could highlight a police officer or replicant character.

The two initial sketches (below) incorporated similar elements – the futuristic street scene and the Spinner vehicle – but shifted the focus onto different characters. The female police officer was chosen over the action scene on the rooftop.

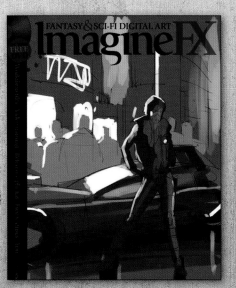

## 2. Thumbnailing

After a bit of pondering, I do two thumbnail sketches. The first is a simple standing pose featuring a female police officer, or Blade Runner, in front of the iconic Spinner vehicle, with a backdrop consisting of a night-time, neon-lit, rainy city street. The second sketch is more of a re-creation or re-imagining of a scene from the movie, in which a rogue female replicant is dangling a Blade Runner policeman over the edge of a rooftop, with the city street and Spinner more in the background than in the first sketch.

## 3. Sketch approval

Paul picks the first sketch, and suggests a scene from the movie for inspiration, showing star Harrison Ford reading a newspaper in front of a storefront window that's lit up with pink and purple neon. He also sends me a file containing the cover text and graphics, as well as a mock-up of the composition with the new cover elements. The text and graphics were done in a colour palette influenced by the scene from the movie, and provided a basis for the palette of the painting as well.

 **Assembling references**

Being a big fan of Syd Mead, as well as a giant fan of *Blade Runner*, I have plenty of reference and inspirational material in the form of Syd's books and a director's cut of the movie (which I have playing on a separate monitor while I work on the painting).

For the figure, I reference some stock photography from an artist named Marcus Ranum, who provides a huge variety of model photography at his website www.ranum.com/fun/lens_work. I use an image from his Sky Captain series (which he has given me permission to show here), showing a steampunk-influenced character standing in a cool action heroine-type pose. I end up tweaking the figure a bit here and there, adding an upraised arm brandishing a blaster (based on another of his photos of a pirate), but the model's pose was spot-on.

 **Location reference**

I also pull a few photos of my own from a recent trip to Japan. This is a shot of a neighbourhood in downtown Tokyo, taken right after a rainstorm. The scale and density of the street, as well as the interplay of lights and signs in the wet surfaces, were elements I wanted to include in the environment.

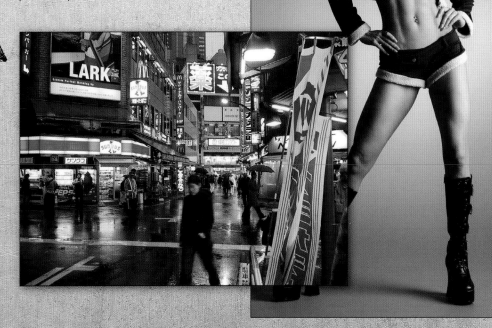

 **Colour palette**

For the next phase I refine the illustration a bit, establishing a colour palette based on the cover graphics and the screen grab. I also add a few elements that I wouldn't ordinarily add until late in the process, including rain and glow effects. I add these on separate layers, including them at this stage to give the editor a more accurate impression of what the final art would look like.

# PROSECRETS

**FAST FINGERS**

My left hand usually rests on the keyboard so I can quickly hit various hot keys and shortcuts. I noticed not too long ago that I was using the base of my thumb to push down the space bar so I could quickly pan around the image. This also enables me to easily hold down the space bar and press Ctrl/Cmd with my pinky, which brings up the Zoom tool without having to select it from the toolbox.

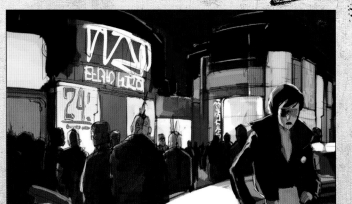

##  Back story

At this point a bit of back story is already forming in my mind for the character. I want her to have a certain level of sex appeal, but not in such an over-the-top way that she'd have no credibility as a futuristic street cop. It is important to convey a sense of power and confidence. I feel some wraparound shades will serve a number of purposes – invoking the visual of the typical American cop's mirrored sunglasses, referencing the cyberpunk mirror shades aesthetic and providing a reflective surface that echoes some of the colours in the environment. Obscuring the character's eyes also heightens the sense of mystery, subliminally adding to the 'is she a replicant?' factor.

## **8** Refining

I keep a layer on top of the painting containing the cover text and graphics so that I can easily see what will be obscured by it in the final art, and then turn it off once all the major elements are blocked in. I feel pretty confident about the background environment, but know the Spinner will require a fair bit of attention as it's kind of the co-star of the image. The curvy, bulbous form proves to be a challenge to correctly portray in terms of perspective, and I end up eyeballing it into shape, with a lot of tweaking and adjustments.

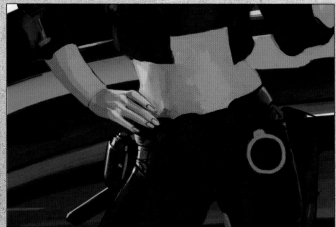

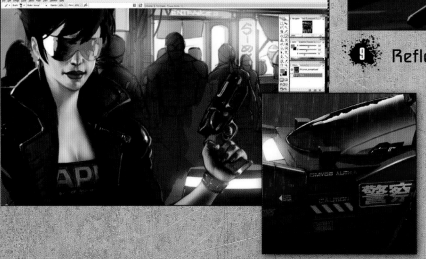

## **9** Reflective surfaces

Aside from the car's form, the reflections in the metallic surfaces present another mix of challenge and opportunity. Accurately rendering vehicle highlights and reflections is a whole other aspect of industrial design that almost seems like alchemy to me, but it provides another chance to echo the environment colours. As a bit of a car fanatic I've looked at a lot of vehicle renderings, but for some reason I've rarely been called upon to produce one. Luckily, I have the benefit of adding logos and graphics on the car to distract the eye a bit!

 ## Filter effects

Ordinarily I don't use a lot of filter effects. This isn't necessarily because of some personal prejudice against them, but more because I haven't really figured out how to use a lot of them in a way that seems natural. Having said that, one effect I do find useful in this particular case was the Ocean Ripple effect in Photoshop, which helps to add a bit of the distorted reflection feel to the wet street surface.

## Last five per cent

It's been my experience that the last five per cent of an illustration tends to take at least 50 per cent of the time. That's the case with this image as well, and there was plenty to work on. One bit of useful feedback that my friend and former boss Farzad Varahramyan gave me was to add some separation between the various layers in the scene, to increase the sense of depth. Adding some mist behind the Spinner but in front of the crowd helps push them back a bit. Some atmosphere also pushes the storefronts and noodle stands further back in the middle distance. Finally, massive high-rises are implied in the far distance, their scale established by the tiny pinpoints of light indicating lit windows.

## PROSECRETS

### QUICK NEW LAYER

Although it kind of feels like I'm trying to do a Vulcan mind meld on my keyboard, I'll sometimes use the Ctrl/Cmd+Shift+Alt/Option+N combination to quickly create a new layer in a Photoshop document.

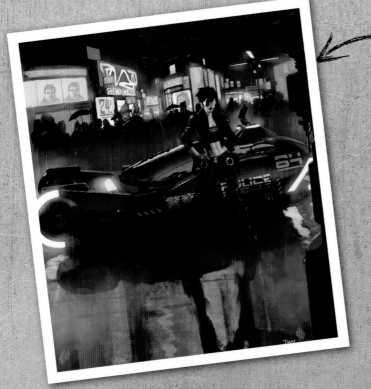

## Final touches

I also want to keep the rendering a bit looser in the background characters and environment. The graphics and logos on the Spinner are pretty closely based on the movie vehicle, although I do take some personal liberties here and there. The main character's outfit is totally made up, and has much more of a motorcycle cop aesthetic than Deckard's outfit had in the movie. The choice here again is made to take advantage of the wet and reflective feel of the image, and some of the same colours and graphics from the vehicle are incorporated into her outfit. A subtle colour adjustment layer, some indication of rain splashes on the ground and some texture on the road surface are the last things I add before shipping the final art off. The foreground will be covered by text on the front cover, but the policewoman's reflection isn't the only way that a moody, rain-soaked, neon-lit atmosphere has been conveyed.

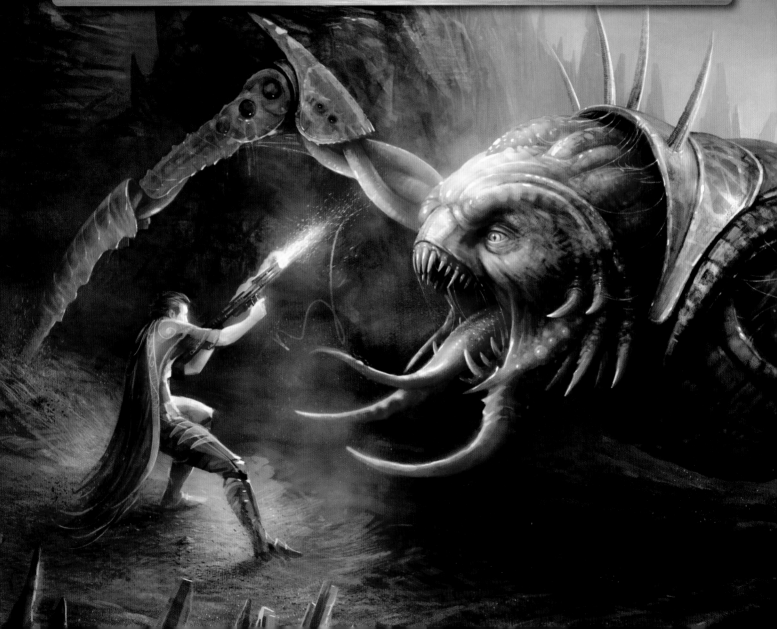

# CREATURES

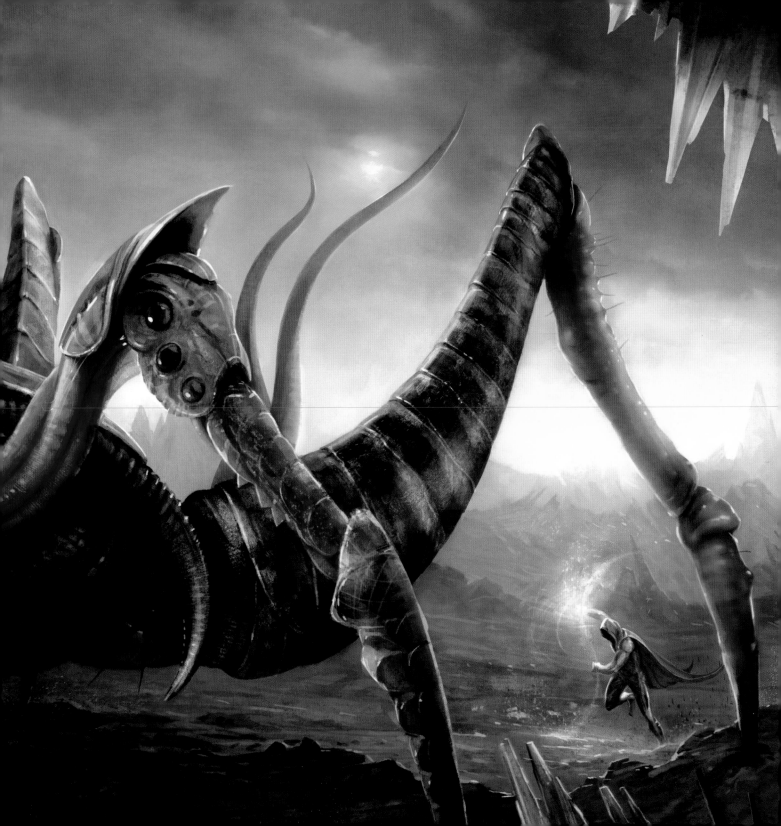

## ARTISTPROFILE

### John Kearney

**COUNTRY:** England

John has many years experience as a 3D graphic artist in the video games industry. He is currently freelancing on various projects.

**WEB:** www.brushsize.com

# MONSTER CREATIONS

## The creation of The Malesquis: an insight into the evolution of a beast

This article will provide you with a walkthrough of my experiences during the creation of this project. I hope that you pick up some useful tips and find it entertaining and informative.

First, I assess what is required and set a few targets. I'm being asked to paint a striking monster, which immediately gives me the main focus of the painting. My design has to be solid, unique, and convincing enough to clearly visualise its movement. I want it to look stylish and be able to captivate the viewer's imagination. Lastly, I want to place it in a setting of some peripheral interest and create a composition with visual impact. It's good to be ambitious! I realise that this is no easy task, and

that preparation will aid in making my goals a reality. The first task is to come up with a scenario – even a basic story will give a design purpose and direction. I normally scribble down some ideas that will be used throughout the project as a source of inspiration and guidance.

My beast will be from a breed of alien creatures called The Malesquis. They can only be found on one planet, a barren and desolate place called Arrazine. This world is a hostile environment. It's a deadly battlefield for warriors and hunters brave, or stupid enough to enter its domain. The deadly Malesquis are thus a prize trophy for those wishing to better their reputation and wealth.

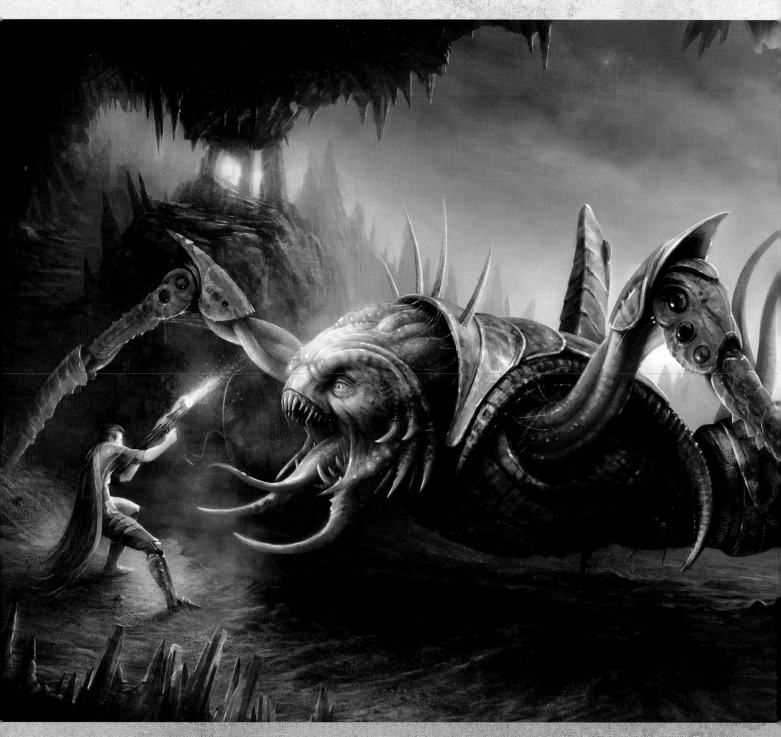

## 1 The Malesquis concept

I've been given landscape dimensions, which influences my decision to go with a quadruped rather than a biped. The monster has to be the main focus, and I feel a biped would have made the composition potentially problematic. Using my storyline, I'm able to get a feel for the kind of beast that would work well in a harsh habitat. I think the perfect mix would include armoured shells, mobile limbs for climbing rocks, an impressive arsenal of weapons for attack and a few vulnerabilities, indicating that adept warriors would be able to challenge them.

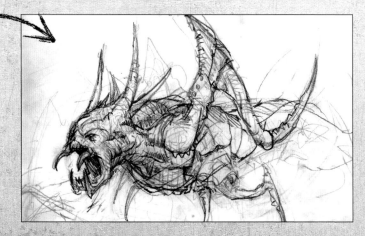

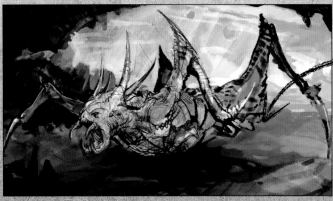

## 2 Gathering reference material for inspiration

I write a quick list of insects, animals and anything else that might provide useful eye candy. Then I go about searching for some reference, both on the Internet and in my book collection. I end up with a folder packed with numerous photographs. Included are scorpions, turtles, crabs, earwigs, wasps, rams and even seashells! Many thoughts begin to flood my mind, so I take advantage of them by knocking out some incredibly crude and rudimentary sketches. The purpose of this is to begin to get my ideas down on paper. I don't worry too much about the quality of my initial thumbnail sketches. They are just mental notes that are there to be built upon.

## 3 Selecting and developing a sketch

Usually I take quite a lot of time to develop my chosen sketch. This time I feel impulsive and eager to get straight into Photoshop. I choose a thumbnail that is barely enough to start with, scan it in and get straight to work. I quickly create rough landscape dimensions for my canvas and then begin adding to the pencil sketch digitally. I know the pose has to be fairly strong and clear enough to show off the design, so I get stuck in with some basic, loose shapes. A rough impression of the caves is introduced so that the environment is indicated for compositional purposes. If ideas are flowing, it's usually a good idea to go with them and capitalise on the inspiration.

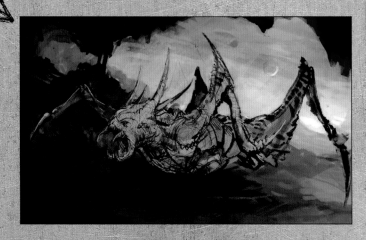

## 4  Canvas set-up

I carefully review the dynamics of the creature and think more about composition. I also make mental notes of places where I could add the hunters and then rotate, crop and scale the image to half of my intended final resolution. I do this for two reasons. I know that I will eventually refine and detail the whole picture once all the basics are in place – this is the stage where the resolution matters. Secondly, I want to use Photoshop quickly during my initial sketching. Once I reach a basic milestone, I begin to think about brushes that I might need during later stages.

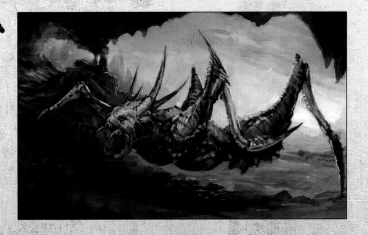

### SHORTCUTS

**STRAIGHT LINES**
**SHIFT+CLICK**
Have trouble drawing straight lines?
Hold down Shift and click at the point where you want the line to end.

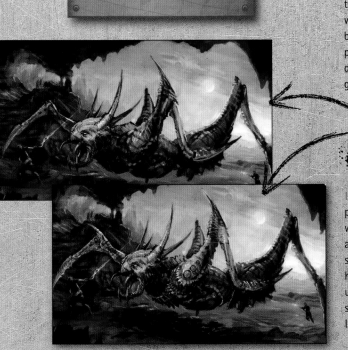

## 5  Brush management

Texture is always important to me. More often than not I prefer to manually draw a lot of it rather than use large brushes, as that can make things look linear and samey. You can define contour and shape much better with smaller brushes that are endowed with a hint of texture. One of my favourites that I use in a good 90 per cent of my work is the Pastel brush, which ships with Photoshop's Natural Media brushes. It gives me a bit of grain and a nice shape, which I personally prefer for painting. I supplement this with custom brushes that I have drawn myself, usually with pencil on paper. You get a lot of organic grain for free, and this makes things look very natural.

## 6  Colour and tonal foundations

I consider that tones, values, contrast and overall lighting generally take paramount importance. Colours can be changed incredibly easily when working digitally. As long as I am near the mark I don't worry too much about having a palette laid out. With the knowledge that new light sources will be added at a later stage I proceed to paint some blue hues of differing brightness to give me a basic ambience and an underpainting on which to work. Doing this provides an effective starting point, because the fundamental tones of the image are set. I recommend getting rid of the white canvas as quickly as possible.

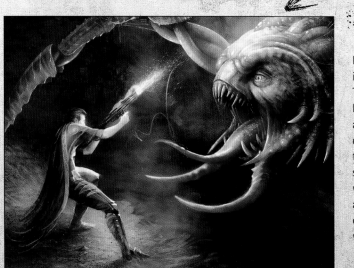

## 7 Lighting and colour

Lighting affects absolutely everything, so consider its colour and intensity very carefully when selecting and mixing surface colours. Think about the quality of light and the effect it will have on shadows. Light can be used to add areas of focus, add contrast, create atmosphere or describe form. Since my scene is going to be set in a dark cave I use the foreground hunter as a source of light via his weapon. This is planned and absolutely necessary, otherwise the beast's face will be in darkness.

## 8 Compositional enhancements

Stalactites and stalagmites provide ideal contrast points against the sky and foreground, which frame the picture and add more interest. While painting the ground, I try to incorporate natural patterns that will help lead the viewer's eye into the picture and create depth. Complementary light sources often add some colour interest. If placed correctly, they can also provide you with the ability to use rim lighting. This enables you to highlight one edge, a technique often used in film and photography for dramatic lighting. It's most striking when used in high contrast.

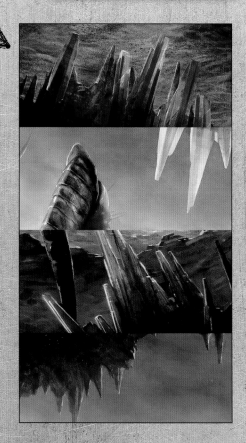

### PROSECRETS

**OPTIMISING KEYBOARD SHORTCUTS**
I dislike using my Intuos touch strips and prefer keyboard shortcuts. I permanently have one hand on Ctrl+Z (undo) because it often takes multiple tries before hitting the correct brushstroke. My most used shortcuts are dispersed around Ctrl+Z, and I find it an inconvenience using square brackets to change brush size. Therefore, I have remapped brush-size shortcuts from the square brackets to [Z] and [X] which means my eyes never have to leave the screen.

## Improving weak areas and correcting mistakes

It's necessary to make some comments regarding the organic nature of painting fantasy artwork. Making critical decisions on the quality of your painting is vital every step of the way. Learning to critically assess your work is the first step in being able to point out problems and make corrections. Fantasy artwork is not like drawing a portrait. You have no real direct reference. As a result the painting has to be given a chance to evolve.

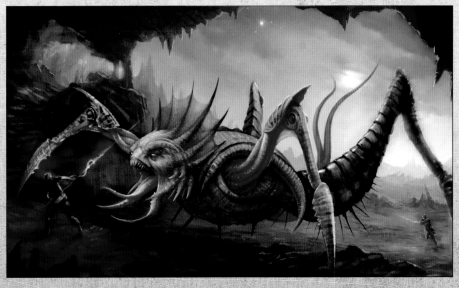

### SHORTCUTS

**SCREEN MODE [F]**
For switching screen modes –
a great way to save yourself time
when working away on your picture.

## 10 Character and detail considerations

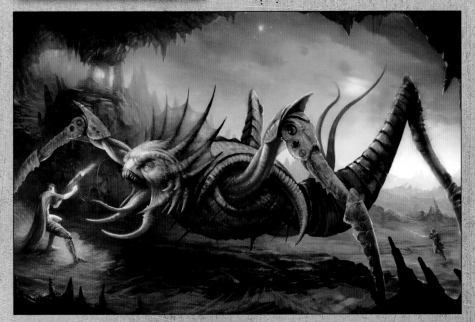

I rarely make a proper design for character clothing in a painting like this, because the scale means that most of the detail is just suggestive. My initial foreground character pose isn't working too well, so I change it to something more dynamic. The revised character's feet are positioned to give the impression that they have slid, with bits of debris spewing up. The decorative cloak adds balance to his body position. It's important to plant The Malesquis' front legs into the ground and to add further dust and rubble around them. I make the landscape fairly inhospitable by adding sharp rocks and convey depth by drawing a few distance layers that gradually fade into the sky.

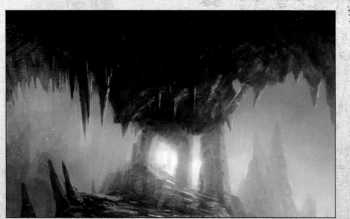

## 11 Complementary elements

I always try to think of things that will add decorative interest and be complementary to the look of the finished painting. What is complementary? It boils down to personal preference and artistic vision. This is where individuality shines through. I decide that crystal sparkles from the rocks would work well. Partially obscured light sources tend to create glow effects on camera lenses, so I decide to implement them at the back of the cave. Doing so gives the area a cinematic feel with a hint of mystery and atmosphere. The area that has a rocky stepped pathway is one of curiosity and encourages the viewer's eye to roam around the picture. These little touches can add an awful lot to a painting.

## PROSECRETS

### HSB COLOUR PALETTE

Colour selection is incredibly important when painting. Making sure you have the right brightness and hue can be time-consuming and frustrating, especially when using the default RGB Colour Palette. Try changing it to the HSB Colour Palette by left-clicking the small arrow at the top right of the Colour Window. With a little practise you should find that colour selection becomes much more intuitive and accurate.

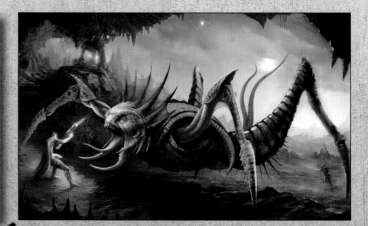

## 12 Adjusting dull sections

If an area needs a bit of life or slight colour variation, I'll simply create a new layer, change it to Overlay or Hard Light, and hit this layer with hints of my desired colours using a soft-edged brush. This keeps the texture you have underneath, but changes the underlying colour, the intensity of it and adds vibrancy in the process. I use this sparingly.

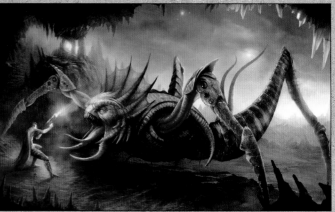

 ## It's bugging me!

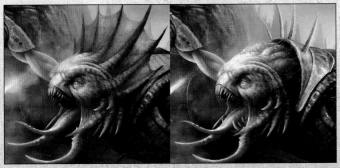

If anything is catching my eye and annoying me then I feel compelled to change it. The horn crown feels a bit too clichéd and too similar to a Triceratops for my liking. This design doesn't work too well when I imagine The Malesquis brought to life. If placed in a film or game, the head movement would have looked severely restricted because of the horns clashing into the shell. It bugs me the whole time, so I decide to try an alternative near the very end. It occurs to me that the themed muscle tissue might work well as a neck and be consistent with the design of the limbs and tails. The tissue suggests the neck can extend out, increasing its manoeuvrability and enabling The Malesquis to quickly strike with a snap of its jaws. The result is a weirder design, similar to a tortoise, but definitely more threatening!

 ## Adding effects and finishing touches

My custom brushes are used to create the debris, dust, and little sparkles. The debris/sparkle brush consists of noisy smudges and dots. I adjust the Scatter and Angle Jitter settings of the brush, so it's sprayed randomly when painting. The dust is created with a brush that I have created myself. It's always nice to create your own brushes to solve a problem. As a final measure, I flatten the image and make colour corrections using Levels dialog. At this stage I sometimes like to hit the image with a few subtle glows in key places. I do this by creating a new layer, setting the layer mode to Colour Dodge, and painting the blooms with a soft-edged brush.

 ## Summary

It takes a great deal of time and effort to be able to put something down in a way that enables others to capture the essence of your idea or fantasy. You need to balance technical ability with creativity and be willing to suffer plenty of frustration in the process. Painting a picture is often a struggle against yourself, but the sense of achievement when you are finished is enough to make you go through it all over again.

Overall I think I manage to achieve quite a few of my goals with my picture of The Malesquis, so I am reasonably pleased with the result! I hope this article has inspired you, and has helped demonstrate a workflow for creating your own fantastical beasts from concept to completion.

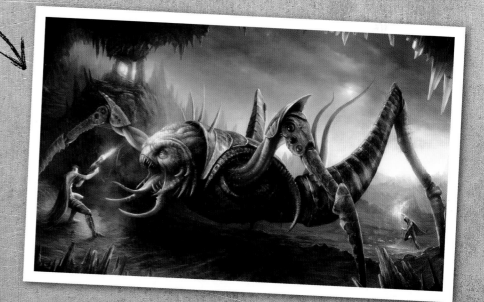

## ARTISTPROFILE

### Andy Park

**COUNTRY:** USA

Andy is a concept artist and illustrator who's worked on a variety of comic books, magazines, and TV shows. In recent years he's worked as a video game concept artist for Sony, working on the acclaimed God of War 2 and its upcoming next-gen sequel.

**WEB:** www.andyparkart.com

# QUICK MARTIAN CONCEPTS

## Sony concept artist Andy Park explains how he develops his characters

When illustrating a character or creature, the approach I take varies depending on many factors, such as who I'm doing it for (be it a client or myself), what I'm trying to communicate, the time I need to do it in, what effect I'm going for and even what mood I'm in.

All of these make a difference in my approach because depending on those factors I'll attack an image differently. For example, if I'm designing a character for a production, like a movie or a video game, I might do paintings initially that are only black and white and perhaps a bit looser so that I can come up with a variety of design options for the director to pick and choose from.

In contrast, if I'm given the freedom to design a character without the constraints of a really quick turnaround and the need for many variations, I'll treat the concept more like an illustration – planning and painting an original piece of art at my own pace, while at the same time meeting the needs of designing the character or creature. This was more of the approach I took when tackling this image.

I decided on a Martian, and then I asked myself, 'What does a Martian look like?' I wanted to bring both the expected and unexpected aspects into the design. Martians are from the Red Planet and are typically depicted as little green men, so I decided to use red and green as the two main colours.

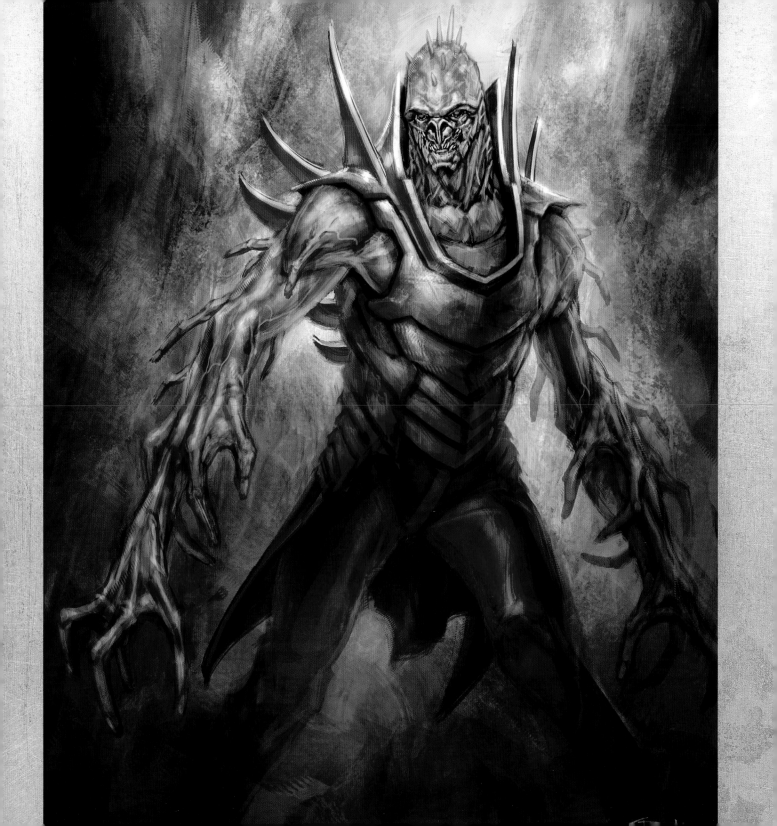

# 1 Background base

When starting a painting I almost always begin with a background base. At the very least I'll make the background a mid-value grey. In this painting, I decide to do a few things to get my creative juices flowing. The idea is to get rid of the scary white canvas and make things interesting.

I start by making a simple gradation. I then use the standard Leaf brush and paint all around the canvas. I want to create some kind of motion, so I use a Motion Blur filter with the distance pixel value set to 279. Next, I decide to sharpen things up by using the Unsharp Mask filter (Amount: 172, Radius: 71.5, Threshold: 0).

After that I adjust the overall colour palette to include more red, because I know that the Martian will be green. I create a Hue/Saturation Adjustment layer (Hue: -20, Saturation: +15, Lightness: 0). Lastly, I apply a circular gradation on a new layer set to Multiply in order to darken the overall painting and reduce the focus on the many different textures and colours.

There are a million ways you can create an interesting background base. This is merely what I came up with for this particular painting, so experiment and find your own different ways.

# 2 Character sketching

Now that I have a background base I can work with, I create a new layer and set it to Multiply. I then start to paint the basic silhouette of the Martian. I go back and forth between painting and erasing to find a silhouette that I like. I'm creating as I go, and that's the great thing about Photoshop. You can go in a specific direction and make drastic changes at any time. You're never committed like you would be with real paint.

## SHORTCUTS

**MERGE LAYER DOWN CTRL/CMD+E**

Use this as a quick and easy way to merge the selected layer to the one below it.

### Fleshing out specifics

I create a new layer and begin painting the specifics of what this Martian will look like. I want to create a civilised and intelligent being – not just a creature or monster. I give him a typical sci-fi-style armoured jumpsuit costume. I also hint at evolved anatomy.

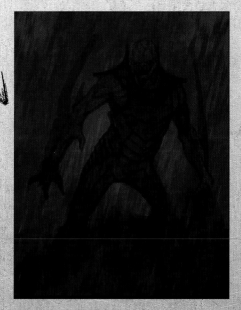

### Continuing to define the character

I continue painting opaquely, defining what this thing looks like. As I paint, I decide to give him a hand within an arm, or an arm within a hand. I don't want to give him a straightforward-looking human anatomy. As he's from Mars, I think he could have evolved in a very different manner than a human that breathes earthly air. I also continue defining his suit of armour.

### Defining form

Now that the character is pretty well defined, I begin to work on his forms. This is the fun part because it's where it comes alive and jumps out of the screen. I decide where the light will be coming from and allow that to dictate how I'll render out the forms. This will be a basic top-down light source, so everything I render will adhere to this.

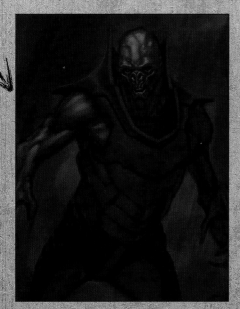

# Overall adjustments

At this point I realise how dark everything is and make two Adjustment Layers: a Levels layer (with the input levels set to 28, 1.00 and 102) and a Hue/Saturation layer (set to 0, -25 and -19). The Levels adjustment brightens everything up, but also adds unwanted saturation with it. So the Hue/Saturation adjustment works to correct this by lowering the overall saturation.

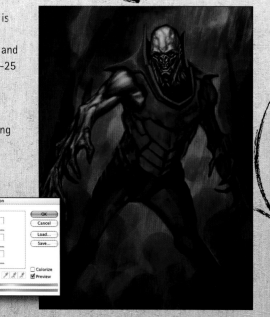

# Adding texture

I use a texture brush to give more texture to the background and (subtly) to the character, too. You can create your own texture brushes, use the default ones in Photoshop, or even use photo textures to add texture to your paintings.

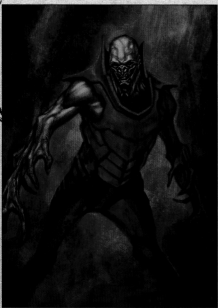

# Background variation

I now want to create a separation between the background and the character. I decide to experiment and try painting on a new layer set to Colour Dodge. I choose a turquoise colour and begin painting around the character. This helps separate him from the background, making his silhouette stronger. You'll also notice that the image has been flipped. I often do this to get a fresh perspective, helping to minimise my mistakes.

 **Make design decisions as you go**

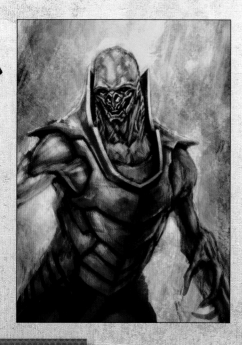

I step back from the painting and feel that the Martian's head looks very squat, so decide to give him a longer neck. It also makes sense with the design of the armour. So what I do at this point is to make a copy of his head and move it higher up, to where it looks right (see Pro Secrets on p. 52 for more on making a copy). I then paint in the details in his neck to complete the adjustment.

 **Add details to tell a story**

I continue to add details by painting in teeth and suit attachments. This helps the Martian to stand out, not only in the picture, but also in the society he lives in. It gives him a regal look – perhaps he holds some kind of higher position. Normally when I'm painting a character concept I try to get all the background information and study it before tackling the design. As this is more of a fun exercise, I'm designing as I go – if you're painting for yourself, this is totally fine.

## SHORTCUTS

**HIDE ALL WINDOWS**
**PRESS TAB**
This hides all the windows, so you can view the image without any clutter.

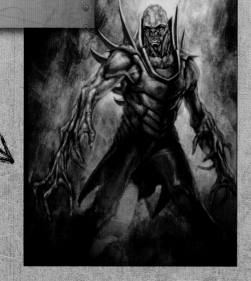

 **More design adjustments**

I decide to make more design adjustments at this stage. I want to lessen the twist and exaggeration in his lower torso, so I make a copy of the entire image (check out the Pro Secrets), select just the waist and legs, and delete the rest. I then adjust it using Edit> Transform>Warp. I straighten out his waist, hips and legs a bit, and the end result is a stronger and more imposing stance. I also decide to adjust his arms. With the evolution of the Martian's arms it would be good to enlarge and elongate them overall, which will help make the design unique as well as bring more emphasis to it.

## Darken the edges

I create a new layer and set it to Multiply. I then use an airbrush to paint around the edges. The point here is to emphasise the focus, which in this case is his head area, so I paint around it with a low opacity brush.

## Adding highlights

To add highlights, I create a new layer and set it to Colour Dodge. I then use a warm, dark-brownish colour and paint highlights along his arms and armour (especially in areas closer to the light). You'll also notice that I've added more finger appendages coming out of his arm. Maybe this is how Martians' bodies grow and evolve with age.

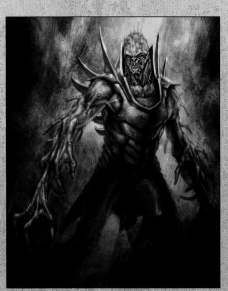

## PROSECRETS

### COPYING AN ENTIRE IMAGE ON TO A LAYER
This is very useful for many reasons – one being when you want to make big adjustments to certain areas without having to flatten the whole image. First, create a new layer and then hold down E+Shift+ Option/Alt, and Cmd (for the Mac), or E+shift+Alt and Ctrl (for the PC). This makes a copy of the entire image on to that layer. Select only the areas you that want to adjust, delete the rest and make whatever adjustments you need to make in that area.

## Value check

We're pretty much done at this point. I do a final value check by creating a Levels adjustment layer. I push up the highlights and darken the shadows a little and it stands out nice and strongly. Using adjustment layers are a great way to check your work to see if something needs adjusting (hence its appropriate name).

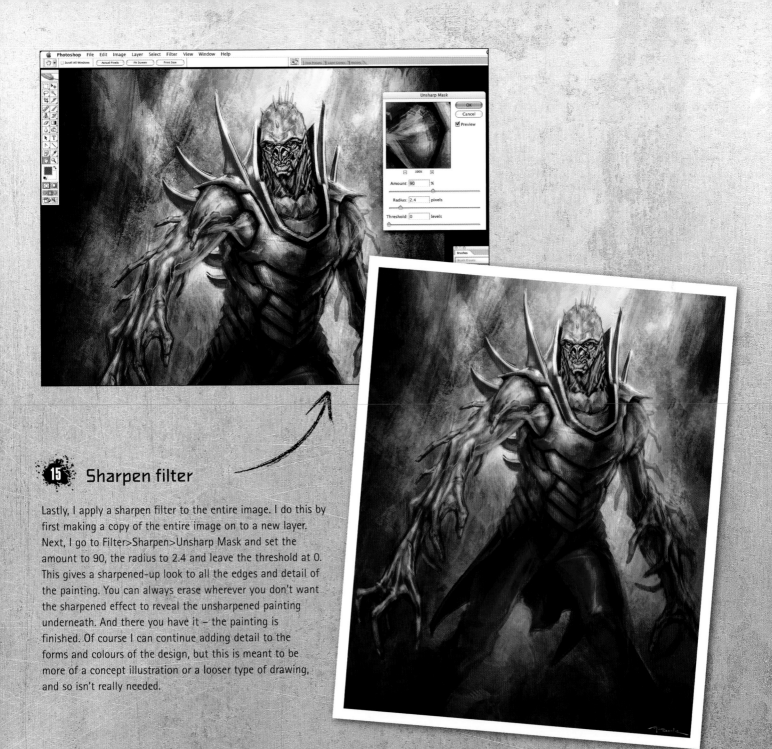

## 15 Sharpen filter

Lastly, I apply a sharpen filter to the entire image. I do this by first making a copy of the entire image on to a new layer. Next, I go to Filter>Sharpen>Unsharp Mask and set the amount to 90, the radius to 2.4 and leave the threshold at 0. This gives a sharpened-up look to all the edges and detail of the painting. You can always erase wherever you don't want the sharpened effect to reveal the unsharpened painting underneath. And there you have it – the painting is finished. Of course I can continue adding detail to the forms and colours of the design, but this is meant to be more of a concept illustration or a looser type of drawing, and so isn't really needed.

## ARTISTPROFILE

### Mike Corriero

**COUNTRY:** USA

Mike is a freelance concept artist and illustrator for the video game and film industries. His work has also featured in Ballistic Publishing's Exposé 4 and 5. His clients have included Radical Ent and Fantasy Flight Games.

**WEB:** www.mikecorriero.com

# SYMMETRICAL DESIGNING

Through the process of abstract asymmetrical duplication, Mike Corriero explains how to produce dozens of unique symmetrical thumbnail designs

Thumbnail designing is always a useful tool for any artist. It triples the amount of designs you can produce with much less effort, and often yields a lot more effective results than a fully rendered, detailed sketch. This is a process undertaken by most artists, especially in the professional field when presenting the preliminary phase of a job to a client or company. Here, I'll show you a few different variations of asymmetrical and symmetrical thumbnail sketching.

When sketching you'll need to keep in mind what shapes might end up as a head or arms. However, it's not necessary to be too precise. Keeping things abstract leaves your work open to interpretation, giving it greater flexibility. So when you're setting up these asymmetrical designs to be copied and flipped, going crazy is encouraged. The more wild and irregular the sketch, the more possibilities it opens up.

It doesn't matter if you use a pen, pencil or digital program to sketch these out because in the end it's the shape and silhouette that matter. You should feel free to let the shapes become exaggerated, and even separate portions, because you never know how they'll be interpreted when you work them out in 3D form.

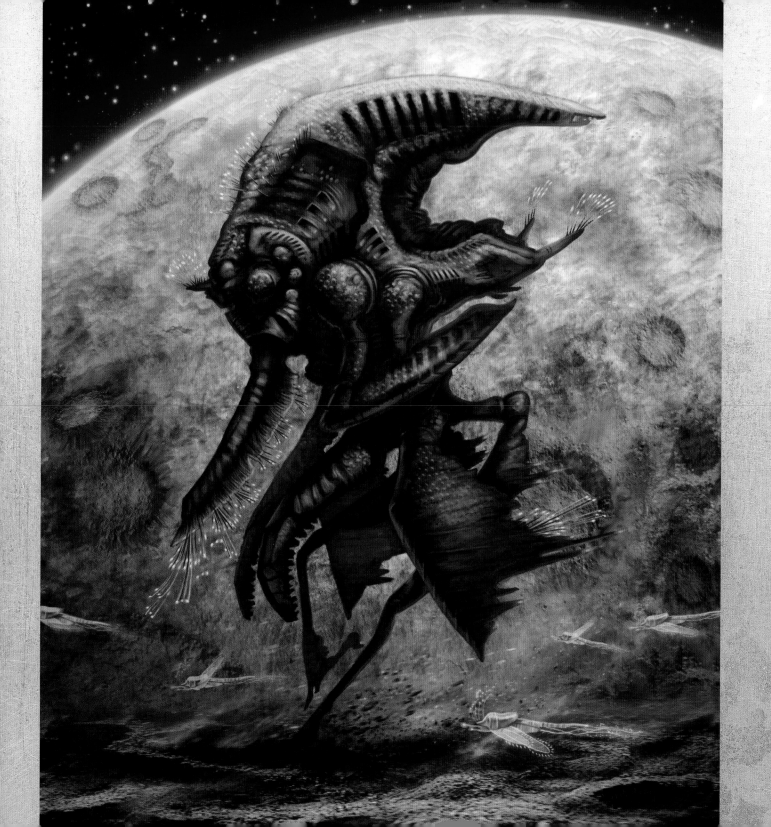

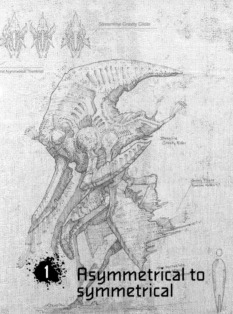

 **Copy flip method**

To produce double the amount of concepts in terms of symmetrical designs, I took the asymmetrical versions – selecting one half with the Rectangular Marquee tool. Then, by using the copy and paste method, I flipped the second paste of the same half horizontally. With my settings applied to View Snap, it's quick and simple to drag and align the duplicated selection to meet and snap together.

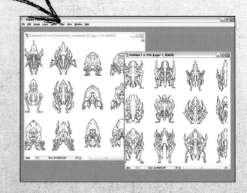

Just repeating this process with the opposite side of the thumbnail will provide a second symmetrical design. This brings the original 12 thumbnails to a total of 36 designs (of which 24 will be symmetrical only) having taken one third of the amount of time it would have taken to produce 36 individual sketches.

# 1 Asymmetrical to symmetrical

I've started these designs with a Staedtler 0.05 pigment liner pen on plain paper. Each thumbnail is approximately 25mmx51mm (1x2 inches). Start by drawing a couple of vertical lines in pencil which will serve as your design separation points – to create symmetrical designs later on. In the thumbnail that's blown up you can see the design split down the middle. Below it are the two symmetrical designs created from the purposely asymmetrical design in order to produce two similar but unique shapes. To the right is a set of asymmetrical concepts, which you can see were each designed to be unique, with different elements, varying amounts of limbs and a mix of height and width.

 **Asymmetry**

In our world there are examples of asymmetrical life forms – usually crustaceans and sometimes fish – but it's rare as most life consists of symmetrical biological constructions. In order to more easily read my designs and distinguish the differences, I've selected all the negative space, inverted the selection and, on a Multiply layer, filled the designs with a solid colour.

It's very easy to manipulate a design via Free Transform if I decide to make it more streamlined or stretch it out. I can even mix and match various portions of one design with another by overlapping a selection and fitting it to the width or height of the other thumbnail.

## SHORTCUTS

**COPY/PASTE TRANSFORM CTRL+ALT+T (PC) / CMD+OPTION+T (MAC)**
Creates a duplicate of a selection and sets Free Transform.

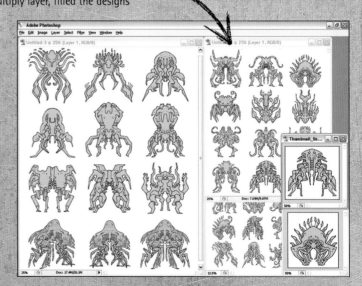

##  Digital thumbnails in silhouette

One other method I use on occasion is the silhouette technique, which is very quick and easy to produce digitally. Using the lost line technique and erasing out the details or separation of shapes is highly useful and makes it easy to produce many designs from just one shape. When you are working with the digital thumbnail in a silhouette manner you can manipulate the shape in hundreds of different and varied ways, erasing and working as you go with a strong use of positive and negative values. Overlaying and Warp transforming (while providing texture) and a rapid Transform repeat technique makes it quick and easy to go from one simple sketch to one hundred – and when you're working to a deadline that's very useful!

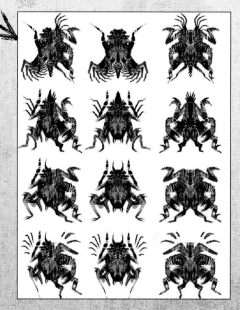

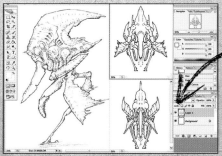

##  Evolution of a thumbnail

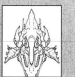  

Now that the thumbnail process has been completed and I've produced around 80 designs, I've chosen two that are close to what I want and have started to sketch my design using the pigment liner pens. It's easiest to start this process by reproducing the large, dominant shapes from thumbnail to final design. I'm taking an easy way out here with a semi-profile view of this life form.

##  Detail and mirroring

How much work you do here is up to whether you want to keep the sketch rough and loose or detailed and refined. Mirror your drawing by first producing the line work and shapes that dominate it then just duplicate the necessary limbs and biological elements to the other side. If you're happy with your sketch, shading in at this point can sometimes help cut down on painting later on.

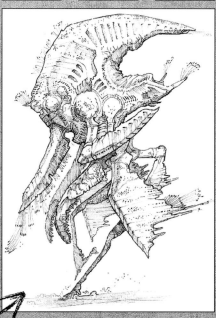

## 7 Sketch complete

I complete the final sketch with sensory fibres, shading and minor details. It actually takes much less time if done using a pigment liner rather than a pencil, as it helps to steady your hand and produces more confident lines if you can't erase. Using small 0.05 Staedtler pens also enables you to shade and control line weight effectively. I line up some of the thumbnails that I liked the most next to the final image, to see if anything else inspires me.

## 8 Base texture

Courtesy of www.mayang.com/textures, I've used a texture photo of an old worn-out wall to give my sketch some colour and a base to begin my painting. I just pasted the photo, rotated it and enlarged it to my liking.

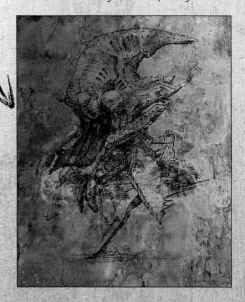

## 9 Establishing a setting

With the use of additional photos from Mayang's free texture library, I've laid down a ground, which was actually a photo of a termite mound, and overlaid another texture on top of the wall photo. At this point I'm just playing with colours through the Hue/Saturation options to find anything that works, keeping in mind what I'm aiming for, which is an unearthly setting and a blue/pink colour scheme. In addition, at this point I've gone back to the original sketch layer and selected and inverted it, filling it with a pinky base colour.

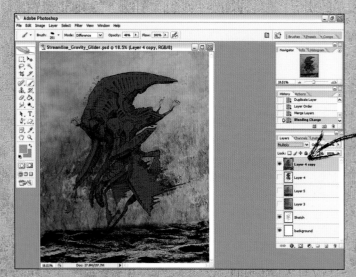

## PRO SECRETS

### TRANSFORMING A SHAPE
Create a shape on a new layer then select it. Now hold down Alt/Option+Ctrl/Cmd+T and that should copy or transform the shape. Then use the Transform tool to move it in any direction, shrink or enlarge it a little and rotate it a bit. Next hit Shift+Alt/Option+Ctrl/Cmd+T and it will repeat the action, and if you hold down Shift+Alt/Option+Ctrl/Cmd and just keep hitting T it will continue to duplicate the action as many times as you want.

## 10 Colour flow

Keeping elements on separate layers makes it much easier for me to play around with the values, the hues and colour shifts. In order to build up colour gradually, I want to use cool, muted and darker tones all from within the same colour spectrum.

## Defining the location

To complement the curved dorsal shape of the creature's cranium, I've used the Circular Marquee tool to create an arch and set the beginning for my planet in the backdrop. In order to create a striking planetary lighting effect, it always helps to paint a glow produced by the atmosphere, and to continue the light around the source as it hits the sphere.

## Planet surface

A quick light and dark value texture is applied with a stippled concrete pattern, inverting the texture to make the pattern more prominent. Reducing the scale of the pattern as it nears the lit edge helps create an appearance of the texture wrapping around the surface.

## Gouged soil

With the use of another photo texture cropped to a circular shape and framing the planet, I can provide a contrast in colour between the foreground and the background. It's also being used to supply additional texture and quick colour variations.

## Overlay

By setting the gouged soil photo texture to an Overlay layer on low Opacity it will give the appearance that it's sitting on top of the planet. It will sink into the existing colour and textures while still affecting the values and the shifts in hue, appearing as different colourations in soil or varied locations and elevations. Erasing with a soft airbrush and breaking up the strength of the photo texture also helps to achieve a more natural appearance. Duplicating the layer will increase the strength of the Saturation and Opacity, which is useful if you want to light a section on one side and leave the other in shadow.

## 15 Atmosphere and particles

What I've found to be an effective way to knock down the strong, clear pixels of a photo in order to give it a more painted feel is to copy and paste a selection directly on top of the image. I then apply a Motion Blur on an angle in whichever direction is appropriate and set the duplicated layer on a low Opacity. This is a great and easy way to supply a misty, soft atmosphere and to help cut down on the harsh pixels that photos sometimes produce in contrast to a painting.

## 16 Gravity Glider edging

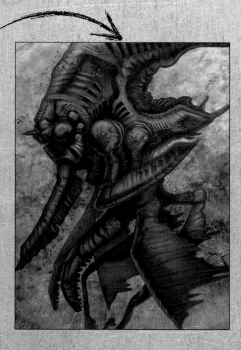

On a new layer above the background and above the sketch, I've started painting dark and light values – working out the forms and shapes of the streamline Gravity Glider. This character has a complex design so I'm trying to keep a good deal of it in shadow, especially since bioluminescent light will play an important part in the creature's biology. Edge control quality consists of defining the silhouette by applying reflective and local colour both from the dominant light source and colour from the background.

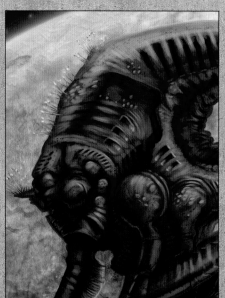

## 17 Contrasting bioluminescence

Important parts of this life form are also important parts to the focal points and interest of the painting. The sensory fibres help this creature in many ways, from its sense of touch and vision to its mating habits and digestion. They're also a great element for the environment in which it lives, as living in space is similar to living in the deep oceans of earth.

## Glider's skin

Using a scratched glass bump pattern created from Mayang's texture library, I'm using the same light and dark value invert technique as in step 12 for the planet's surface. In order to get the most out of my texture, I desaturate the colour, pump up the values and make sure there are no seams so it repeats continuously. Set the Depth to its full extent, the mode to Multiply and check the box that says Texture Each Tip.

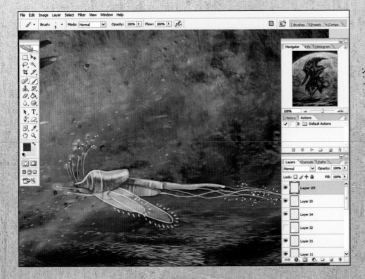

## Not alone

I sketched out these little guys during my thumbnail creations. I felt they would do the job of providing some sense of scale. I only painted one, but by adjusting the scale, the angle and the position of the wings – among other things – the effect of many can be made with ease. Keeping with the deep sea and space theme, I kept the smaller life forms completely bioluminescent to provide enough additional eye candy without being a distraction.

## Light, value and that's a wrap

The last thing I do before finishing a painting is to take some time away from it. When I come back I may find that it's too muted, there might be something missing or the lighting isn't right. So here I have used the Brush tool on Overlay to create a stronger sense of light on the planet and adjust the overall light value.

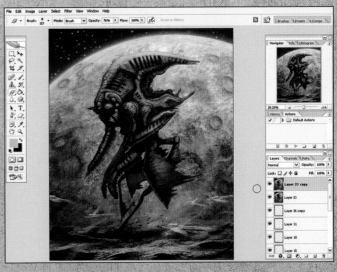

## ARTIST PROFILE
### Marc Taro Holmes

**COUNTRY:** Canada

After notching up 15 years' experience as an art director working on a range of film and game projects, Marc is now a full-time freelance artist.

**WEB:** www.tarosan.wordpress.com

# MAKE THE MOST OF PHOTO-COLLAGE

Marc Taro Holmes wonders if the powerful features of today's creative software means the end of digital painting

Okay, so it's a bit dramatic saying 'the end of digital painting', but over 15 years I've frequently had to upgrade my methods to meet expectations and I've seen good artists become obsolete. I feel that traditional digital painting has peaked, and I'm thinking what to do about that.

Everyone understands how painting replaced drawing. Years ago it was common to see line drawings used in production, especially for tasks such as costume or character design. But gradually painting took over. If it's just as fast, why wouldn't we want to work in colour? Why not convey texture and lighting as well as design? Less isn't really more. More is actually more.

Now that we can quickly render a scene to achieve perfect perspective and lighting, or ZBrush a creature and have unlimited warts and wrinkles, we've developed higher expectations for detail and realism in conceptual work.

When faced with a design task we need to fully answer the question: 'This thing that I'm inventing – what exactly does it look like?' With the fidelity available to the rest of the team, the concept artist can't just sit back and make inspirational speed-paintings. The challenge now is to pack more realism into our drawings, while still being able to rapidly iterate through ideas.

Photo-collage is a natural solution. The visual information is already in the reference we use. Why not go with the source? So let's get going – you'll thank me after you try it! Even if you don't use it every day, photo-collage is something every concept artist should be aware of.

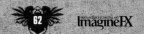

## 1 Painting vs collage

Here's a side-by-side comparison of my painting (left) versus photo-collaging. Which is a better work of art is up for interpretation. The question is simply, which approach is best for your situation? The collage was quite a bit faster, and it's very specific about skin textures and hair growth. The modellers might need that information. Conversely, if I started drawing individual pores and stray hairs on the painting I feel like I'd lose the charm of the chiselled brushwork. And I'd be at it for quite a while.

## 2 Getting the photos

Sometimes it's better to grab a camera and shoot what you need, but mostly you can get everything online. If you're doing collage correctly, you shouldn't fall foul of copyright issues. When you manipulate images to the extent that we describe here, you're creating a new work. Just follow the principle of using parts, not the whole, and you should stay legally in the clear. You could also consider buying from a stock photo service. Of course, if you're in doubt, seek further advice.

## 2 Transform stage

There are only three steps that you'll repeat as you build your image: Transform, Layer Mask and Hue/Saturation. Edit>Free Transform (Ctrl+T) is your standard opening move – check out the video to see it in action. But this might be a handy tip. In order of frequency, I tend to do Edit>Free Transform on every single element; Edit>Transform>Warp on a lot of things; Filter>Liquefy on a few things; and Edit>Puppet Warp (in CS5) under rare, special circumstances.

## PROSECRETS

### PUPPET WARP

This is a promising new tool in CS5 that's becoming more popular – it's originally an animation tool from Adobe After Effects. Clicking Edit>Puppet Warp enables you to place control points on your layer, sort of like pinning it to the wall. You can then move any pin, or group of pins, and the rest of them will hold the image down, giving you control over what stretches and what stays in place.

## 4 Using Layer Mask

Now I blend elements with Layer Masks. Almost every photo element has a Layer Mask. A mask enables you to erase what you don't need, but it's non-destructive so you can bring back what you've erased at any time. To add a Layer Mask, click the 'circle in a square' icon on the bottom of the Layers panel. To edit the mask, click the mask icon on your chosen layer, and just paint black for invisible, white for visible. It's that simple.

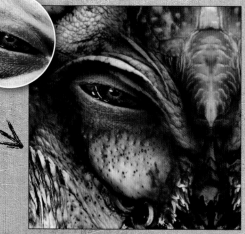

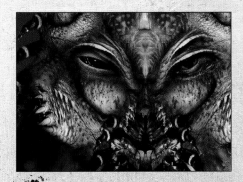

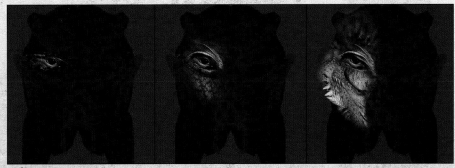

## ⑤ Make tweaks

I keep tweaking the pose and checking it with constant horizontal flipping of the canvas, which I've associated with my own shortcut, Ctrl+Alt+H. This tweaking is making me lose textures and details, but it's no big deal. They're just useful for establishing the concept in my mind, and few of them will make it to the final image.

## ⑥ Down and dirty

An old boss of mine used to say, 'Everybody likes sausages, but nobody wants to see sausages made'. What he meant was that the process looks so ugly, you might doubt the results. I start a collage the same as I would a drawing. I create a rough scribble to mass out the shape and then just start rendering. When I paint a portrait, I always make that egg shape of the head and establish a jawline, then sketch in the eye and socket, followed by mouth, nose and hair.

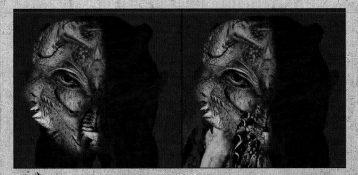

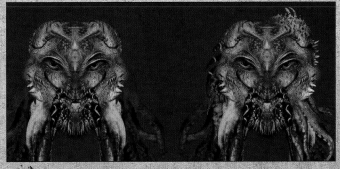

## ⑦ Be more specific

When I was prepping my little photo library I knew that I was going to use reptiles and amphibians – those are the kinds of complex skin textures that scream 'alien life' to the viewer. But I'm also Googling as I go to find specific items that occur to me, like the crab parts in the mouth. I aim to create structures that suggest flesh hanging on a not-quite-human skull. You have to seek out forms in the photos that you can sculpt onto the drawing where you'd normally be modelling with tone. I'm thinking 'I need a ridge-shape here' or 'I need something with smooth bulgy curves', such as the pouch of skin under the eye.

## ⑧ Mirror guidelines

I don't recommend mirroring for anything important because it can look artificial. But if you're in a brainstorming stage rather than doing the beauty shot then it's certainly a fast way to build a creature. Many creatures living on Earth have a level of bilateral symmetry. And it's tricky to make something look intelligent if it's entirely asymmetrical. So go crazy on monsters, but keep it bilateral on guys that have emotions. The important thing to remember is not to just leave it perfectly mirrored. Near the end, start adding to one or the other side to break up that mechanical symmetry.

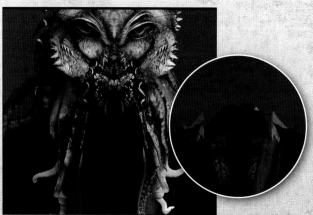

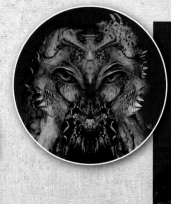

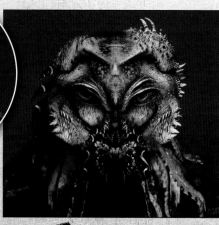

### 9    Adding a costume

If you're doing a character with a unique personality, they need personalised clothing that broadcasts their role. I won't go very far with the costume design in this workshop, but it should still be more than a floating head. For expedience, I've borrowed a costume from central casting. It's not unusual when you're designing creatures that you don't have the whole script in front of you, so this isn't as odd a thing to do as it may seem.

### 10    Lighting edits

There are always lighting inconsistencies when combining random photos. Your work can come out looking flat, so spend some time hand-painting cast shadows in a uniform direction. Often I'll pick an angle from the upper right and create a shadow side and a light side. Since I've mirrored this image, it's better to choose front lit. I set a new layer set on Multiply and paint in some soft shadows on the underside of the larger forms, and some smaller darks on the deeper wrinkly bits. I'll often also do an overall Curves or Hue/Saturation changes adjustment layer.

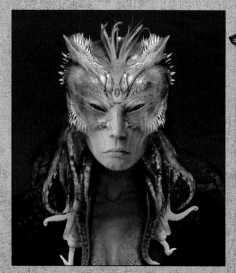

## PROSECRETS

**SEARCH TIPS**

It helps to search for an animal by their Latin name. You might need to first identify what's out there, and then search more scientifically. You could search for 'big ugly frog', but you're better off typing '*Bufo americanus*' into Google.

### 11    Taking things further

I'm keen to show some more drawing examples, so I used almost the same set of textures to create a second character. I grabbed a female face and body to jump-start the remix, and went for something as completely different, yet within the range of variation that you might see on a real project. I love painting. I'd prefer to take my time and paint this from scratch, but I couldn't have done it in a single evening. There's a lot you'd have to fix to turn this into a finished illustration. But if your goal is to be a concept artist, how can you argue with the speed? Half your concepts are never used anyway.

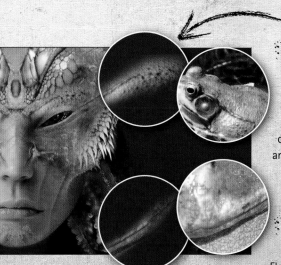

## 12 Extracting lines

When I sculpt or paint I look for places where linear shapes follow the form, particularly along the turning edges of planes. Lines emphasise the structure, and give a nice 'drawn' quality inside the work. It's natural, then, that I also look for ways to create these structural lines in collage. Here are two examples of parts of frogs that I've isolated and used to create the eyebrow and lower eyelid. You can see plenty of these creases extracted from nature throughout the piece. Like I say, I'd be doing the same thing if I was drawing from scratch, and this shows how much these collages still reflect your drawing style at the end of the process.

## 13 Extracting surfaces

Flat textures can be found online, but they're not always useful. When I look for a texture element, I'm also considering the curvature of the surface. I choose convex or concave shapes that describe the mass I'm drawing. The patch of scales from this lizard's jaw is a good example. The lighting on the curved surface suits the swelling on the forehead. I also look for swatches that have a 'direction of marks', so I can apply them as I would a passage of brush strokes. Brushwork in painting follows along the form, frequently feathering along the edge of a plane. I like the way the orange mottling on this fish works in this way.

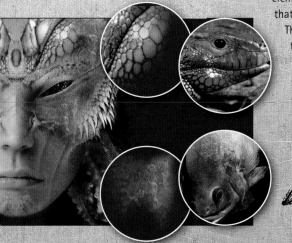

## PRO SECRETS

### PICK A SIZE
You may know this, but I'm surprised how often people don't use it. In Google's Image search, in the list of search filters on the left-hand side, there's a Larger than... option. Use it and select, say, 10 megapixels – the images returned are a great deal larger than the default Large setting. It can be handy.

## 14 Extracting objects

The third trick, most noticeable here in the tentacles, is the use of entire objects. While the exact right photo can be quite useful, it can also look too obviously pasted on. The lighting might be contradicting the average value you're creating, or the pixel density can be too low. The torso that I used is stretched too far. With the tentacles, in the interest of expediency, I was willing to settle for 'good enough, gets the point across'. Then, if this was chosen to go up for presentation, I'd go back and rework them. So that's it! Thanks for reading and I hope photo-collage becomes another weapon in your digital art arsenal!

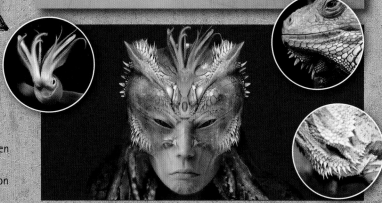

# ENVIRONMENTS

## ARTIST PROFILE

### Gary Tonge

**COUNTRY:** England

Gary is an art director in the games industry and also takes on freelance commissions. In his personal work he favours enormous vistas and grand scenes.

**WEB:** www.visionafar.com

# GETTING COMPOSITION RIGHT

## Gary Tonge shares essential advice on getting composition right

Creating an interesting and inviting composition is the key to pleasing illustrations. Images that are strongly composed with well-solved elements will draw a viewer into them and hold the eye while the details you have spent so much time slaving over are taken in.

Conversely, a badly composed image can undermine even the finest painted subjects, generating a subjective feeling that something is wrong. Many may not be able to put their finger on why, but the image will be less pleasing and read poorly, which, ultimately, will not hold up to scrutiny. The next few pages contain 20 points that I consider to be some of the most important elements of composition – the rules I lean on subconsciously every time I pick up my brush. Want to know more? Read on...

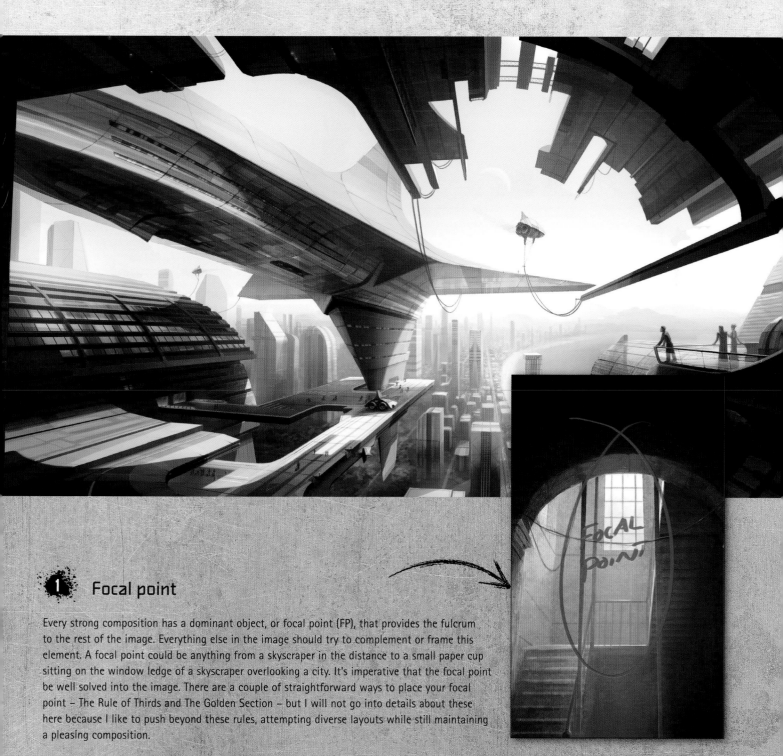

# 1  Focal point

Every strong composition has a dominant object, or focal point (FP), that provides the fulcrum to the rest of the image. Everything else in the image should try to complement or frame this element. A focal point could be anything from a skyscraper in the distance to a small paper cup sitting on the window ledge of a skyscraper overlooking a city. It's imperative that the focal point be well solved into the image. There are a couple of straightforward ways to place your focal point – The Rule of Thirds and The Golden Section – but I will not go into details about these here because I like to push beyond these rules, attempting diverse layouts while still maintaining a pleasing composition.

## 2 Positioning of other objects

Other elements in the composition should harmonise with the focal point and therefore strengthen the overall composition. Carefully placing elements will pay dividends, adding depth, balance and believability to the final image. Some examples of this are the landscape swooping off into the distance in Nimbus (right), which helps underpin the arched structure, or the smaller vehicles tending to the craft in Prometheus (main image).

## 3 Scene to subject unity

It is of vital importance that all elements within a scene look like they belong there. Ensure that shapes and structures in the distance, for instance, are sympathetically influenced by any atmospheric conditions between them and the viewer, or that structures and objects receive light correctly and cast appropriate shadows. If you get this right it adds greatly to the composition. Get it wrong, and it can unravel the entire scene. A good example is the craft on Prometheus, which casts shadows onto the dock and surrounding buildings, greatly increasing the believability of its position in the scene.

## 4 Framing

In a complex composition it can be useful to add cohesion to the perimeter of a piece by framing, which can help contour the viewer's eye into the picture and hold it there. This can be achieved by gently bringing shapes into the scene, or the use of strong silhouettes to help guide the eye toward any areas of interest – most commonly the focal point. Prometheus demonstrates this well: I have framed the top of the image with a large docking bay.

## 5 Avoiding tangents

These can be quite destructive to the way an image is read and should be avoided. Tangents are lines from separate elements which follow on from each other, causing reading problems between the intersecting shapes. A good example would be overhead power lines intersecting directly onto a corner of a building. Shifting the power lines up or down so they meet the building away from the corner will mend the problem, and make reading that part of the composition substantially easier and more pleasing.

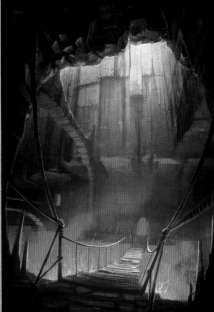

## 6 Temperature

When deciding what colours are going to be dominant in a piece, it's important to remember that generally the image will either be cool or warm in feeling – it can't be both at once (unless it's a panning matte, but that is essentially two or more images). There is no problem in having both types of colour in a piece, but one must dominate, even if only a little, as in The Dungeon (above).

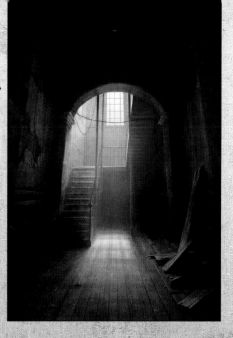

##  7  Dynamic values

Tonal values are an important attribute in generating interesting compositions. Ideally you want to aim for a balance between light, mid-tone and dark, using at least some of each. Look to create a nice balance with a large amount of one value, a medium lot of another value and a small amount of the last, maybe 60 per cent dark, 25 per cent mid-tone and 15 per cent light for an image like The Room (right).

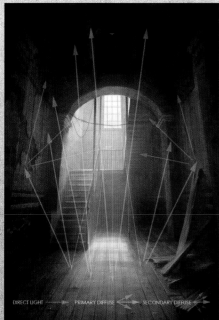

##  8  Depth

Depth and perspective are incredibly important. Vista images require an organised and believable depth using certain perspective cues to draw the eye deeper into the image. These elements could be a fence, railway track, cityscape or even something as subtle as a line of similar coloured flowers in a field. Even within smaller scale still-life images it is greatly beneficial to create depth to hold the image together and draw the eye towards the focal point. All the best composed images look like you are viewing them from within.

##  9  Kissing

Related to tangents, kissing refers to shapes just touching. Elements within a scene should either be definitely apart from each other or definitely overlapped. Kissing elements create a weak, connected shape, which distracts the viewer's eye, causing a pause in reading the piece. Either ensure your shapes positively overlap or keep them apart – no kissing please!

##  10  Light

Once the basic shapes are in place this is the most important element for me in an image. Getting the lighting right in a composition is what I focus on once I start painting up a drawing. I have broken this into a few sections to help explain the different elements involved in creating cohesive lighting, and therefore believable compositional balance.

##  11  Let there be light

Choose a position for the primary (strongest) light source – the sun, a window or streetlamp, for instance – that will produce the greatest opportunity for convincing shape description of subjects and make some interesting shadow work. The primary light source can be the fundamental part of a composition and even its focal point, as it dictates how everything within its influence will be painted. Without light, we see nothing. That's how important it is, so be sure you get it right.

## 12  12 Shadows

Shadow work can be used to great effect to reinforce subject shapes, solidify objects into the scene and add additional framing to the composition if used cleverly – for example the shadows cast down from the upper dock structure onto the lower promenade in Prometheus. Importantly, shadow's effectiveness relies greatly on the initial light source positioning.

 ## Additional light sources

Secondary and tertiary light sources are significant factors in balancing the final composition. Secondary sources could simply be the diffuse or sharp light reflected back from surfaces lit by the primary light source, or attenuated lights including street lamps and car headlights – even a light source that is nearly as strong as the primary. Using secondary light sources adds an opportunity to increase detail, solidity and to reinforce the position of elements in a scene.

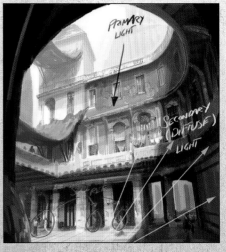

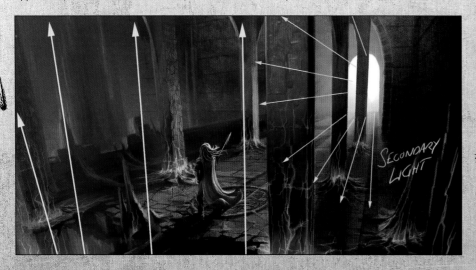

 ## Atmosphere

Atmospheric depth and occlusion are very important ingredients in solidifying the composition of a piece – be it a large vista where the sheer amount of air between the viewer and horizon transform colouring and tonal contrast in the distance, or a smaller area, where light passes through fine particles in the air to create soft diffusion and subtle changes in colouring (you can see this in The Room). Photonic bounce also adds to the relative atmosphere generating diffuse light, which shoots out from lit subjects, bathing the surroundings with soft reflected light.

 ## Materials

Well thought-out and solved materials within a scene are important to maintaining compositional balance. It's crucial to recognise how using highly reflective or shiny surfaces may draw the viewer's eye towards that area of the image. In Prometheus, I have used a number of reflective surfaces, utilising their high impact properties to hold the eye in the image and not just become drawn toward the craft. I also pay close attention to making sure that they don't overrun the focal point, but reinforce it. Alternatively, the clever use of dull and dirty textures can help create setting that feel completely different, like in The Room for example.

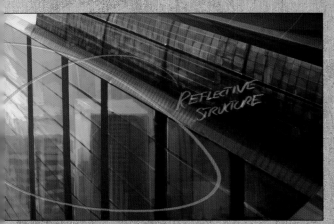

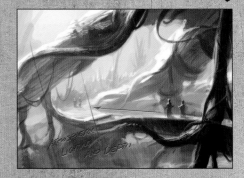

## 16 Leading the eye

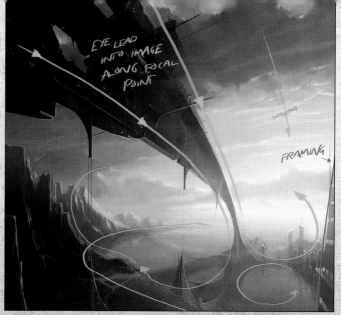

Using elements to draw the eye into and around an image is significant in a pleasing final illustration. You can lead the eye into the piece in many ways, as with an old favourite like a fence or road moving into the distance, or in the case of Nimbus, a ruddy great structure piercing the sky that moves from the top left into the centre. The end result is that the viewer will follow the arch until the end and by then they are in the heart of the piece.

## 17 Keeping the eye within the picture

Once the viewer's eye is within the piece it's important to hold their attention. Going back to the old fence moving from left to right into the distance, you would need something at the right of the piece, like a group of trees or maybe a farmhouse for example, to steer the eye gently back into the composition. Again, on Nimbus, you can see the eyeline that followed the arch is held in the piece by the city, the landscape to the left and the close up building to the right.

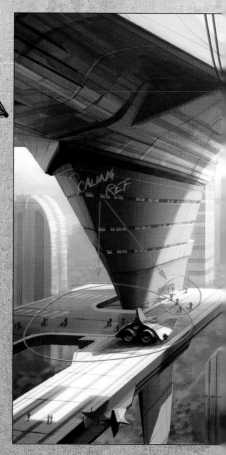

## 18 Drama

Large vistas and epic images are normally either dramatic or very tranquil. Creating a dramatic feel to an image couples a number of basic compositional rules to underline the depth, scale, speed or stillness of the projected subject. In Nimbus the large arched structure comes from over the viewer's head, skims the clouds and falls off into the distance to show just how big it is compared to the relatively small conventional skyscrapers near its grounding point.

## 19 Balance

Balance within a composition can take some practise, particularly if your focal point is a spectacular or dynamic shape that controls much of the image space. Referring back to Nimbus, again, I have balanced the piece by using numerous smaller buildings, the falling away landscape to the left and also the addition of the clouds, which importantly soften the shape as it approaches the top of the frame. These elements together enable the outrageous focal point to sit in harmony with the rest of the scene.

## 20 Scaling relativity

Complex images that show highly differential shapes and sizes require some real life reference to enable the viewer to understand the actual scale of the subjects in a piece. In Prometheus I used a number of people, some close and some far to show the incredible scale of the craft and its dock. You can get away with crazy scaling as long as there is continuity across the scene. The same principles are there for smaller subjects – a set of pencils or a telephone on top of a desk – so that the viewer can understand the size of the table.

## ARTIST PROFILE

### BILL CORBETT

**COUNTRY:** England

Bill is 42 years old and lives in the south of England. He has been drawing and painting since he was 10. In his spare time he works as a freelance artist and has produced artwork for games, music, books, CD media, magazines and online communities.

**WEB:** www.billcorbett.co.uk

# CLASSIC SCI-FI PAINTING

Use ArtRage 2 to create a digital landscape that captures the feel of classic sci-fi cover art using basic painting techniques. Bill Corbett shows you how

If you've ever seen the glorious cover art of the old science fiction pulp magazines, or you've admired the work of artists like Josh Kirby or Rodney Matthews, you'll have an idea of what I'm going to try to achieve.

I'll be working from the initial concept to the finished render step-by-step, and will only be using the basic tools available in ArtRage. For another insight into the creation process I'll also discuss some of the initial conception.

Through this workshop you'll see how things develop and change, and learn my approach to this type of painting.

There's no cut and paste and very little Ctrl+Z needed, so I correct any mistakes I make by simply erasing or painting over them. I won't be using any references other than my initial thumbnail sketch, so there will be a lot of room for individual expression throughout the process. If you feel more comfortable sourcing references for certain aspects, do so, but try to integrate them with a loose approach to painting.

There's no requirement to use ArtRage – you can follow with any paint package. The only requirement is a willingness to experiment and have fun painting. Enjoy!

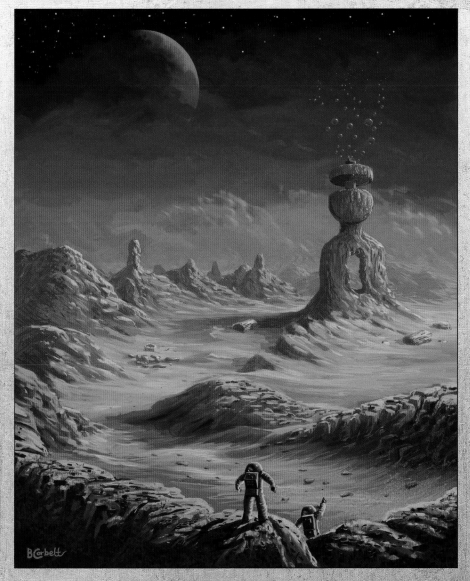

 **Conception**

To begin with I spend some time studying artworks from the classic pulp magazines like Astounding, Analog and Epic. This gives me a feel for the types of compositions used to make the paintings interesting, and helps me find common compositional themes – things that give a sense of the past, but that don't necessarily belong to any one era.

 **Thumbnails**

With these ideas in mind I narrow down a few thumbnail sketches to the most interesting and relevant one. The thumbnail for our painting is based on the idea of exploration. It draws from stories of lost civilizations, but has a distinct off-world feeling with its central point of interest. The composition plan is to bring focus to the mid-ground monument and set a stage for our intrepid explorers. To start, I open a new canvas with a neutral colour, avoiding white.

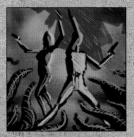
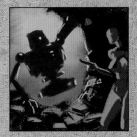
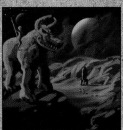
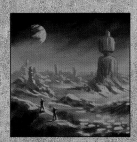

###  3 Colours down

I select the Roller Brush and make it as big as I can, then use a deep crimson from the Colour Picker and work from dark to light to just above half way up. I desaturate a rich orange hue by dragging the picker to the bottom-right corner and work it from midway to the bottom of the canvas, increasing saturation as I go.

### 4 Body paint

The Paint Tube tool is great for giving the paint more body. I squirt on lines of crimson, red and desaturated orange, then use the Palette Knife at 100 per cent to spread the paint around the canvas's top half, keeping it loose, with light blends. It's a good idea to let the strokes go in one direction at this stage. Once the sky is roughly blended, I switch to the Paintbrush sized at 60 per cent.

### 5 Filling in

I block in the rock formations using reddish browns in the foreground, and lighter browns for those further back. It's good to keep the strokes loose and bold and the brush Auto Dry and Clean. For the sandy areas, I alternate between subdued orange and yellow hues. Don't paint too light or it won't contrast well when pulling out the rock details later – just keep more saturated hues nearer to the bottom. I paint loose, varied directional strokes and avoid green and blue hues.

### 6 Blending out roughness

By now the painting should have all the basic shapes down, so it's time to switch to the Palette Knife and blend some of the roughness out. I set the Palette Knife to 50 per cent and loosely blend the sky in a horizontal pattern, varying the angle of the stroke where I can build up a cloud-like atmosphere. I'll do the same for the areas that will eventually become sand or open space. Don't over blend, and try to keep a balance between roughness and smoothness – even if you have to paint back into the blended areas.

### 7 Adding depth

To add depth, I create a new layer and switch to the Brush tool. Next I paint a low saturated hue of orange at the horizon and above, drop the layer's opacity to around 50 per cent and paint up with darker, complementary colours (orange, red to violet). I blend lightly with the Palette Knife, then drop the layer. Now I make another new layer and paint in the rock ledge. I'll merge layers when satisfied. If you need more distance, create some atmospheric dust and cloud – just remember where the light is coming from.

## PROSECRETS

**TUBE TEXTURE**
Create a new layer and use the Paint Tube to paint onto it. Switch to a small Palette Knife and cut into the paint. Use a Pencil or the Eraser Brush to break the texture up further. Position the layer over an area of foliage and merge the layer for added effect.

##  8 Levels of detail

As a general rule for painting rocks, think of them as edges that catch varying degrees of light. I start by blocking in the random ledge patterns at a low contrast for the acute angles, before introducing lighter hues at the angles more perpendicular to the light source. When doing this you have to keep in mind that the distant objects will be less saturated in colour because of the atmospheric conditions present. Don't make background rocks overly defined or colourful. I remember to detail the sky a little more too, but also keep my strokes more subtle and blended in that area.

##  9 Refine

Once there's a balance to my colours I use the Colour Dropper to grab the ones I want from the canvas avoiding the Colour Picker. It will help with the consistency of the painting.

Now I'll concentrate on refining and defining the rocks. I work from the back to the front, increasing detail as I move to the foreground. I'll take a step back occasionally and think about the terrain. Sand storms etch into rock while sand and debris drift into crevasses. Thinking about the terrain will help you understand the painting process a little more. I'll try to blend a bit of sky colour into the shaded part of the rocks to help the formation blend into the landscape.

## 10 Point of interest

When I'm reasonably happy with the background rocks I've painted, I'll add the base rock for the main point of interest on a separate layer. I haven't finished the foreground rocks, but that's fine – I'll go back to them later. Using the Colour Dropper, I select the colour of the rock shadow parallel to where I'm going to place the rock plinth and paint in the shape of my base. I'll also add some small formations around the structure to create a semi-circular path up to the plinth. When detailing the rock base itself, I'm going to be a little more generous with its direct highlights.

##  11 Half way?

At this stage of the painting I'd recommend to start alternating between Auto Clean and Instant Dry with the brush strokes. You'll find that you can add more expressive strokes and increase the variation of textures this way. The brush should not exceed 40 per cent at this point, so I work on the rock detail and the drifts of sand. If you find any part of your image taking on a greenish hue, pull it back by dropping a low opacity layer of red or orange over it. You'll find that you'll have to paint back some of the contrast afterwards if this happens.

### ERASER TEXTURE

Create a new layer and flat paint into it. Use the Eraser tool to scratch out a rough texture and then lower the opacity. Position the layer over a rocky area for extra textural effect. Clean up before merging.

## 12 Moving around the picture

As the painting progresses it's a really good idea to move around the image and keep a good level of consistency in each area. I try not to spend too long painting any one area, splitting my time between the sky and the sand, the rocks and the central point of interest. The things that you need to work on last are the small details that help bring the picture to life. If you want to add a new element, paint it on a layer first and only merge it when you're happy. I decide to add some smaller rocks here and there, and vary the shapes of the rock formations a little. I'm happy with what I've done here so I move on to the bigger details.

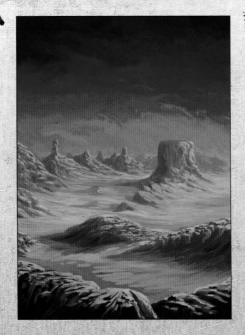

## 13 Paint in the planet

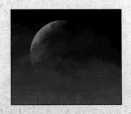

Some objects in this image need to have an accurate shape, so – unfortunately – it's time to use the stencils and the rulers. For the planet, I select the Sphere 2 stencil and rotate it round so that the unmasked area is in line with the direction of light. I resize the stencil to a reasonable planet size and move it to the top of the screen. Then I create a new layer and roughly paint in a gradient of yellow to red. Now it's time to use the Eraser Brush to take care of any overpaint, and pull out some craters or other interesting features. I'll drop the layer when I'm satisfied it all looks okay.

## 14 Point of interest II

For the rock formation, I use the Square Ruler stencil shape to fill in the general area. I resize the Ruler and fill out a shape on the top and bottom of the larger object. Use the Sphere 2 stencil to round off the object's bottom and the Long Ruler for a straight line through the middle. I render the shapes with the colours used for the plinth. For effect, I add broken bits of structure, but keep the rendering consistent with the painting.

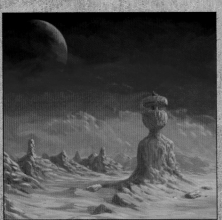

## 15 Mystery bubbles

The strange bubbles at the top of the structure give the painting another layer of mystery. They fit in nicely as an uncomplicated but acceptable phenomena for this style of picture. It'll give our spacemen something else to look at too. To paint the bubbles, I create a basic sphere in a dark pink, and add a crimson shadow to the bottom. I spot a highlight at the top corner nearest the light, and another in the opposite corner and it's done! Repeat the process, but vary the sizes.

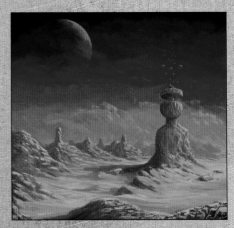

 ## Introducing the spacemen

Because the planet is quite bright, you need to use the landscape colours. On a new layer, I paint the spacemen's basic shape in the darkest foreground colour and immediately paint the sharpest highlights that define them. Get this right and the rest is easy. Then, I work the light into the dark using the reds and oranges of the landscape. Try to define the shapes, but don't over define – keep it consistent with the surroundings. I add a layer beneath the spacemen to create a long shadow, and to finish, I add a few random star dots.

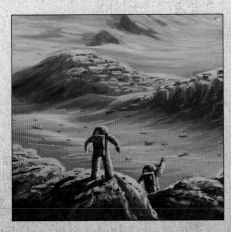

# WORKSHOP BRUSHES

**ARTRAGE 2**

**CUSTOM BRUSH: ROLLER BRUSH TOOL**

Set pressure: 25 per cent

Set thinners: 25 per cent

Set loading: 75 per cent

Auto Clean: On

Size: 100 per cent

*Use this to cover the canvas quickly*

**CUSTOM BRUSH: PAINT BRUSH TOOL**

Set pressure: 50 per cent

Set thinners: 25 per cent

Set loading: 50 per cent

Auto Clean: On

Size: 50 per cent

*Use this for all-round painting*

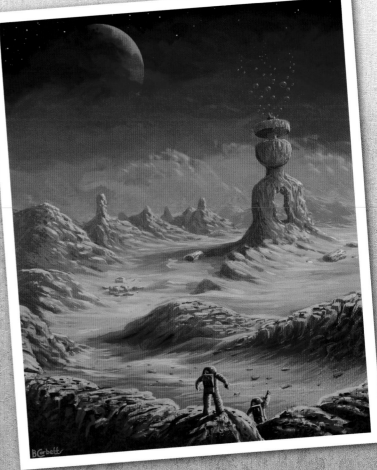

B Corbett

## ARTIST PROFILE
### Ioan Dumitrescu

**COUNTRY:** Romania

Known as Jonone to the sci-fi and fantasy art community, Ioan is a 22-year-old architecture student, who also works as a freelance illustrator and concept artist.

**WEB:** www.jonone.cgsociety.org

# LIGHT YOUR WORLD

## Ioan Dumitrescu shows us how to light a night-time sci-fi cityscape and how to use light to shape worlds

Before I start working on an image I make a conscious decision to put aside any fear of failure and let the joy of imagining wonderful worlds take over. In this tutorial we're talking about how to light an image, and what could be better than a cityscape at night? Full of neons, headlights and all kinds of other lights interacting with different surfaces, unveiling some shapes and hiding others.

Before I start out, I ask myself questions that can inspire my painting. For example, what word best describes big cities at night? Contrast. So that's what I'm looking for here – relating colour, mood and organic shapes. The work shows that this city

doesn't sleep, that it's more alive at night than it is during the day. I'm going to use light as a design element and in a way that hopefully creates some drama. At the early stages I'm not sure quite what the scene will look like, although I have an idea of some kind of hanging bus station, with a hybrid of a maglev and a bus.

In this tutorial we'll look at the use of different types of artificial light in order to confer atmosphere in an illustration, but also to model and design. I used a standard round brush for this workshop, with Opacity/Flow Jitter set to Pen Pressure and the Spacing to 0. But I often use Mathias Verhasselt's brushes too.

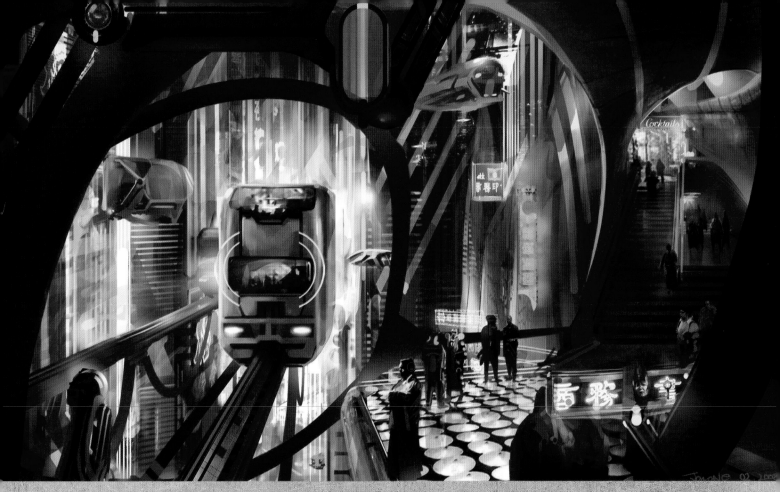

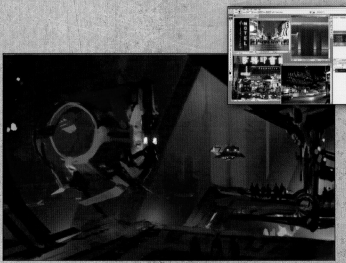

## 1 Points of reference

The first step in every illustration is the concept art. I start searching for reference – in this case I look for major city streets just to see how artificial light works and interacts. I pull the shots together into Photoshop and blur my eyes a bit to see if any images pop into my head. I select a few images that I like and play around with the colours to see if there's anything worth exploring.

## ② Composition

I really like some of the blueish tones from my reference points, so I start sketching things out roughly. I usually like to do a monochromatic study first, but this time, in the spirit of throwing caution to the wind, I just jumped into things. First I need to find a suitable composition, without committing to anything. I start pulling out reference images I think might integrate well and try using them to shape things out, erasing and painting over and over again. Even at this early stage make sure that you save, as a crash can ruin a potentially fruitful train of thought. The next step is to start putting light in – just punchy saturated colours (I can desaturate later). I decide that the perspective points will also be focal points (one of the oldest tricks in the book), so I start lighting them. I choose a cooler bluish tone for the outside and a soft purple for the inside, just to differentiate the areas.

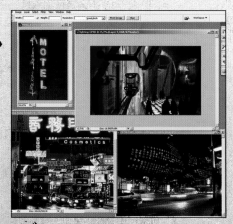

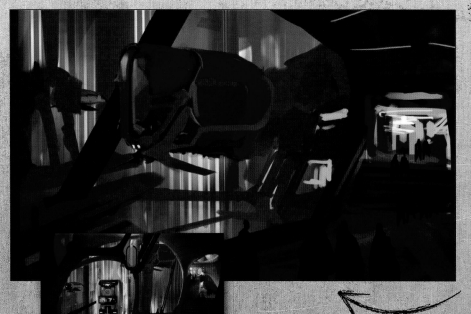

## ③ On the buses

The interior space leads out to the deck of the bus station where commuters wait for something that sort of resembles a double-decker bus. The bus station is made out of transparent glass, with all kinds of light fixtures hitting the scene from underneath. It's nice eye candy for the viewer, but it will also help define the people standing there later on. Always try putting dark against light for contrast in your areas of interest. At this stage I'm a bit overwhelmed by the background and middle ground. It still looks like there's a lot to be figured out. I put an array of lights in the background to help with the atmospheric perspective, and also make the foreground bus appear more visible.

## PRO SECRETS

### STEP AWAY FROM THE PAINTING

Try to look at your image with fresh eyes, either by leaving it alone until the next day, or by working on another project. You'll find all the little mistakes that you couldn't see before and be able to correct them.

## 4 Fleshing out details

I circle the bus to make the viewer go back and forth between the foreground oval shape of the station roof and the bus. I flesh out the matchstick men walking about to make them resemble human beings. I know the guy sitting on the edge will be hit by a lot of direct light from the bus, so I expose that part a lot, then rim-light him from the floor, and ambient- light him from the structure. I then add some futuristic nuns staring at an invisible hologram that I'll add later.

## SHORTCUTS

**CREATE A NEW LAYER
SHIFT+CTRL+N**
Hitting this shortcut enables you to create a new layer in situ.

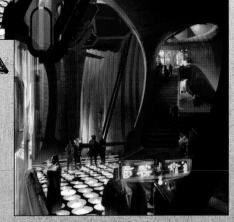

## 5 Holograms and neons

Next I border the deck using some long neons to separate the foreground and middle ground. It's good to add glow to powerful lights, as that's the way your eyes perceive them in real life. I add the nuns' hologram, bathing them in light. For the writing, I use some reference, and play around with Layer modes until it works (try Screen or Overlay). For added realism I make an underlying layer to show the hologram and have volumetric light emanating from it.

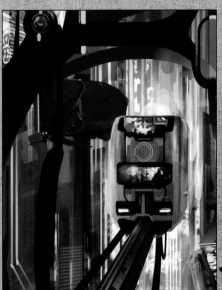

## 6 Flip-reverse it

Always remember to check your image by flipping it horizontally. No need for mirrors here, just go to Image>Rotate Canvas>Flip Horizontally. You can check your perspective, composition and values this way, as your eye might have become used to any mistakes that have snuck in.

## 7 A city brought to light

Still working with saturated colours I start painting the city. I think I'm going to avoid over-detailing it. The viewer has enough things to look at, so I just use the advertisements and the light they make – more as a graphic for the composition. I start blocking out more of the bus using direct and rim light from the surrounding neon advertisements. I make sure that the lights in the background all reach maximum intensity behind and around the bus. I also move ships that I created early on in my sketching around the scene, to fit them in.

## Retaining focus

I keep on bringing in reference, playing with layers to get the blacks out and keep the light. I erase and paint-over until I'm happy with the results. I don't want the viewer's eyes to fall off the page in the lower left-hand corner, so I bring in a traffic light. This in turn makes the left-hand corner look like it needs more depth.

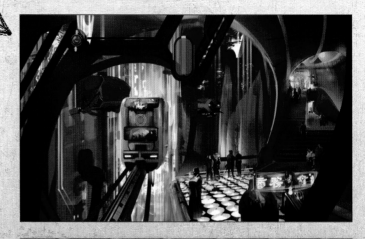

## Glow layers

I continue adding lights, keeping it loose and messy adding layer upon layer of painted underlaying and text. Adding the reference over what I call a Glow layer helps integrate the advertisements into the scene. I have to break the stair surface a bit and put in some reflections from the light fixture in the shop above. Don't be afraid to experiment with crazy colours or shapes in your own work, you can always tone them down later. Take full advantage of your imagination.

## PROSECRETS

### MUCK IT UP

If you're not making any mistakes it means you're not working hard enough! Experiment with things that you don't normally do and you'll learn a lot more.

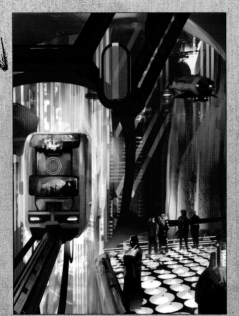

## Happy accidents

In a lucky mistake I move one of the foreground layers and see a pillar holding the hologram for the nuns. Just what it needs. It's good to not be too committed to what you've already done. If something else works better, then by all means use it. I also worked a bit on the traffic light, which I connected to the structure, helping to give it a more organic feel. As mentioned, it needs a bit more depth so I bring in another bus line on the left side of the image, which is another opportunity to use some volumetric light coming from its headlights to show off what's in front of it.

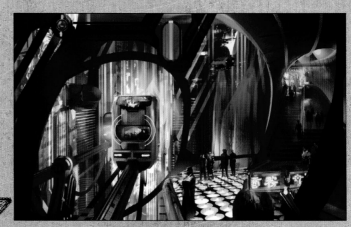

## Light touches

The painting really feels like it's coming together now and it's time for some finishing touches. Primarily I make sure that light hits the objects it's supposed to hit, thus integrating things well. I also try to place them better to certain anchor points. I've changed the old ships, scaling them to better give size and depth, also causing them to catch the surrounding lights. Finally I give the green light to the racing buses.

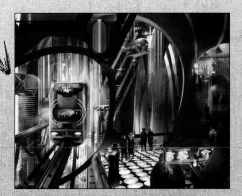

## Fight for the right

The right side has been neglected, so I bring in some adverts in this area. I immediately have to tone these down as they're a bit too eye-catching. To place them I make their reflection into the building. I also reflect them into the glass flooring of the deck, along with the people standing there. I darken up the corners, avoiding any distraction from the lights there and better leading the eye inwards.

## Adding contrast

I add more atmospheric perspective and dramatic lights while raising the contrast a bit to suggest that there's a lot more going on behind the bus, and making the viewer want more. I'm not shy on using Colour Balance to integrate things, and because I want some colour diversity, I make the adverts on the right-hand side a little more cyan green to get away from the blue. Along the way I used different colours for the glows. Don't be scared to use more than two colours – as long as you're careful, they can work nicely with each other, or you can use them to create contrast.

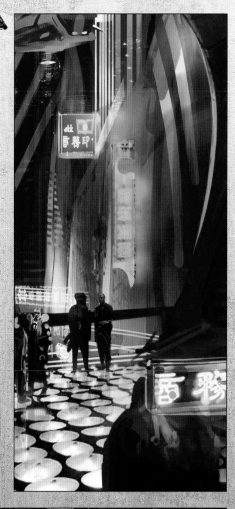

## SHORTCUTS

**SELECT LAYER CONTENTS**
**CTRL+CLICK INSIDE LAYER BOX**
This shortcut enables you to select what's inside a layer.

## Final blooms

Nearly there. I rotate it one last time and expect the worse. Thankfully it's not that bad. I apply the final touches here and there, trying to find the right balance between finished and unfinished areas of the illustration – but I choose to stop here. After a couple of sketches I found my direction, and by the final image I hopefully got the idea across.

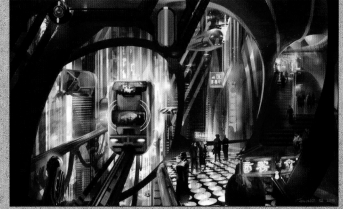

## ARTISTPROFILE

### Dr Chee Ming Wong
#### aka Koshime

**COUNTRY:** England

Dr Wong has many years of creative visualisation and pre-production artwork experience, having freelanced on a range of independent game projects, publications and CGI pre-production artwork. In addition to all this, he also hosts free digital workshops and tutorials on CGSociety, ImagineFX and CGPAD forums under the alias of Koshime.

**WEB:** www.koshime.com

# EPIC SPACE BATTLE

Dr Chee Ming Wong takes you through the step-by-step process of illustrating an all-out space battle scene to beat all others

When you tackle any illustration, it's best to first come up with a theme or storyline. Here I'm going to share with you my entire workflow for generating an illustration of a space battle. This will build upon the initial idea of producing strong conceptual design of unique spacecraft – in this instance drawing spaceships ranging from small to large frigates, interceptors to destroyers, carriers and battle cruisers.

The story that I've created involves a raid by a modestly large fleet of capital ships upon a deep space mining facility situated near the thin arm of a nebula. With that concept in mind, all the transport designs should either have heavy armour-plating or sufficient shielding (depending on their tech level).

For the purpose of this workshop, I have split the two into opposing forces, each with some general differing traits. The main defence is heavily armoured with a bulky transport design, which fire red lasers. This includes a large, deep-mining facility with huge, heavy cannons and a few heavily armoured destroyers, carriers and frigates on the perimeter.

The main offence will consist of a sleek, long angular design with minimalist features. They fire blue lasers.

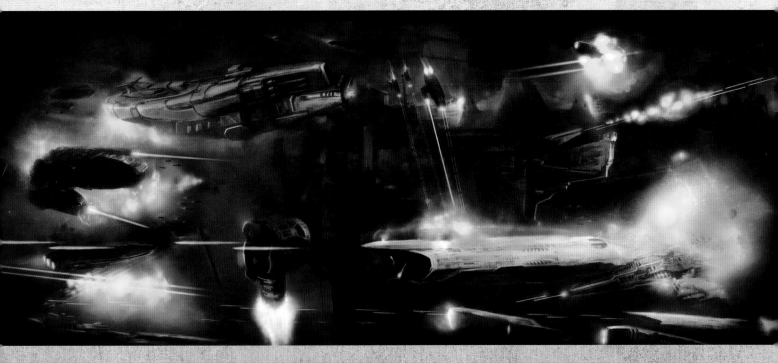

 ## Initial sketches

Using the battle plans and storyline that I outlined in the introduction, I work on various designs for both the battle station and the various ship transports using an iterative process.

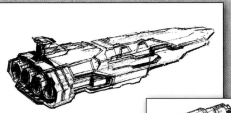

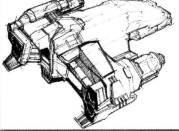

 ## Mood boards

Based on the finalised sketches, I move on to paint a few monochromic thumbnails – essentially a mood storyboard. Each thumbnail is around 900x350 pixels at a 96dpi. Out of these, I select three key images that best represent the action and mood of the whole theme. I now have enough basic background and design from which to work up a good space battle.

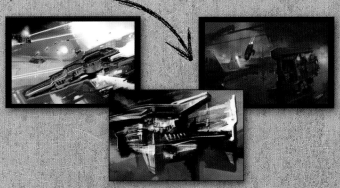

 ## Initial composition

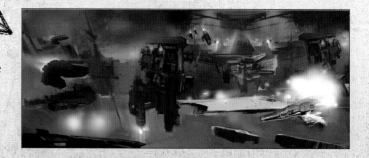

Using the initial thumbnail, I expand the canvas and resize up to 1,800 pixels wide. I then fill this canvas by duplicating the image of the space station and start to incorporate elements of the design sketches and mood storyboard into the composition. Using a mixture of compositing and painting, the main aim is to generate a key frame to sit well in the background.

 ## Establishing the value range

I use this opportunity to establish my darkest darks and lightest lights, to provide a range of values to work with. For objects in the distant background, a simple sweep of the airbrush at low opacity enables atmospheric perspective to register vague, general shapes. By using this process we have effectively delineated the principles of foreground, midground and background – and if the composition works well as a thumbnail, chances are it will work compositionally throughout the whole process and final image. In addition, out of this process, the main opposing force battlecruiser is generated digitally (almost by grand design) as a lucky accident.

 ## Rendering: from line art to a digital model

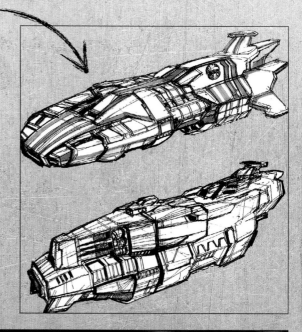

When incorporating sketches or line art into a digital workflow, the quality of the line work is paramount. Try to clean up and refine the edge of the design as best you can, and then paste just the sketch alone on a new transparent layer. Duplicate this, and set the upper copy to Multiply. You can use the lower (original) copy to block in your monochromic values. You can do this by setting your layer to Lock Transparency. Now for the 3D effect. I find the easiest way to produce a relatively convincing 3D look is to fill in with a dark neutral grey colour and work with just lighter greys.

 ## Composition

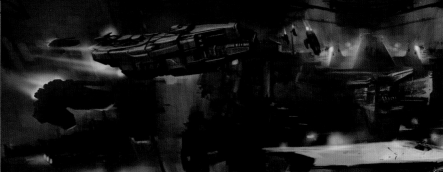

Reincorporate this hero transport into the main composition. Because of its relative detail, it's best to position it near an area of interest or focus for the eye. In this instance, I position it opposing the attacking hero vessel, so as to take on the theme of two forces approaching one another from different sides. In addition, it's probably useful to resize your image by half (up to 3,600 pixels wide) before adding colour.

## 7 Initial colour pass

Fill a new layer with a gradient fill of any colour (we use blue in this instance), and set the layer option to either Overlay or Multiply. After some adjustment with the Opacity, this will produce a basic colour tint to your monochrome painting. Try to add a second complementary colour to work as a highlight using the same process, then erase out the undesired portions. In Photoshop CS3 you can use the layer options to make a new black and white layer with colour tint, then apply a gradient function. Repeat with another colour. This is essentially the same process in four clicks.

### SHORTCUTS

**PHOTOSHOP
LAYER OPTIONS**
Enables you to paint and adjust colour, lighting and mood without deforming the underlying layer.

## PROSECRETS

**UP THE RESOLUTION!**
Paint your final image at least twice the resolution of your intended output. For example, for an image of 1,600x900 pixels, try to paint at 3,800x1,800 pixels. This enables you to use broader strokes and add much finer detail – so much so that by your final image, the client will be astounded by the quality of your illustration.

## 8  Nebulae 101

Space to the naked eye is mostly grey with varying points of luminosity. Nebulae have a certain colour palette dependent on their constituents: hydrogen alpha (red), helium II (blue) and oxygen III (green). Since nebulae are 99 per cent gas, of which 90 per cent is hydrogen, it makes sense that they are mainly red with various elements of blue and green, depending on the amount and type of ionised gas. As such, this enables us to accurately paint swathes of red-orange with some trade off between artistic licence and accurate scientific portrayal. It is also entirely possible to paint a purely blue or green nebula.

## 9  Building nebulae

For such purposes, I favour the use of Painter because of its blenders and naturalistic brushes. Start with a dark grey background and fill in some swathes of yellow and red to represent elements of hydrogen (and fusion with helium), to create a strong, dense core. Elements of blue and green can represent ionised gasses of helium, oxygen and other elements on the fringes. Once some rough colours are put down, use the Blender tool to smudge and create an even, cloudy effect. Next, use the Glow tool to create a strong, bright core and the nearby stars by hand on a new layer. Once you have painted a few stars, you can duplicate them to multiples to create a whole star field.

 ## References

For a study of nebulae and star fields, I can recommend the astrophotography books of Robert Grendler, and the images produced by the Hubble heritage website at www.heritage.stsci.edu. Any image taken via a telescope is only in pure greyscale. Colour is painstakingly added by various individuals or scientists for representation or general publication, while false colour images are used for interpretation of data, including radiowaves.

 ## Local glow and effects

The main aim is to incorporate the colour and variety of the nebulae into the existing image. Copy the nebulae on to a new layer and set to either Overlay or Hard Light, and adjust the Opacity accordingly. Keep a spare copy of this as we will reuse it over and over throughout the project. Now flatten the whole image, and work on introducing some darks and lights using the Muted Colour palette. This process is akin to painting watercolours, where colour is added via thin multiple washes. Just remember to evenly distribute your attention on all parts of the canvas, and only have lavish detail on the main focus area. This way, no part of your illustration will stick out like a sore thumb.

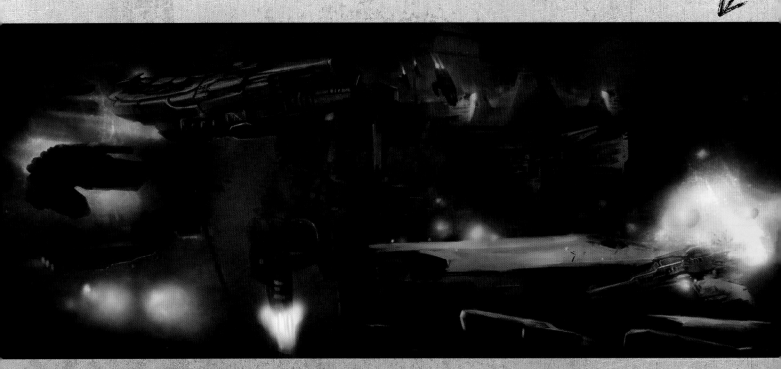

 ## Adding morecolour and light

Using an Airbrush, set your brush to Colour, or Linear Dodge and low Opacity to bring some colour and light to your key explosions and lighting. Once you have done this, you can now add hard rim lights to the edge of every vehicle that may require attention. This immediately gives the feel of a hard surface of a mass that's relative to a lighting source, and looks very effective.

##  Lighting in space

In space there is minimal ambient light. All the lovely images you see about space is a result of multiple hours of exposure. The luminosity of the stars is minimal and the colour is often hard to even see, to the point that it's best ignored unless from the local star, nebula or supernova. So, how then can you really light your objects and make the battle look exciting? A realistic painting in deep space could well be a pitch-black canvas with only tiny, faint dots on it, and the outline of a space vessel merely marked by the absence of light. Fantasy, sci-fi and even scientific artists have pondered how best to illustrate such subject matter. A useful fallback is to paint a distant nebula in the backdrop and to add local lighting, including light from the ship panels, or perhaps laser beams, or explosions.

##  Hero vehicle detail

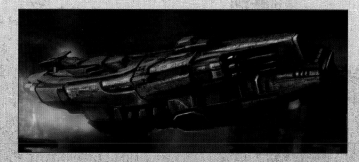

Earlier I created a monochromic hero vessel. Now I take the same hero vessel, make a new file, and double the image size. This enables me to add textures and ship details while eliminating various design flaws and make minor adjustments. Since this is the main focus of your image it needs to be fairly detailed. I use this opportunity to paint in mid-tones, and attempt to eliminate any harsh contrasts and dark lines. However, this can be an arduous challenge. The fact is, on its own the ship looks great with high contrast, but not naturalistic in the grand scheme of things – it's perhaps too detailed for use. Nevertheless, let's bring this concept back into the painting. Try to soften any hard, dark edges which have a light background. I find the Smudge tool's the best approach for this.

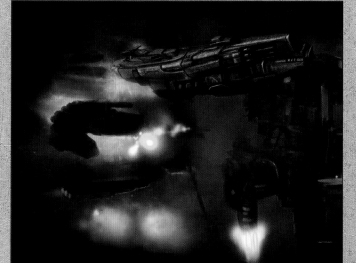

##  Bits and pieces

We need to tackle the colour and lighting even more now. In Painter, you can use the Lighting option to add in general ambience and colour lights. In Photoshop, you can manually Gradient Fill a layer and set it to Linear Dodge. Use whichever program you favour. I prefer to use this opportunity to move back the detail from the hero vessel by using a very low Opacity Airbrush to push it backwards into the midground and obscure some details. I also use the opportunity to add more coloured glow to the explosions and perform some general tidying up of the image all over. It's best to do this in a circular fashion to hit all the key areas. Once satisfied, I flatten the entire image.

 **Let there be stardust**

Duplicating the entire illustration, I set a Film Grain filter and lower its Opacity to about 30 per cent. This is to simulate the diffused and diffractive nature of multiple fine particles in space. Erase out the dust layers for objects in the background, but retain some of it in the fore and midground. One satisfied, I flatten the whole image and use Painter's Blend tool to work back the nebulous background and stars into the image.

 **Laserlights and explosions**

Now I switch back to Photoshop and, using a new layer I hold the Shift key down, and in Brush mode apply a stroke across the canvas, using a neutral base colour – I choose blue. Next, change your brush to the default Hard Round brush, set it on Colour Dodge at a smaller diameter and swathe across a few times. This will generate a pillar of light, with a bright central core. Apply the Free Transform tool into this layer and adjust to form large, long beams, or multiple smaller beams. Repeat and rinse all around – just don't overdo it as it can get very messy.

## PROSECRETS

**TOOLS OF THE TRADE**

Use Painter's natural brush set for its exceptional blending and oil brushes. Try not to limit yourself to just one tool. If there's a better toolset to produce the effect you want, try to learn it. By learning how to use both Photoshop and Painter you can get the best from each application and also compensation for their respective flaws. The end result is what is most important, though, regardless of the methods used – and always remember that the client is king.

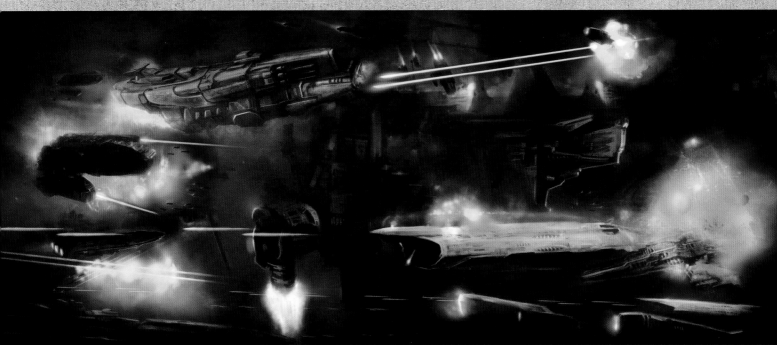

## 18   Final adjustments

Flatten everything, and make the appropriate colour grading (according to your own personal taste, of course). You will find that this is easiest to achieve by using the Layer Options mode in Photoshop, enabling you to paint these changes without causing any unwanted and distracting amendments to the underlying layer.

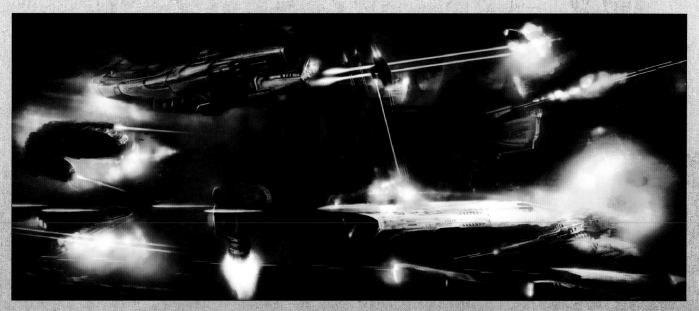

## 19   Realistic vs romantic ambience

Once all the above is complete, I only need choose between a realistic or romantic ambience. I have included both images on the DVD for comparison. The realistic lighting image has a faint blue filter but is otherwise much darker, with only tiny pinpricks of lights and explosions. I much prefer the romantic ambience, though, whereby you approach an image as if you can see the full spectrum of visible and non-visible colour. This allows for more greens and blues to be brought in, making it akin to an impressionistic style of depicting outer space.

## ARTISTPROFILE

### Sam Burley

**COUNTRY:** USA

At a young age Sam was captivated by anything on a grand scale. The *Lord of the Rings* trilogy and a love for artists of Hudson River School formed the desire to create deep space and immersive environments.

**WEB:** www.samburleystudio.com

# DRAMATIC WATERSCAPES

## Sam Burley uses waves as a compositional element, adding a sense of energy and realism to a sci-fi landscape

Whether it's sci-fi, fantasy or from real-life scenes, water is a common element to many landscape scenes. With this workshop I hope to show how to take advantage of the energetic quality of waves to liven up what might otherwise be a boring illustration. Additionally, I'll focus on composition, colour and atmosphere to make a complete, coherent and effective environment. My process tends to vary by image, so how I start, the number of layers used, how long it takes, and when I add colour will always be different.

What does stay the same, however, is a constant analysis of how the image might be improved. With Photoshop, every whim is at your fingertips so there's no excuse not to fix something if it looks out of place. Take the time to experiment and see what works best. During this workshop you'll see me retrace my steps, sometimes jumping forward and back throughout the process, but the image always becomes more effective because of it. Every error is a chance to do something again and better, so try to embrace those mistakes when they happen.

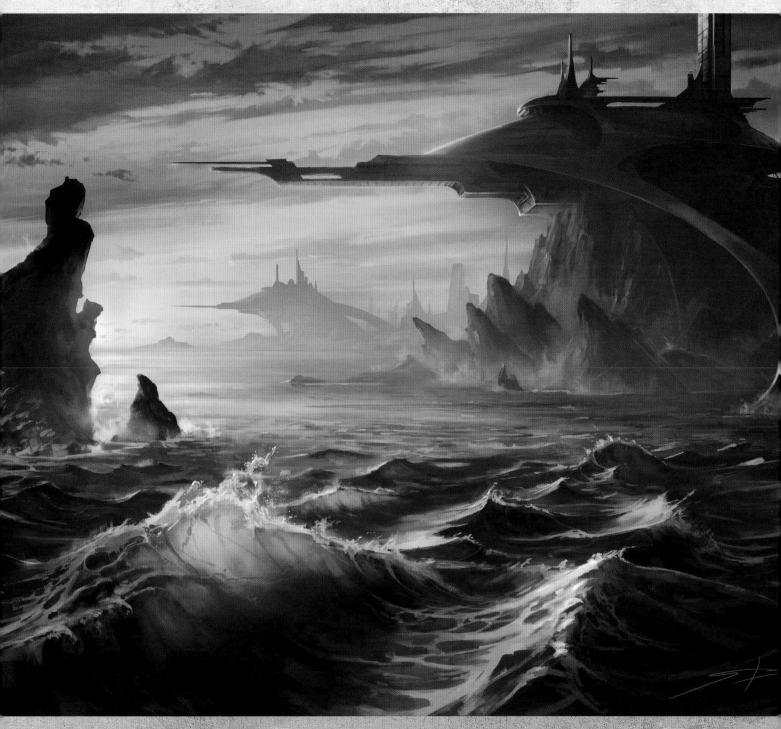

## The concept

I have a clear idea of what I'd like the scene to be: the light of a setting sun cutting through choppy waves, crashing into the rocky coast of a distant, futuristic city. I start by doing tiny thumbnails on paper, focusing on silhouette and trying to come up with an interesting structure to suit my needs. The spiked dome feels like a sea creature – some kind of horseshoe crab or strange urchin. The curves suggest a wave-like form, while the straight, sharp edges feel mechanical and industrial. This is a good toolbox of shapes to work with and complements the original idea.

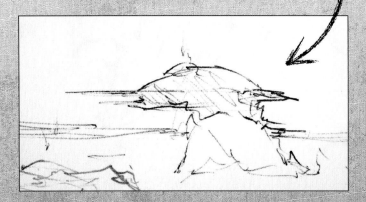

# PROSECRETS

### CREATE AN OVERLAY LAYER
Under Tablet Preferences, set the first Express Key as keystroke Cmd+F1. In Photoshop's Action Window, start a new Action, create a new layer and set the mode to Overlay. In the Action window, stop recording, double-click the new action (away from the text) and set the function key to Apple+F1. The corresponding tablet button will now create a new Overlay layer.

# SHORTCUTS

### LAYER VIA COPY
### CTRL+J (PC) / CMD+J (MAC)
Creates copies of a layer, so you can make changes without harming the original.

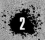

## The composition

With the building as a starting point, I can begin to define foreground, middle-ground and background layers that are essential to establishing depth in any landscape. It's vital that my values are laid out using hard, opaque brushes to avoid semi-transparent layers for when colour is added later. Duplicating the main structure and making it lighter and smaller helps sell the perspective and convey distance, and because there are lots of strong horizontals here, I balance them out with diagonals in the clouds and verticals in the towers. I'm also focusing on how shapes lead the eye. The large rock at the bottom-left is important because it keeps the viewer within the picture frame as the two dome shapes fire one's eye off to the left.

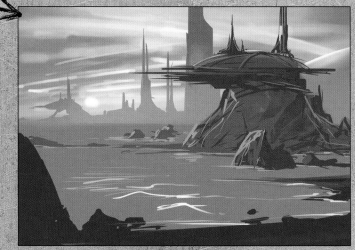

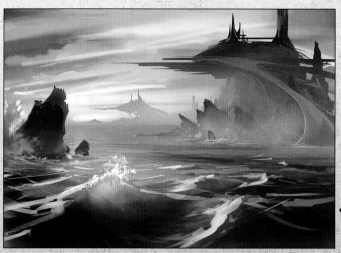

##  3 Refining the composition

The structure needs to look big so I've lowered the point of view, raised the building up, eliminated the coast and made a foreground out of the waves. Large city towers in the distance were competing with the scale of my dome, so I've decided to get rid of them, too. Additionally, the crossing verticals and horizontals between those two layers made an awkward, grid-like intersection that destroyed any natural feel to the composition. Angled rocks and crossing waves now provide opportunities to integrate diagonal lines and break up the rigidity of the remaining structures.

##  4 Make use of the waves

Because the waves are so close they become a strong compositional tool, pointing upward and forcing the eye back into the rest of the composition, away from the dark edge along the bottom. A translucent wave illuminated by the setting sun makes for tasty eye-candy attracting the viewer's attention to the lower portion of the image, but also helps break up the repetitiveness of the large mass of water.

##  5 Tweaking the sketch

I add definition to the shapes and make sure my value hierarchy is reading properly. If the structure becomes too dark it could feel too close and the effect of scale would be lost. Alternatively, if the foreground area becomes too light it won't have enough presence and the image won't have the punch it needs.

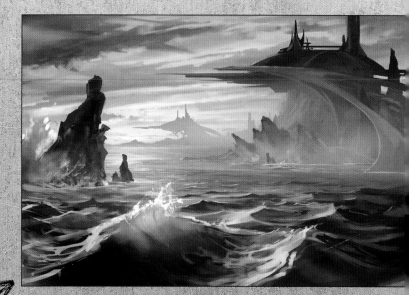

##  6 Layer strategy

I'm now working on four layers: the large rock, the structure (and its rocks), and the city all separately, with the water and sky on the fourth. Having the foreground element on the lowest layer might seem counter-productive, but by the nature of painting a body of water, it makes sense. It travels backward under all the other objects and there's no clean breaks that make for a good separation point. It's also preferable to paint crashing waves and ripples at the base of their respective objects, because if something is changed later then it can be done easily and all at once rather than bouncing between multiple layers.

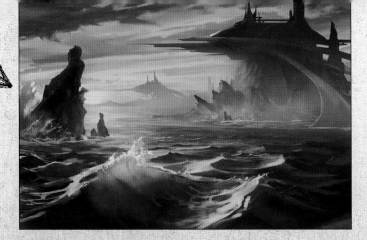

##  7 Adding colour

I begin adding dozens of layers above my four existing ones. First is usually a solid Overlay layer of sepia. The specific colour isn't important because it generally gets painted over, but this makes a good starting point. Above that will be a series of layers including Color, Darken, Lighten and Overlay modes as well as Hue/Saturation, Levels and Curves Adjustment Layers. There's no specific order here – for now it's about getting the colours to a spot I'm pleased with. I'll use huge, soft, Round brushes almost exclusively here, and tend to group many layers together painting out parts of them all at once through masks.

## PRO SECRETS

### EVERYDAY SKIES

The sky is something that everyone sees on a regular basis. If it doesn't look right in your image then people will notice it, even without recognising what's wrong. As such, it's important to use reference materials whenever possible. You need to think about altitude, weather, humidity, temperature and time of day when designing your clouds, because those are all factors seen in real life.

## 8 Merging layers

To merge my collection of layers while retaining my original four, I select all the upper layers and group them. Starting with the highest of my four originals, I Cmd+left-click the layer's thumbnail to select its active pixels. Then using Edit>Copy Merged first, I paste the contents into a new layer. I move that layer above the group that was created and hide it, as well as hiding the layer the selection was made from. I do the same thing for the next two layers. On the fourth, everything within the group and below can be merged into one. There are now four layers containing all the same colours and adjustments from when I had 50 layers, but with the same footprints as my originals.

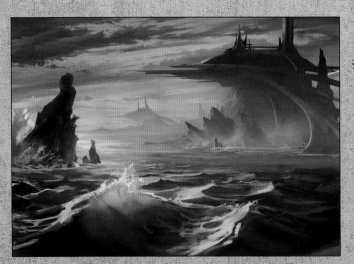

## 9 Atmosphere

The colours are settling into a palette I like, so I begin lightly brushing over the structure's base to add a sense of atmospheric perspective. Generally it's best to sample sky colours for this, so it's usually blues and greys instead of red. Large objects affected by atmosphere will appear darker at the top than at their base. This is because of the amount of particles in the air between you and that object. The atmosphere is thinnest when you look directly up, out towards space, whereas it becomes denser closer to the horizon because you're looking around the Earth and through that much more atmosphere. I chose to accentuate the effect by adding thick mist surrounding the rocks.

## Fixing the colour

Looking back, it's clear that the reds are far too intense, especially in and around the base of the structure. Using colour from the water instead, I try to cover them up with greens, while leaving a hint of warmth to help round out the structure of those rocks. The benefit to backtracking in such a manner is that those areas become full of subtle colour variations, which eventually make for a rich finish.

## Refining the structure

I've kept the structure free of detail because I knew it would be affected by shadow and atmosphere. Even still, I'm regretting not working more on the design in my preliminary phases. I like to keep my image working as a whole and on the same level detail-wise as it progresses, yet the perspective and large prongs have suffered from serious neglect.

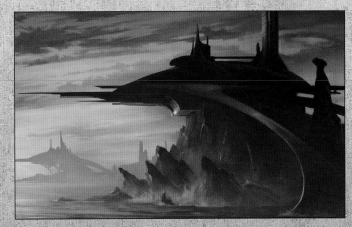

##  Refining the water

Waves are a physical representation of pure energy. It can be tricky to reproduce something so chaotic, so this is where reference becomes important. Looking at your own photos is always best: having peered through the lens it's possible to recall details that might not be apparent in the photo. With water especially, I've also found it helpful to look at other artists such as Ivan Aivazovsky and how they've managed to capture the impossible. Note where the light source is, and make sure waves are wrapping around and dipping into each other rather than following a simple W shape across one plane.

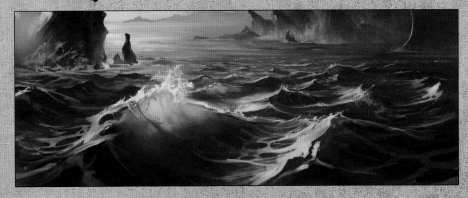

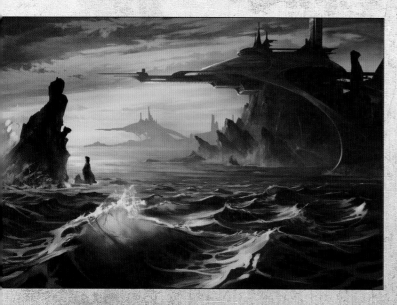

 ## Adjust the colours

Looking at the work of other artists for help with the water convinced me to revisit my colours. Again painting on top of all my layers, I'm using big, soft Round brushes in Overlay mode and sweeping straight across the sky with transparent whites and bright yellows. A red silhouette colour now works much better on the structure as it gradually fades into green. I'm confident about the design of the building after integrating more curves into the dome portion. I'll continue painting soft colours into it with my Standard brush, trying to perfect the atmospheric perspective.

## WORKSHOP BRUSHES

**PHOTOSHOP**

**CUSTOM BRUSH: STANDARD**

I use this brush during most of my time painting. It handles closer to a traditional brush and tends to give surfaces a soft, lightly textured look.

**CUSTOM BRUSH: GRUNGE**

This brush works great for getting down an initial texture on many surfaces, or for creating random shapes ideal for water splashes.

## Nudge the elements

Merging back down to my four original layers, I've decided that the structure needs to be moved higher. It's a small thing, but helps the gradation of waves read better and ensures the building sits in front of the clouds and city in a way that feels less contrived. I'm also working on adding implied detail to the backside of the structure and the distant city.

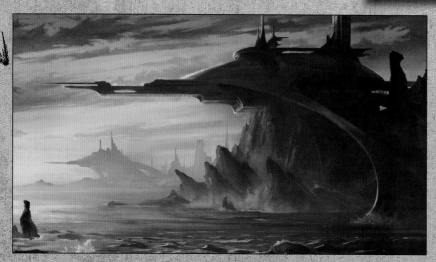

 ## On the rock

It's darkly silhouetted against the sun, so the rock doesn't require much work. Some texture, mist and softer edges and it's almost done. The wave crashing into it was looking too dark and certainly benefits from the same translucency as in the big wave. Both painting and erasing with my grunge brush around the edges of the wave helps achieve the effect of spraying water.

 ## The home stretch

Once again above of all my layers I'm making slight changes with Adjustment Layers, adding glowing light from the sun where appropriate, and hitting all areas at once trying to bring everything together into one unified image. I'm working on one last detail pass over the waves and hitting the dips with nice dark overlays to give them some more weight.

 ## Finishing the water

The waves were getting too busy in areas so I've smoothed them out where the focus was scrambled, particularly in the shadow behind the rock. Some more detail in the foam, and at long last a final pass on the splash of water rising from the translucent wave.

ROBOTS &
WEAPONS

# 25 STEPS TO BUILDING BETTER ROBOTS

## Learn how to design and paint compelling robots with the help of Christian Alzmann

Throughout the history of sci-fi, robots have always created a sense of wonder. We're fascinated with the idea that machines could walk, talk and even think on their own, and with just some scrap metal and genius we can create our own Pinocchio or Frankenstein's monster. Growing up in the '70s and '80s there were so many memorable robots to inspire me. Take *Star Trek*, for instance: while I don't consider myself a Trekkie, I can definitely remember Data, the holographic Doctor and Seven of Nine.

I grew up drawing all of the things that intrigued me, many of which were robots. They can be drawn in endless varieties and attitudes. As an art director at Industrial Light & Magic I've had the pleasure of creating a lot of robot-based concept art. Some of the projects I've worked on are *AI*, *Men in Black II*, *Star Wars Episode II*, *War of the Worlds*, *Transformers* and, most recently, *Terminator Salvation*. In this workshop, I'll take you through my top tips for painting better robots.

## ARTIST PROFILE
### Christian Alzmann

**COUNTRY:** USA

Christian is an illustrator and art director. His artwork has been featured in *Star Wars Mythmaking: Behind the Scenes of Attack of the Clones*, Van Helsing: *The Making of the Legend*, *Inside Men in Black II*, and *Spectrum 9* and *10*, and many other books.

**WEB:** www.christianalzmann.com

## 1 Building a story

Designing anything is much easier when you have a place to start. Often writing a paragraph or two of backstory on the robot can be a huge help. Where does it come from? What's the robot's history? Who made it? Who is it? What was it designed to do? Ask yourself these questions before you start, and then illustrate the answers.

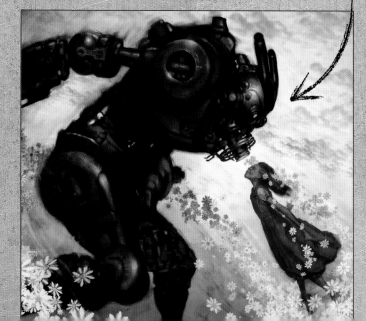

## Break the humanoid mould

Don't constrain yourself to human forms. Whether it's intelligent or not, a robot can take any shape or form. Often, people latch on to humanoid shapes when designing robots in order to get the viewers to identify with them. Of course it works, but it's not mandatory. Cartoons have been breaking this rule for decades.

## Personality

Give it some personality. Without one, any robot can be lifeless – which isn't to say that a lifeless or zombie robot doesn't also have its time and place. Is your robot a big angry palooka? A mad scientist? A hero or a hungry bug? Defining this will help keep your robot in character and make the design coherent.

## Rusty metal

Rust can be great for adding colour to otherwise grey metal robots. Looking at references, you can see that rust usually occurs most where water and moisture get trapped. Add some of that distinctive orange colour to the undersides and nooks of a robot to give the design a real-world feel.

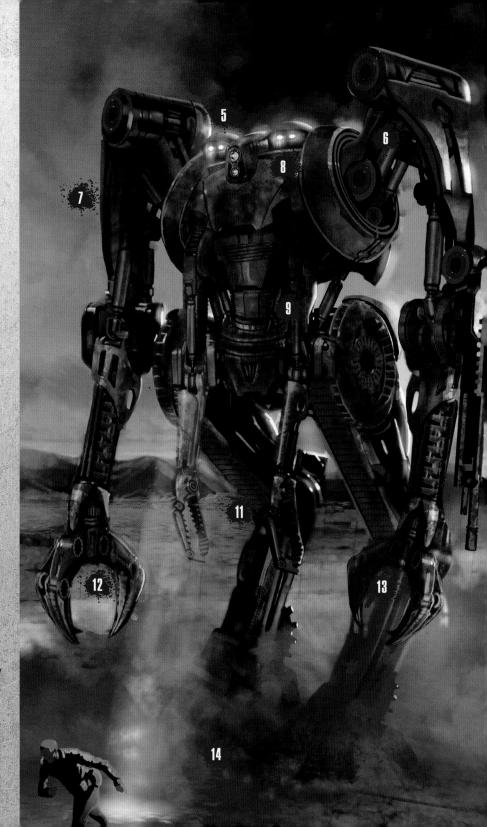

 ## Throw in a curveball

Oddity stands out. We see a lot of robots, so think about what you can do to push your design somewhere less obvious. For example, maybe you have a round, jolly-looking robot that has a couple of long, sharp fingers. There's visual tension in this because it looks as if he could be a danger to himself.

 ## Repetition

Repetition is a basic principle of design. If there's a part of the robot that you like, use it in a few places. This ensures that the overall design has a theme and isn't a hodgepodge of stuck-on pieces that have no relationship to each other. Repetition can also be a great help if you're having trouble with filling out design details.

 ## Shapes

Strong shapes and silhouettes can help make a design memorable. I always try to get a strong, readable shape. Build a clear, dark silhouette that still reads well when it's the size of a postage stamp. At this stage, keep the shapes simple and, as you add details and breakup, remember where you started. Aim to keep that initial statement.

 ## Rendering lights

Robots often have a power source in them somewhere. Sometimes I use a bright value on its own layer and add an Outer Glow layer effect to lay in where I want my lights. For a more painterly feel, I change the Brush mode to Color Dodge, use a fairly desaturated colour and build up the centre, getting brighter and brighter.

 ## History

Whenever it's applicable, add history. If the robot has been around a while, you can add dents, scratches, grease, rust and replacement parts. This can give the robot a past and add to its on-screen persona. I always liked how C-3PO had that one silver leg. It added to a personality that said, 'I always seems to be in the wrong place at the wrong time.'

 ## Point of view

Every image has to have a point of view. To make a robot look big, put the eye level at his knees. If you have a tiny robot, look down on it. The dead-centre point of view that you see in a lot of concept art shows the design, but you can add more story by changing it to something more dramatic.

 ## Functionality

Functional details can make or break a design. For realism, it's vital that joints look like they can move, extend and rotate. Practise drawing gears, pistons and other mechanical parts so you can produce them from memory. When it's time to design a full robot, you can hit the ground running because you now have an arsenal of mechanical knowledge for your design.

 ## Reference

Study mechanical references to add reality to your design. It's easy nowadays to look online at pictures of jets, cars and engines – and to take your own when you're out and about. Keep a reference folder on your computer of all the images you might find inspiring. There's nothing that can ruin a robot design like appendages that don't hinge properly or have no means of locomotion.

 ## Purpose

What's its purpose? As with all design, the old adage that form follows function applies here. All robots have a purpose – some reason for being built. They can be scouts, fighters or thinkers. Pretend you're a robot engineer and you've been given the task of creating this robot to perform something critical. Does it need to grab objects? Does it need to be fast or stealthy? It's important to know how it'll move around and animate before you start drawing arms and legs.

 ## Setting

The setting can really help sell the robot's story. It doesn't have to be a whole finished background, but just something small like the ground he's standing on or a prop in his hand. It's also an important step if the robot is big or small – a bit of added setting can go a long way to help define it.

 ## Perspective

Practise drawing basic cubes and cylinders in perspective. It seems as if every How-To book in existence says you should draw a lot, but that's because it's true. The ability to draw cubes and cylinders from any angle is key. A humanoid torso can be two cubes connected in the middle with a cylinder. Arms and legs can also be basic cylinders. Details that come after should always sit in perspective on these basic shapes. Much of the best concept art stands out because of these solidly drawn basics.

## Maintenance and construction

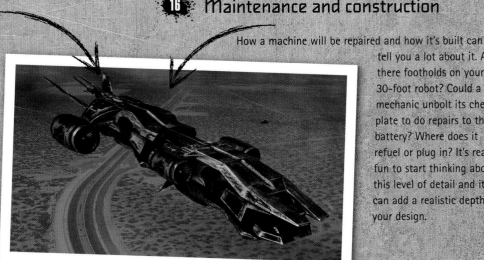

How a machine will be repaired and how it's built can tell you a lot about it. Are there footholds on your 30-foot robot? Could a mechanic unbolt its chest plate to do repairs to the battery? Where does it refuel or plug in? It's really fun to start thinking about this level of detail and it can add a realistic depth to your design.

 ## 17 Shiny metal

Shiny metal doesn't need to be tricky to paint and full of complicated reflections. A good rule of thumb is to work from dark to light, adding the highlights last. For something to look shiny, it has to have bright, sharp-edged highlights. These highlights are a reflection of your light source and, since they're bright, the only way to see them is to put them on top of something dark. Even if your robot is shiny white, bring the values down in the areas surrounding the highlights.

 ## 18 Simplicity

Keep it simple and readable. Many robot designs suffer from having too much detail and texture. Some are busy with details that the viewer doesn't know where to look. For a design to be good it has to have places where your eyes can rest. When the robot needs a million parts on it, make sure you leave simple areas in key spots, because those are the places viewers will look.

 ## 19 Graphics

Use the Type tool for graphics. Type and graphics can be a nice added detail, but again, make sure they follow the story. Is the font or graphic in an alien, human or machine language? Once you have a graphic you want, transform it to fit on top of the robot using Transform>Mesh Warp.

 ## 20 Balance

Keep your design balanced. Whether it's futuristic or steampunk, try to maintain one aesthetic only. There are most certainly times and places where a Frankenstein-like mix will be called for, but if you have high-tech robot parts next to bicycle parts, then you should have a good reason for it. Don't mix and match technologies from different historical periods. In fact, a useful rule is to make it look like your robot was built in one era and by one culture.

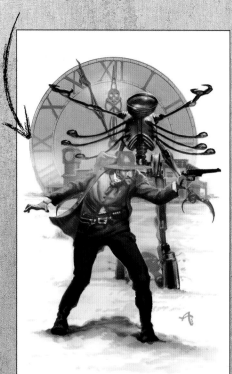

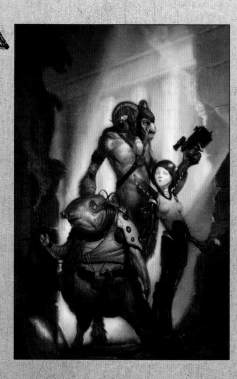

 ## 21 Colour

Remember to choose your colours as if you were the engineer who built and designed this robot from scratch in the real world. Colour should also follow its function. Ask yourself questions – what practical reasons might there be for the robot being a certain colour? Should it be stealthy, inviting or frightening? I also recommend that you avoid using too many colours for the painted surfaces. Start with only two and work out from there. Also, it's okay to paint the whole robot in black and white, and add all of the colour at the end using a colour layer.

 ## Textures

Whether pitted, rusty or cast metal, texture can be very alluring – and with Photoshop, it's easy to plop a photograph on top of everything to texturise it. However, texture needs to be used carefully and, whenever possible, it should wrap around the forms in perspective. You should favour either the light side or the shadow side with the most texture. Covering everything equally won't help add a realistic quality to your images.

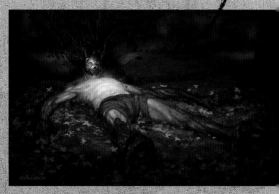

 ## Originality

Keeping the robot original is very important. Put away any pictures you have of famous designs. We all draw inspiration from them, but as a professional designer, existing film creations are only to be used as something to avoid. Unless you're working on a sequel, draw your inspiration from some other source. There are many amazing things in our world to look at for inspiration, so find the ones that interest you most, take pictures of them, draw from them and set yourself apart with an original design.

 ## Gesture

Robots require gestures to come alive. They're machines, but you need to have a sense of character and movement for them. Take a look at the animals and people around you. They all walk, stand and eat differently. If you were an actor and had to wear the robot as a costume, how would you walk or stand?

 ## Shadows

Rendering shadows can be done using a Multiply layer over your drawing. You can change the Opacity for a lighter or darker shadow. The edge of the shadow describes the form. As light rolls off a round form, the shadow edge is soft. When a shadow is cast on an object, it's sharp. Render in this way to clarify your robot design.

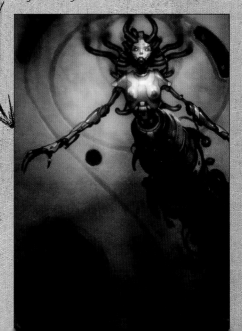

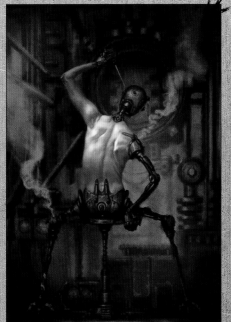

**ARTIST**PROFILE

## Keith Thompson

**COUNTRY:** Canada

Keith is a freelance artist who specialises in concept art for books, movies, video games and role-playing games. He's written several books teaching the creation of concept art. His work's been featured in the Spectrum art annuals and has been displayed at the Museum of American Illustration.

**WEB:** www.keiththompsonart.com

# CREATE A ROBOT CONCEPT

## Keith Thompson runs you through the process of creating a robot concept design, from sketches to final touches

I'm going to guide you through a traditional artistic process, from pencil on paper, to the digital process used to create a robot concept. Note that the specific artistic techniques used would simply be one way to come to something closely resembling the finished result. This is the best way for me.

The initial step in any concept design is often nebulous and regrettably hard to detail, it being an idiosyncratic process often unique to the artist. There are two common approaches to the conceptual realisation of your design, and these are applicable to cases where you have a detailed brief or an open slate.

One is the on-paper shotgun effect, where you put down a rapid series of thumbnail sketches, often simple silhouettes, and begin to home in on areas that catch your eye. Another approach is to obsessively roll detailed images around in your mind's eye for a period of dedicated time before laying down a single, definite thumbnail sketch to ensure that the visual imagery is working. The latter technique is how this particular design will be created.

For this robot concept, a concrete time and setting has been decided upon. It's going to be set in a relatively near future, in a post-nuclear war Europe. Despite no background or additional elements in the picture, this environmental concern will run as an undercurrent through the appearance of the robot. The robot itself would match its setting with a bleak, worn and muddied impression.

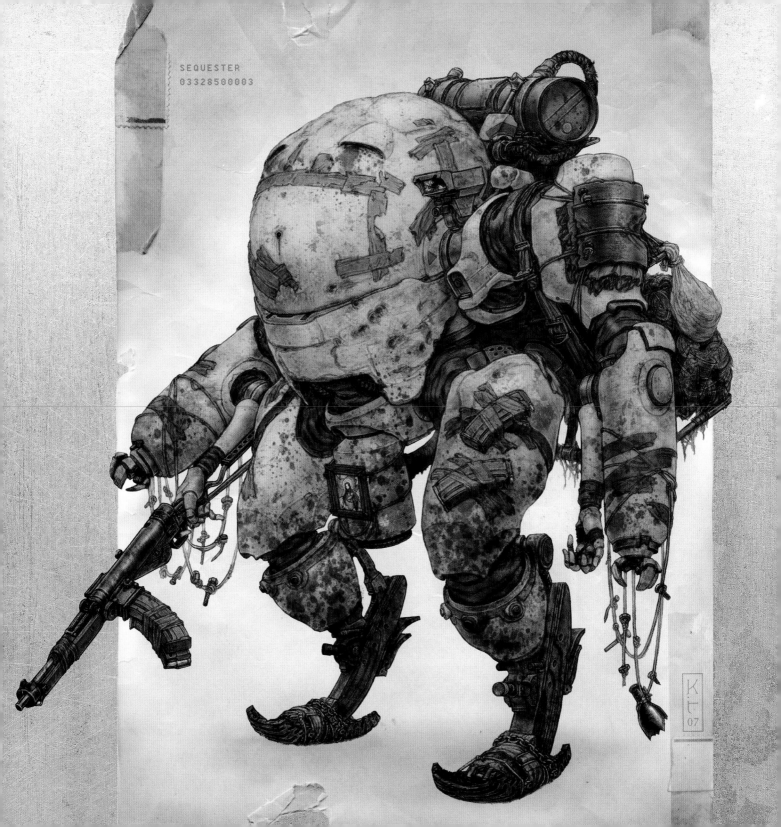

## Thumbnail sketch

This is the culmination of the imaginative development of the robot. The major elements of the design are first and foremost defined by the setting of the robot. In this case, it exists in a post-cataclysmic scenario. Conceptually, this will actually encompass the relics of a technologically developed near-future, and plunge these themes into a shattered, primitivist world.

A broad, tank-like body is the central approach to the robot's silhouette and initial impression. This is padded even further with contrasting additions, which merge the technologies of two widely varying situations in one concept. The robot will be loaded down with scavenged junk, with parts of its plating buckling and additions haphazardly tied and taped on. A quick secondary thumbnail sketch explored making the robot slightly more agile, but this lost the desired feel and went unfinished.

## Sketched layout

This is the line work for the full-size design, and it'll be carried forward to the finished artwork from here. This closely mimics the thumbnail. It's possible for you to actually blow up your thumbnail, transferring it to paper to work over, or tracing it on a light table. This can preserve the proportion and gesture of the original sketch, but can also prevent you from introducing more visual sophistication in the larger depiction. Occasionally, when switching to full size you may become aware of possible modifications or improvements: it's important not to become bogged down in blindly carrying forward specifications without giving these some thought.

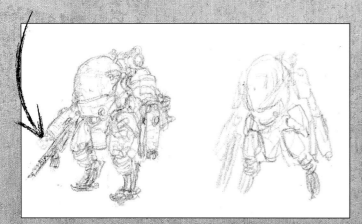

### PROSECRETS

**BACK IT UP!**
As you work, it can be a good idea to stagger your progress through a series of files. For example: robot01.psd, robot02.psd, and so on. This enables you to keep a progressive backup in case of a saved mistake or corrupted file, and also enables you to go back and grab parts of the artwork that may now be flattened. Ensure you keep track of the newest file so you do not return to the task and accidentally redo work already completed in another file.

### SHORTCUTS

**FLIP BETWEEN DODGE AND BURN / ALT/OPTION**
Hold down the Alt/Option key when using Dodge or Burn to switch back and forth.

 ## Points of interest

New points of visual interest can be incorporated into the design at every step along the way, which helps create a rich layering of depth. Certain elements that I've added, including the large sockets on the breastplate section, will be worked out in detail later – at the moment, they look a little bit like eyes.

By this stage, the major design elements of the robot are solidified, with only minor details to be added during further rendering. The real impression of the finished design should be fully apparent at this stage, and any areas that fail to please you need to be fixed before you move on from here.

 ## Scan the line work

Now I'm going to scan the pencil line work in, as the rest of my work will be done digitally. It's important that the pencil work meets your standards at this stage because it won't really be possible to directly modify this line work without returning to the drawing, rescanning it and transplanting it into the digital stage. It becomes a whole job of its own.

It's a good idea to scan at a resolution higher than you plan working on. Clean up this scanned image and then convert it down to the working resolution. Depending on the type of medium and paper, it may be advantageous to scan in colour and take advantage of the ambient hue variety.

 ## Greyscale value

I do a mask of the character (in the case of an artwork depicting a scene, every major element may have its own mask) made with a layer and a colour fill, which I then set to an Opacity of 0 per cent. You can return to this mask by using the Magic Wand on the layer, and any modifications can quickly be made by erasing or adding to the colour fill. Shadows are loosely laid in with an Airbrush. I use a white fill set to Multiply on a new layer above, with the Burn Tool set to Highlight. Remember to keep the shading basic and consistent – it should not appear perfectly shaded at this stage, because this process is more intended to designate areas of shadow.

 ## Canvas ground

Now I lay an undercoat or base texture over the shaded line work. The hue of this base will affect the unity of the finished piece, so I opt for a warm earth tone. This specific texture is a composite of several layers of cracked leather and paper. I like to compose my own individual textures and build them up with use. Your choice of textures will help give a uniqueness to every piece of artwork you create.

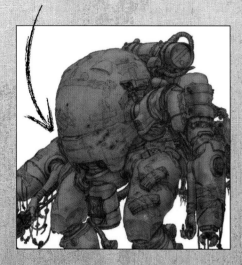

 ## Highlight value

I flatten all the layers together and pass over the entire work with the Dodge Tool set to Midtones (in the top toolbar). Some slight fixes using the Burn Tool, also set to Midtones, are worked in during the process. This stage is as much about drawing as painting, with highlights being applied in a line to support the existing black line work. An obvious variation of hue is starting to develop and will affect the colour glazes that follow. If you want, you could work up to this point completely in greyscale, then use the Colour Balance menu to warm that with red and yellow in the shadows before proceeding to the glazing stage.

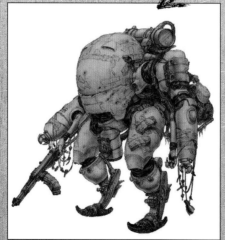

 ## Initial glaze coat

I create a folder in the Layer palette set to Soft Light, with individual layers within it acting as colour glazes over the shaded drawing below. Each main hue has its own named layer and each coat is a flat glaze of colour, with the only variance being slight adjustments to the individual layer's Opacity setting. Remember that using this technique will actually change the value of the greyscale underpainting, potentially throwing the composition and visual hierarchy out of whack.

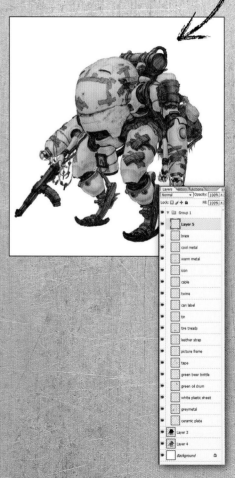

## SHORTCUTS

**MAP BUTTONS**
Map the buttons on your tablet pen to adjust the size of your brush on the fly. Playing around with the zoom will fine-tune the brush size.

 ## Final glaze coat

Next I create a secondary set of glazing layers that compound an additional colour to the previous glazes, adding a warmer hue in a highlighted space, or a cooler hue in the shadows. Additionally, I create a series of layers outside the Soft Light folder. These new layers are set to Multiply and are used to introduce a series of scans of splattered paint specifically created to simulate the mud, rust and mould on the robot. I'm sure to take care on their build-up, so that a complex, multi-layered coat is created, which conforms to the curving surfaces it lies upon.

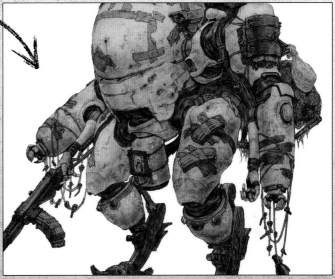

## Elaboration

The entire work is flattened again, and additional passes with the Burn and Dodge Tools deepen shadows and bring out focal points.

An old piece of paper is prepared and scanned as a backdrop and worked in behind the artwork. Take care that this backdrop supports the artwork without dominating it or clashing with it.

Whatever method you use in the conceptual stage of your project, be it a number of sketches or one focused design, make sure you get it up to scratch before going digital. It'll make your subsequent work much easier.

## PROSECRETS

### TEXTURE LIBRARY

Multiple layers of canvas ground interacting with each other increase depth and richness. Even if the compounded effect seems subtle, it'll still give more complex hues and textures in the finished piece. Build up a library of papers, painted undercoats and other materials you have scanned, then pick and choose between the various combinations.

## ARTISTPROFILE
### Trevor Claxton

**COUNTRY:** USA

Trevor is a senior concept artist at CCP Games, where he's working on World of Darkness, EVE Online and DUST 514. His free time is split between family and art for Magic: The Gathering.

**WEB:** www.trevorclaxton.com

# UNIFY ELEMENTS OF YOUR CONCEPTS

## Thoughtful design and detailing can give you an idea of the world in which a character concept exists

Over the past few years I've spent most of my time on personal pieces creating worlds, rather than one-off paintings. I'd like to explain how a single image can define a design philosophy for the concepts to follow.

I'll start with the mech and its weapon, to get an idea of technology level, manufacturing techniques and common materials in this world. I'll then move on to the pilot and her accessories, again trying to tell a story about this futuristic world while trying to balance unified and divergent design elements and materials within the design. I'll finish up with accessories, colour and detail work, all of which attempt to further increase an understanding of where this concept fits.

I tend to take my time and design on the fly instead of doing an exhaustive amount of sketch work. You can expect the design to change throughout this process as I massage shapes and forms into the final image. While this may not be the speediest way to work, I believe a relaxed pace enables you to explore more options within a piece, as well as play with painting techniques. Overall, taking my time allows me to have fun with the design and think about it. My style of working is also not particularly process-oriented, so you can expect a lot of jumping around from element to element as I develop ideas for them.

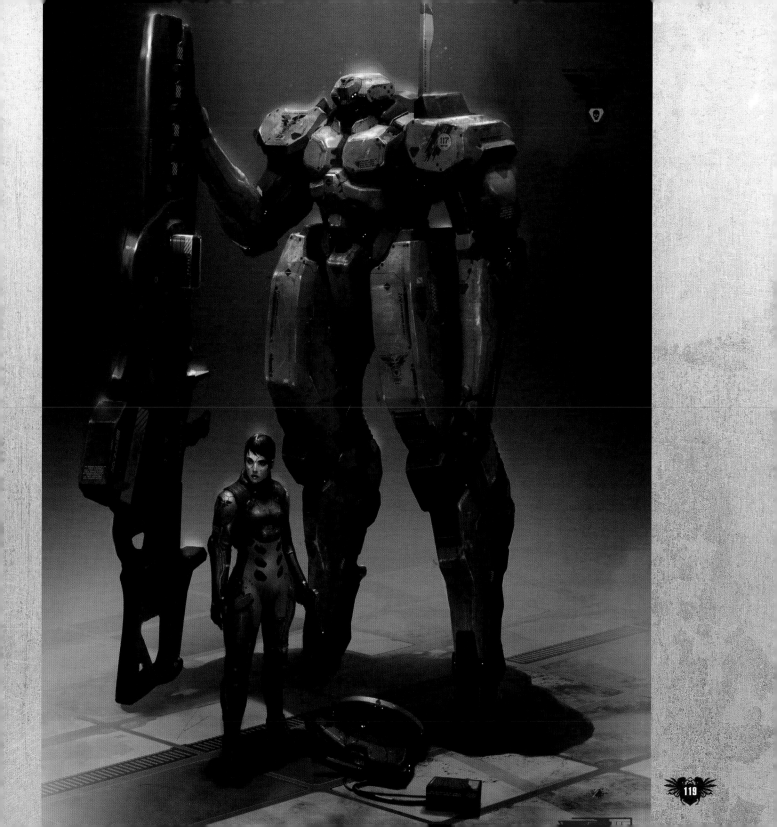

# 1 The initial sketch

I start my piece with a very loose and choppy sketch. I focus on the mech design because this will be a broader canvas for materials and details compared with the character or accessories. I want to mix hard-edged surfaces with organic-looking designs, so I begin with the more solid elements and block in huge shapes with a flat, palette knife-style brush. I'm not getting too attached to any of the concepts at this stage.

# 2 Blocking in the rifle

I drop in a perspective grid to loosely follow and start sketching in the arms; I want the mech to be holding its rifle in a relaxed way. I now use the palette knife-style brush to carve in the planes of the anti-tank sniper rifle, which will be the mech's primary weapon. Because this is a mech, there's no need to lie down or use a scope while firing the weapon, so I plant the handle on the top of the rifle. This is a rail gun so I think about what it would need to operate: a battery unit, a magazine and a grip. I start adding forms to the legs to get an idea of the detail level and materials.

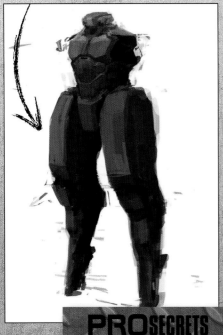

## PROSECRETS

### VANISHING POINT FILTER

This filter is invaluable for creating quick ground planes or wall coverings from a flat image or texture. You can also accurately place patterns or text across any flat plane or set up a perspective grid by simply drawing directly in the filter UI or pasting in a source image. You'll quickly find it an important part of your toolbox.

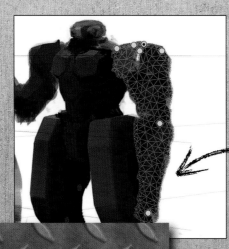

# 3 Finalising the design elements

Now that I've decided on materials I start on the facing arm, mixing organic forms and hard surfaces. I envisage the organic forms as a nano-material that's flexible with a hard, rubber-like finish. This enables me to play with how the hard surface and organic materials fit together. Because of the flexible nature of the nano material the connection points can be as complex as I want. I'm not happy with the angle of the arm so I use the Puppet Warp tool to bend it at the elbow.

## Brush settings

Now that I'm getting my design down, I try to correct the mech's perspective. I access the Brush Tip Shape tab in the Brush palette and adjust the angle of my brush. I turn off the Transfer tab to eliminate opacity effects. At this point I'm just Shift-clicking in big lines and planes by clicking, holding Shift and clicking the end point of the stroke I want to make. This is a fast way to achieve clean lines and planes. I add a second perspective point to use as a guide.

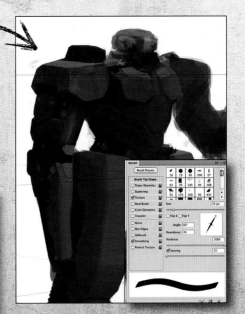

## Massaging forms into place

I start focusing slightly more on the accuracy of the forms that I'm dropping in. The mech's far arm isn't in the right position and so I use the Liquify tool to push it into a more natural angle. I continue to do this in one area or another throughout the course of the painting. The front thigh planes are looking too flat so I Transform Warp them into a slightly rounded shape to keep the design looking interesting.

## SHORTCUTS

**LIQUIFY**
**CTRL+SHIFT+X (PC)**
**CMD+SHIFT+X (MAC)**
Use this in Photoshop to adjust elements in your artwork quickly.

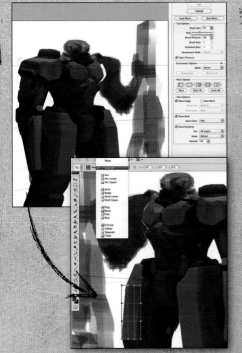

## The perks of simple SketchUp models

It's time to flesh out the gun a bit more, so I load up SketchUp and import a Jpeg of my image as a Matched photo. This enables me to set up the perspective in the program to match the perspective grid that I've laid out in my drawing, by matching up the red and green axes. From here I create a simple rectangle that I extrude into a 3D shape using the Push-Pull tool. I then use the Line tool to draw in the shapes I want to remove before pushing them to the opposing face, which eliminates them. From there I make a few more adjustments and then export the file as a Png. I place this file into my concept image and match them up. This acts as a decent framework for the perspective of the rifle. I don't have to commit to the model, but it does come in handy as a reference device.

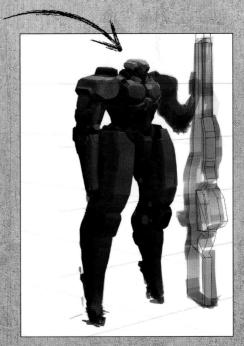

## ⑦ Ground plane and the Vanishing Point tool

This is a good time to drop in a ground plane. I want it to inform more about the overall design of this world, so I decide on an industrial-looking panel and grating system. I draw one quickly with the Marque tool, add a few details, then dupe it and make variants. I then line them all up and copy the layer. Now I open up the Vanishing Point filter, line up the waypoint with the perspective grid, paste in the copied image and move it into place. I make a mask to block out the mech from the ground.

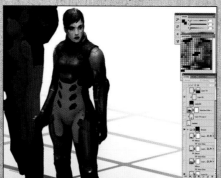

## ⑧ The pilot

I want to relate the pilot's costume to the mech's, but have it contain enough differences so it doesn't feel stale. I use a few different materials, to reinforce the common manufacturing ideas of this world. Due to her driving position in the mech she'll need flexibility around the waist and hips, so I keep it simple. I like the idea of bulky yet soft armour, so I push her silhouette out a bit more. To imply a war-torn world I add scars to her face to hint she's seen a lot of combat. Plus it just looks cool!

## ⑨ The drone

At this point the design is so well established that the drone's design will be a breeze. Any sniper is going to need a spotter and that's just what this drone will be. I keep the size small and compact so that more than one unit can dock in the rear unit of the mech. I quickly paint in a simple shape for the body, then use the Outer Glow layer style set to Multiply to outline a few ellipses, which become the lift unit. A few details later and the unit is done.

## 10 Adding colour

I use a selective Color Adjustment layer to tone the piece and then add a Soft Light layer above it. On the Soft Light layer I use a grungy scattering cloud brush and paint in a sloppy colour. I then adjust the colour and opacity of these layers until I achieve an interesting, uneven texture with colour variations over the whole mech. I repeat this for the pilot, spotter unit and rifle.

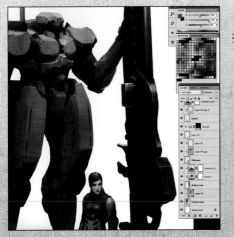

## 11 Scratch and damage details

I use a dirty textured brush to follow the edges that would receive more surface contact in black on a Soft Light layer. I then create a Color Dodge layer and use a lighter colour to create exposed metal bits over the scratched black areas. The same brush made larger creates imperfections on the larger forms with a light stroke and either fading or erasing it back.

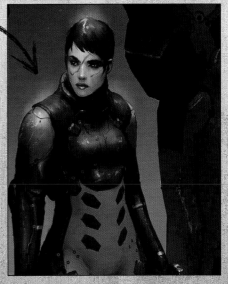

## 12 The fun part

At this point the bulk of the rendering and colouring is complete, so I move on to the little details that add a bit of realism. Adding small bits of text, warning symbols and graphics to a concept can easily make it stand out from the crowd. I start by looking for areas on the mech where branding and cautionary text would be likely to be found, such as joints, vents and moving parts. I use my predefined text block brushes and stamp them into these areas before transforming them to fit the surface. At this point I just erase or Color Burn them to fit the lighting situation and move on to the next stamp. These don't have to make a lot of sense – they just have to look interesting.

## 13 Finishing

At this point I think I'm pretty much done. I take a step back, both proverbially and literally, from the image and think about what, if anything, can be improved. After some chin stroking, I decide on adjusting my levels and perhaps adding in some more shadows with a Soft Light layer or Dodge in some highlights. I've now established enough of this world, through materials, design philosophy and implied manufacturing techniques, that I feel contented enough to move on to other concepts within this world with relative ease.

# ARTISTPROFILE

## Jesse van Dijk

**COUNTRY:** Netherlands

Jesse is a concept artist hailing from
Amsterdam. He currently works at
Guerrilla Games as a senior visual designer. He studied
Industrial Design at Delft University of Technology
and worked for several game studios prior to joining
Guerrilla in 2009.

**WEB:** www.jessevandijk.net

# CREATING
# A GIANT ROBOT

## Learn how to create a grand, complex robot design on an epic scale
## with Jesse van Dijk

Giant robots are cool. I guess it's something about the idea of a larger, stronger, mechanised image of ourselves that seems to resonate with a lot of people. So when you start working on a new image that has a giant robot as a centrepiece, you know that if the image isn't a success it won't be because of the subject matter.

This workshop will focus on creating a concept illustration of a large-scale robot that has a sense of believability about it. I'll be aiming to keep the overall look somewhat in touch with comparable, modern-day pieces of space machinery. The image should suggest this machine could really be produced as some

secret government project. In other words, it must feel kind of serious, and it must be so big that you can't help but feel a little small yourself.

There are some difficulties with designing and visualising at the same time. Doing both simultaneously isn't always as effective as concentrating on one action at a time. I'm more interested in the overall feel of the design, and not so much an exact blueprint. This means I'll be suggesting details rather than engineering them at micro-level. In a production pipeline, such an image could be used to determine the feel of a certain shot, and provide a rough preview of what a design would look like.

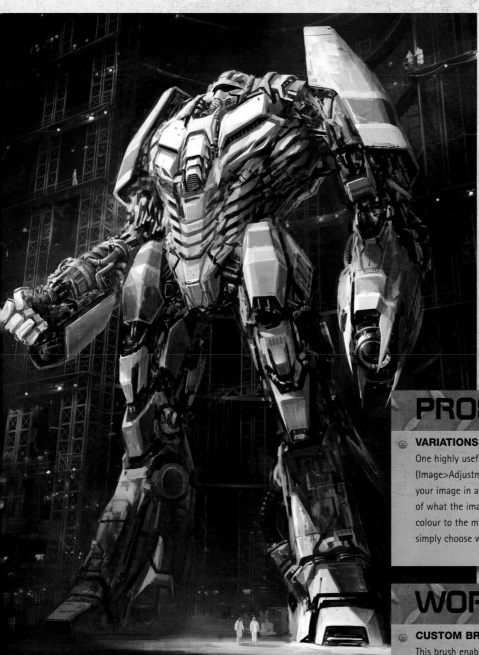

 ## The concept

Always think about the image you want to create. Before actually picking up a pencil, Wacom pen, or whichever drawing material you prefer, try to envision the sort of thing you're aiming to portray. This doesn't mean pinpointing a composition or colour palette beforehand – it's about the general feeling you want the image to convey.

 ## Acquire reference

Larger-scale objects have some specific visual aspects. Shapes become simpler as they get bigger, and colour patterns are less complex. Gather proper reference to identify these. In this case I look at construction equipment and a space shuttle. A collection of 50 images or less is enough and will prevent you from losing track of your goals.

# PROSECRETS

### VARIATIONS

One highly useful feature Photoshop offers is Variations (Image>Adjustments>Variations). It enables you to colour-balance your image in a straightforward and visual way. You'll get a preview of what the image would look like if you added more of a specific colour to the midtones, highlights or shadows, enabling you to simply choose whatever looks good.

# WORKSHOPBRUSHES

### CUSTOM BRUSH: BRUSH TECH

This brush enables you to quickly create a surface with an industrial look. It also performs well on a separate layer with perspective transformation applied.

 **Determine the silhouette**

Before I think about lighting, details, colour and everything else, I want to make sure I get a rough idea of what my silhouette is going to be. This will be a first macro design pass, as well as a determination of the pose of the robot. Digital tools enable me to paint, cut and paste, distort and transform my sketch as much as I like. I don't worry about resolution or tightness for now – I just concentrate on the silhouette.

 **Further defining the robot pose**

Once I've got the initial pose more or less the way I like it I go on to consider the basic proportions of the individual limbs. In this case I'll go with what I consider to be a conventional masculine male figure as a rough guideline. One specific area I need to put in special effort for at this stage is the position of the feet. If they're too unclear, I'll risk making him look unstable, which is the exact opposite of what I'm aiming for.

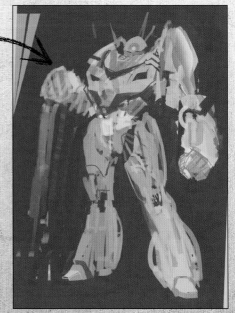

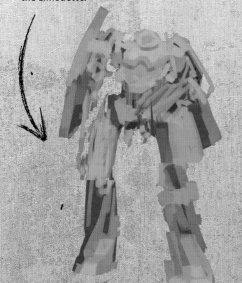

 **Perspective**

The overall proportions of the robot are okay, but the perspective isn't impressive enough for my liking. I'm still at a very early stage, so I can get away with a lot of brute-force approaches, like transforming the entire sketch in perspective. Doing this will initially make it very obvious that I've just transformed a flat plane with my sketch on it, but a few simple brushstrokes will fix that. What also helps is to include some elements that have obvious and in-world perspective distortion, like the frameworks shown here. If needed, you could paint a perspective grid.

## PROSECRETS

**FLIP THE IMAGE CONTINUALLY**
Remember to flip your image all the time – not just horizontally, but vertically as well. It will help you to get a fresh perspective on your work and prevent nasty compositional troubles from creeping in. Remember to walk away from your work every now and then too, for the same reason. Maintaining a global view is crucial.

## SHORTCUTS

**QUICK MASK – Q**
Enables you to paint a selection. Very powerful in combination with the Gradient Tool.

## 6 Sense of scale

I've got the rough design down and sorted out the perspective. Now it's time to set a temporary scale marker. I put some people down in the scene to constantly remind myself of the proportions of the scene I'm working on. At this scale these people are little more than white dots, but that will still work. I find people work best to indicate scale. Objects like cars or trees can vary quite significantly in scale, so be careful when you use those. Note that these people aren't necessarily intended to remain in their current position in the final image – they're really just scale markers for the time being.

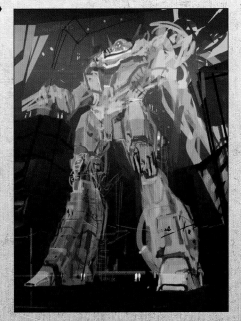

## 8 Design definition

At this point I'm starting to think about a little more micro-design. The proportions of the robot are roughly based on a muscled male figure, so to further bring that point home I'll use some major muscle groups as inspiration for some design elements – there are some repetitive elements in place for the abs, for example. Like the feet, the ground plane is used to place the robot in the world correctly, so pay close attention to its position in the scene.

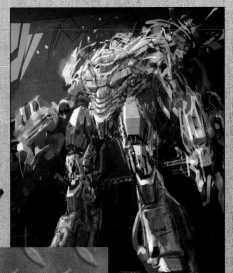

## 7 Lighting scenario

The final macro-pass is the lighting scenario. To make sure the robot's design features pop out later, I'll light him from above and the left, ensuring the light is almost perpendicular to his side. Some areas of the robot will be dark because of self-shadowing, meaning lots of contrast – which is good. With the critical elements in place, it's all about less important issues from here on.

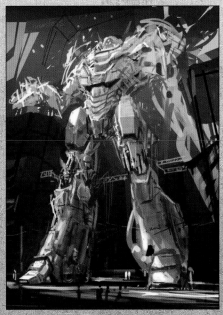

## PROSECRETS

**CUSTOM BRUSH: BRUSH FENCE**
This is useful for adding a fence at a recognisable human scale. As with the Brush Tech option on page 157, it's great when put on a separate layer and then transformed in perspective.

## SHORTCUTS

**DODGE TOOL – O**
O selects the Dodge Tool; Shift+O alternates between the Dodge, Burn and Sponge tools.

 ## Facial features

As I keep looking at the robot design on a more detailed level, I consider some of the most important micro-design elements, including the face. A face is often the single most important aspect of an image, but since this scene is so big, and I'm looking at a mechanical object with lots of other design details, I can get away with more looseness in the face than I might have if it had been a human I was painting.

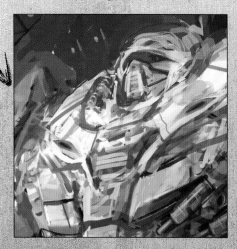

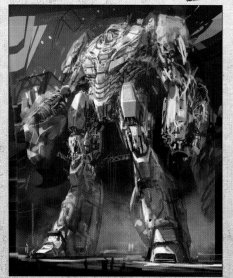

 ## Final detail alterations

Before I start out with colour, I have to go over the design I've done so far. His arms aren't working, so I need to address that. I want to have a better image of them before I continue, because once I apply colour things will be slightly more tricky to fix. Another thing I must do is get some sense of the detail level of the final image. To save time I'll paste some photos on top of the painting, taking care not to overdo this step. It's always tempting to start detailing too soon, and I might have already done just that anyway. Time for some colour.

 ## Colour planning

I consult the reference material gathered earlier. For this image, the overall colour pattern of the robot will be mostly simple – relatively desaturated materials coloured primarily through lighting. My approach for colouring this image is uncomplicated – I'll change the colour of the light along the direction of the light rays. I'll go from a warmer, orange light colour for the objects close to the light source, to a colder, bluish colour for the objects further away.

 ## Beginning to add some colour

To realise the above, I first flatten the black-and-white sketch. Next, I create an Overlay layer and fill it with a warm greyish colour. Depending on the colour you choose to fill the layer with, you have to tweak the Opacity of the Overlay layer to make it look good. Initially I am looking to achieve an overall warm feel for the entire image. Once I've got it, I flatten the whole image again.

 ## Further colour variations

Next I duplicate my single layer and use Colour Balance to add blue to the layer. Then I create a layer mask for this blue layer. This contains a linear gradient, from black in the top left corner to white in the lower right. I make sure the silhouette of the robot itself is also black in the mask – this is to prevent the bluish tint from affecting him, limiting it to colouring only the background. Finally, I flatten everything again and, with the brush set to Overlay mode, apply a selection of local colour variations to the image to liven it up.

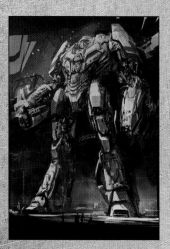

 ## Colour consistency

Right now the colours are a bit all over the place, but that's not really a problem. If you want to experiment with different colour schemes, now is the time. Mess around with your Colour Balance options or Curves Editor – whichever works best for you – until you're satisfied. The colours in the image are currently too disparate, so in order to pull everything together, I create a new layer, fill it with a desaturated orange, set the layer to Overlay and flatten again. The colours in the image are now slightly more alike.

 ## Cleaning up

My result so far is very rough, so I need to clean it up. It's time to get rid of all the junk – in the course of trying out various design elements and colour tweaks, the silhouette has suffered a bit. It's very useful to save a selection of the silhouette once you've cleaned it up, since it enables you to tweak much faster later on. As there's a lot less noise in the image now, I can be a bit more subtle with the saturation, so I desaturate the robot a little and add some coloured orange bands as saturated centres of interest.

 ## Background creation

Time to consider the background. With such a detail-rich centrepiece, I don't want to place too much emphasis on the background, but it would be good to reinforce the sense of perspective by using it. You can create some simple geometry with lots of repetition and without any significantly eye-catching features. Because of the heavy repetition, I generally use 3D in such cases – but of course painting is just fine as well.

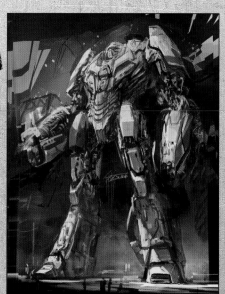

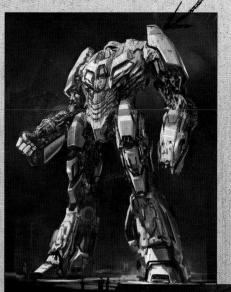

 ## Background integration

Using the selection I saved of the robot I can easily place the background behind him. Here I've used a lit 3D model, but the lighting doesn't fit the scene. I use the Dodge and Burn tools to resolve this. To suggest lots of activity, use night time photographs of city skylines with their blending mode set to Lighten, so the coloured highlights remain visible.

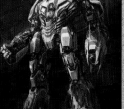

## Final tweaks

To finish, I make sure the levels are correct, tweak some last bits of colour, or change a design detail. Take care not to overwork things. Nothing you do now will make or break the illustration.

## ARTIST PROFILE

### Saejin Oh

**COUNTRY:** Canada

Saejin Oh is a 24-year-old freelance illustrator based in Canada. He works for Udon Entertainment, specialising in character design and manga art. His professional work includes covers for Blizzard Entertainment's *Warcraft: Legends* and *Starcraft: Frontline* comic series. In his free time he also enjoys playing games, such as Team Fortress 2.

**WEB:** www.saejinoh.deviantart.com

# MECHA'S HEART

Saejin Oh explains how he created this stunning image, from concept sketch to the final rendering

You don't create something out of nothing – your imagination creates something new based on what you already know. In a sense, your artwork is a mosaic of the knowledge you possess, put together in a certain order to create something vibrantly original. All that might sound daunting, but there's nothing to worry about – it's how you use your ideas that counts. Painting sci-fi enables you to unleash your creativity, bringing to life anything from weird aliens to hulking robots. The flip-side of this is you need to know how to paint different materials and create futuristic designs.

Before getting started, I like to have a clear idea of what I want to draw. Think of your work as a tree – you can always branch out with your ideas, but you'll always need a trunk for those branches to stem from. You can develop ideas and finishing touches as you draw, but you'll need to have a solid direction for your ideas to grow into, and the end point in your mind's eye to aim for.

For this workshop, I chose the subject of a female mech pilot in a bright, colourful suit. So, let's see where our imagination and that topic takes us.

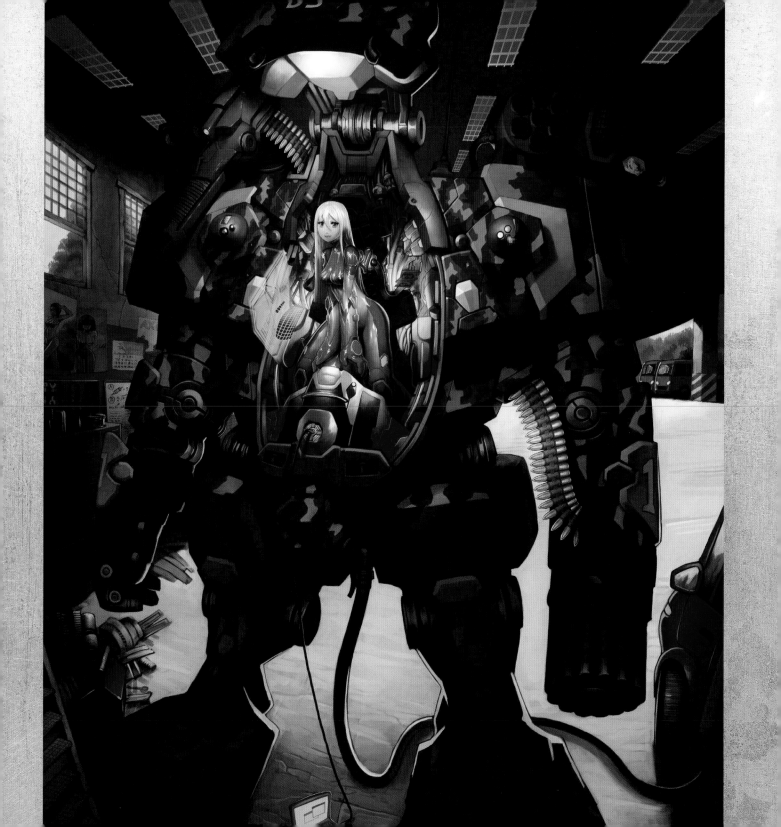

 ## Start with a thumbnail

Every painting I do starts with a thumbnail, outlining the goal for the finished piece. You don't need to put a lot of detail in your thumbnail: just try to clarify in your own mind what you're striving to achieve with the image.

At this stage, it's important to keep it simple and display your idea clearly. Remember, your sketch doesn't have to be structurally or anatomically sound – those errors can be mended as you develop your painting. All you're doing is getting down the design elements and creating a basic colour reference.

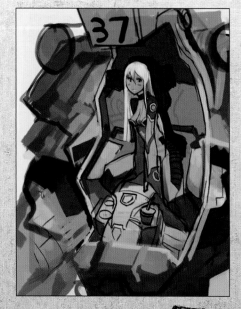

 ## Expand the view

If the object you're drawing is larger than the entire canvas, you may have trouble understanding the structure of the object as a whole. I'm sure that this is a problem every artist experiences occasionally in their work. To combat it, and to restore your sense of perspective, just increase the size of the canvas until the entire object fits. You can always crop out stuff you don't need later. Because of the canvas increase, my file size is pushing the limits, but that's fine for now. I quickly draw in limbs for my mech. It looks rather awkward, and will need adjusting as the image develops.

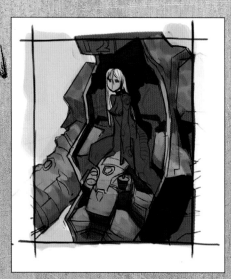

 ## Create a rough end goal

Now that you have a subject and a thumbnail to develop your painting with, try going a bit deeper into the elements of the sketch. Add new ideas and remove old ones that don't work as you originally envisioned them. Modify clunky ideas as you go. At this stage, I feel that the mech design isn't working because I'm having trouble grasping the concept as whole. Fortunately for me there is a simple solution to this problem.

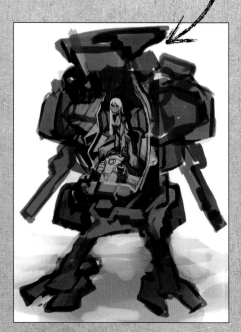

 ## 4 Develop the idea

The skinny limbs aren't working well for the size of mech I'm drawing. I decide to buff the mech up and change one of the guns into a hand with an opposable thumb, adding variation to the design. I drew inspiration for the mech from modern tanks, as well as sci-fi games and movies. As a result, the design of the mech is sharp, angular and boxy. Most of the exoskeleton is well protected, as are the internal wires, hydraulics and gears. I have other design ideas popping up, but I'll hold on to those for now. Since I have the basic structure, it's now time to connect the girl and mech together.

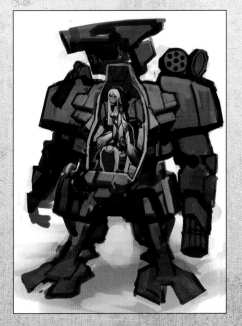

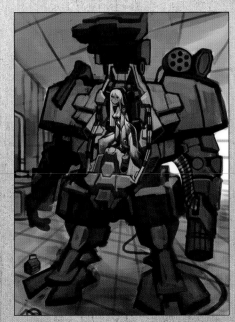

## 5 Add dimension

Since I drew the whole mech without any perspective guidelines, there are bound to be errors. To find them, I quickly draw a two-point perspective on a foreground Multiply layer, erasing any lines that cross over the mech. With this indication of space, I have to choose where it will be in the composition. This means selecting a background.
As I drew the pilot with the hatch open, I can't really have her on a battlefield. After some internal debate I settle on a garage, to complement the mech's passive stance. I also sketch an oil heater on the wall, blending the elements together.

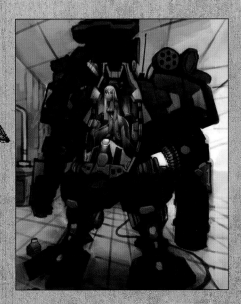

## 6 Add colour

This stage could have come much later, but I want to get a feel for the contrast of the pilot and mech. To colour the pilot I create an Overlay layer and a Multiply layer. I find the Overlay layer is great for assigning colours to greyscale paintings. You could use a Colour layer instead, but I think that tends to look dull unless you use an Overlay layer on top of it – so why bother? After the pilot is coloured, I expand the canvas to the right to give more room for the mech's left arm and shoulder armour. I also correct some minor perspective errors as I go along. While doing this, I add rough indications of a few new ideas I've had for the mech, like belt-feed bullets, new gun designs and cockpit lights.

 ## Fix perspective lines

I'm not particularly organised when I work, so I often end up going back to correct perspective after my initial rush of ideas. If you can avoid getting caught up in your sketch stage then I'd suggest drawing with correct perspective from the outset – it saves plenty of redrawing time later. As I correct, I think about improving my mech design, adding some weaponry and moving elements after my tweaks.

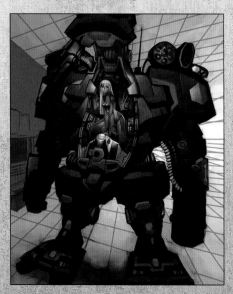

## Add a rough background

I've already decided that the mech will be in a garage or repair shop, so I do a quick Internet search to get some real-life references. From the reference, I draw in a red toolbox and fuel pumps. I also add some people to create a sense of perspective, but end up removing them later because they clutter the image. During this process I get a few more ideas, mostly for the mech's navigation mechanism. If you look at the top side of the hatch, there's no obvious peek hole for our pilot to look through, indicating this mech is a fully digital machine that gives the pilot a monitor-feed of what's going on outside. To allow for that, I add sensor spheres on both sides of the mech's shoulder, using UAV and other military helicopters as my reference. I also draw a few exposed wires in the interior to echo modern-day fighter cockpits.

# PRO SECRETS

**SAVE OFTEN**

If you're in the habit of working to the end of an image with just one save file, you're at risk of losing your important work to crashes, file corruption or hardware failure. Having multiple save files helps to reduce that risk. If you can get your hands on some extra hardware, make sure you set up a backup drive where you can save a copy of all your work. It might seem excessive, but it may save your neck someday.

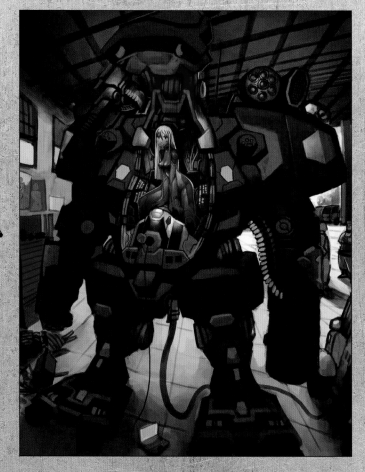

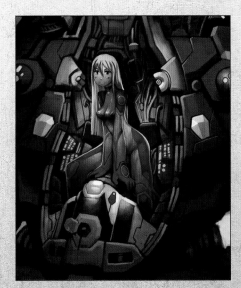

 ## Developing the character

With all the elements starting to develop, I turn to the painting's central focus – the character. Because she'll be getting most of the attention, she really needs to shine. Her immediate surroundings should be interesting as well, drawing the viewer's eyes to her. The lighting and the colour in these areas are too dull at the moment, so they're the first things I'll focus on.

 ## Altering the character

After I've brightened the colours, I still feel something isn't quite right. I try to convince myself that it might be because all the details aren't in yet, but I know this isn't a simple detail problem: there's no quick fix. I think that the overall direction of this character design needs to take a slightly different path.

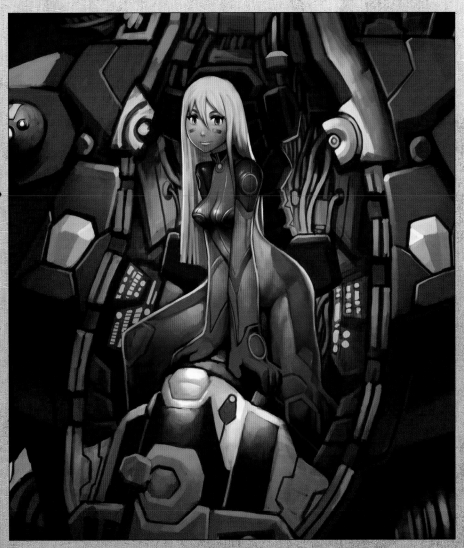

## SHORTCUTS

**UNDO TO CACHE /
ALT+SHIFT+Z**
Cmd/Ctrl+Z only performs a single undo, but this shortcut enables you to undo until your cache is empty.

## ⑪ Glossing over it

Eureka! It was the gloss – I've been painting a latex suit without a gloss. It's easy to forget the simplest facts when you're hours into a painting. Taking a break to refresh your eyes and your brain can really help to identify these discordant elements. Sadly, even with the gloss, it's still not right. She's now too glossy and her posture is awkward.

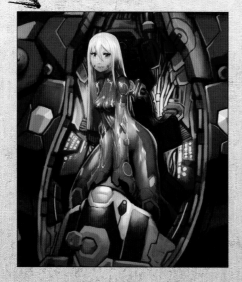 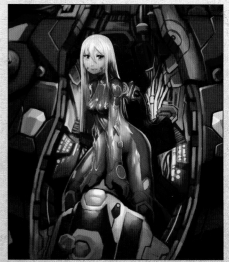

## ⑫ Deglossing and fixing posture

I reduce the overall glow by taking a brush and cutting out the areas that are over-glossy. I already have all the layers flattened, so using the Eraser isn't really an option. To work around this, I pick the colour nearest to the gloss reflections and tone down each part individually. Her posture is another issue. She was off to the side in the last step, so I use the Lasso to cut around her silhouette, Copy and Paste it, then slide her over to the left. In her new position, I completely redraw her right leg and make both her arms an equal length.

Next, I work on the colour of the suit, painting it a mixture of orange, red and pink on an Overlay layer. Finally, I add a data cable, placed behind her back, to complement the design.

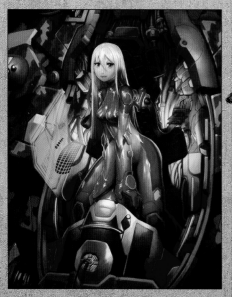

## ⑬ Head adjustments

The character is almost done, but not quite. I suddenly realise that her head is too big. Every time I zoom out, her head sticks out like a bobble on top of a car antenna. I might be being a perfectionist, but in my eyes it needs to be fixed.

I use the Lasso Tool to select the head, then resize and slide it around using Free Transform. Her hair gives me some trouble because I didn't select the bottom part of it when I moved her head. I lasso each section of hair separately, resize them and try to fit them as closely as possible to the existing parts of the image. Any colour/texture differences between the sections are painted over with a brush.

## Developing the background

I got the rough background ready in step 8, but now it's time to take it further. Be careful not to cram too much in and distract the viewer, but avoid a barren look in your backgrounds as well. Cracks in the wall, pin-up posters, whiteboards and calendars are all characterful hints about the kind of people who work here.

After all of the details are done, I darken or brighten them as needed. I darkened most of my details (except for the outdoor scenery through the window) to highlight the mech and create a good contrast. Remember: the subject you're drawing must be easy to see, or you'll lose your good work in visual clutter.

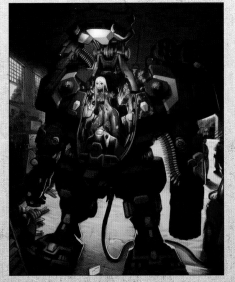

## Finishing touches

To finish up, a holo-interface, camo and a few other details are added to make the mech even more interesting. When you feel that your painting is done, save and close the file. Return a few hours later, open the file again and thoroughly examine your painting for any errors. You'll always find something you'll want to go back and fix.

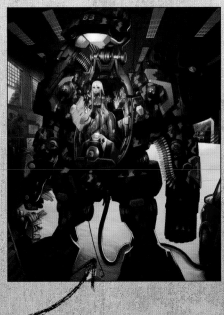

## Finalising details

I've achieved pretty much all of my goals at this point. All that remains is to add a few more details. I try a test patch of camo on the mech to see if it will work and redo the tricky roof of the garage to accommodate a more simplistic approach.

When finalising your painting, it helps to quarantine sections off mentally as you finish them. This kind of thinking enables you to estimate accurately when your painting will be complete.

## PRO SECRETS

**BIND YOUR TABLET KEYS**

Chances are you've got a digital tablet. Many of these come with programmable buttons, so bind them to shortcut keys and make use of them. It may feel alien at first, but once you get used to it, you'll never have to reach down to the keyboard while working. Bind keys like Colour Picker, Hand Tool, Brush Sizing and Zoom In/Out to increase your productivity.

# INVENTING RETRO WEAPONRY

Taking inspiration from Art Deco, streamline and other vintage styles, Patrick Reilly reveals how he creates elegant weapons

## ARTIST PROFILE

### Patrick Reilly

**COUNTRY:** USA

Patrick has always been into sci-fi and fantasy art, and his styles range from cartoons to more painterly work. He's been involved in projects for Simon & Schuster and Bacardi.

**WEB:** www.preilly.deviantart.com

## WORKSHOP BRUSHES

**PAINTER – 2B PENCIL2**
One of my favourite brushes, it's great for simulating real pencil strokes during my sketching process.

**THE ROUND CAMELHAIR SQUARE2**
My most frequently used brush when I'm going for a traditional-looking, painterly image.

What happened to the classic style that defined the sci-fi genre during the early and mid 20th century? And what happened to the soft-curved raygun designs or those spaceships with the fluid fins? Elements like these may be archaic, but they're still instantly recognisable.

Today, most spaceships and weapons are all about sharp angles and functionality rather than class. I miss the way sci-fi elements of yesterday were defined by the designs that were popular during that era. The classic sci-fi style used applied art that imbued the object with a point of reference in real-world pop culture. Sci-fi designs work better when they have elements that the viewer can relate to – in this case, the style was rooted in Art Deco, industrial and streamline elements.

In this tutorial I'll share my process as I delve into the creation of sci-fi weapons that might have been conceived between the turn of the century and the 50s. I'll reveal what reference materials I look at for inspiration, how to incorporate these elements into the weapon, and of course, my illustration process. Just because a weapon's primary function is destruction doesn't mean it can't be classy.

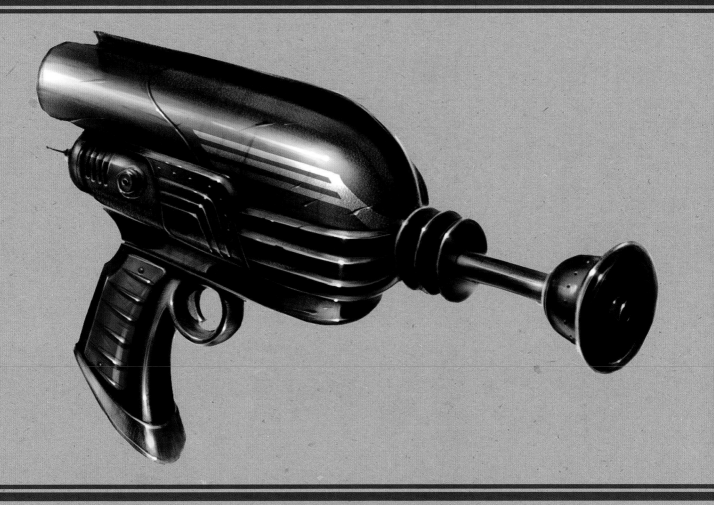

## 1 Starting off

Since a raygun is a weapon, which could be defined as an object that serves a specific function for everyday use, I needed to find a similar real-world object for reference. Vehicles, machinery or appliances are usually good reference material for a balanced mixture of design and functionality. In this case, I've found some pretty interesting objects: a cool-looking machine with some nice lines (I don't know exactly what it is), a vintage bicycle lamp, a streamlined train and a vintage 50s car.

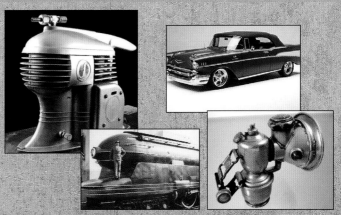

## Sense of style

After finding the desired reference photos, I usually like to study the design elements and create some thumbnail sketches to get a feel for the style. I could just look at the reference material and copy elements into my final illustration, but I'd rather get an understanding of how these vintage styles work, so that I can extrapolate future designs without the aid of reference photos. These reference objects deal with styles that consist of curves and consecutive horizontal lines, so I use my Pencil brush in Painter and practise creating curvy and long strokes.

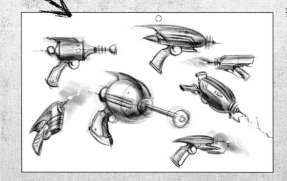

## The outline design

I decide to start off with the locomotive as inspiration and incorporate the rounded bullet shape, along with the lines and vents. The rest of the gun I'll have to improvise – this is another good reason to get a feel for the design style. First, I create a new layer and then, using my Pencil brush, I add some simple three quarter guidelines. I then draw a quick, loose pencil outline of the gun.

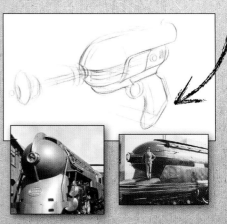

## Shading the weapon

Next, I create a new layer and use the same Pencil brush for my shading. To save time, I usually make the diameter of the brush very big. This enables me to shade a large area with only a few strokes. I keep the shading fluid and use long, easy strokes. I follow the contours of the design and don't worry about the shading going over the lines. When I'm ready, I group the two layers and collapse them.

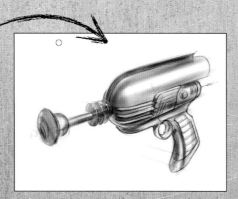

## SHORTCUTS

**ENLARGE BRUSH**
**ALT+CTRL+DRAG (PC)**
**ALT+CMD+DRAG (MAC)**
In Photoshop CS4, select the brush, press Alt+Ctrl and drag the pen across the tablet.

## SHORTCUTS

**ROTATE CANVAS**
**SPACE+ALT**
In Photoshop CS4, pressing Space+Alt enables me to rotate the canvas when I drag my pen across the tablet.

## The colour of retro

I move on to the colouring process by converting my pencil layer to Multiply mode and then creating a new layer underneath it. Selecting my customised Oil brush, I begin painting in the colours on the new layer. Since I want this gun to have an industrial feel, I go with dark grey for the body and a brownish colour for the handle grips. I add saturation, shading and highlights with the airbrush as well. I'm not worried if I go outside the lines.

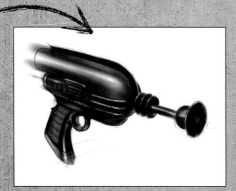

## 6 Adding stylised lines

After my initial colouring is finished, I decide to add some of the trademark Art Deco lines that are commonly found on 30s and 40s-era vehicles. I create a new layer and place it between my colour layer and my pencil layer. Next, I choose silver as the colour and select my custom Oil brush. I begin with a curve along the front of the gun and then gradually shift to a straight horizontal line, sweeping towards the back of the gun. I follow this up with a row of lines going in the same direction.

## 7 The highlight of the show

Once I'm satisfied and confident with the colours and stripes, I group the layers and collapse them into one working layer. I select my custom Pointy Oil brush and then add the specular highlights to the gun. Specular highlights are small, concentrated areas of high-contrast light that reflect off objects that have a metallic or wet surface texture. Along with the specular highlights, I also use my custom Pointy Oil brush to tighten up any thin lines or details that I may have missed along the way.

## 8 Creating texture

I prefer to do texture and clean up work in Photoshop, so I save my raygun as a PSD and then open it in the program. I then open a second file with the desired texture. On my artwork, I create a new layer and set it to Overlay. I then use the Clone tool to transpose the texture onto the Overlay layer I created on top of my raygun. When I'm done, I can adjust the texture effect by playing around and adjusting its contrast and transparency.

## 9 Cleaning up the mess

After my texture has been added, I merge the texture layer with the raygun layer. Now it's time to clean up some of the rough edges. There are a couple of ways to accomplish this: you can either use the Eraser tool to remove any stray lines or use the Lasso tool to capture the mistakes and delete them. After this, I use Photoshop's Brightness, Contrast and Saturation tools to make final tweaks to the image.

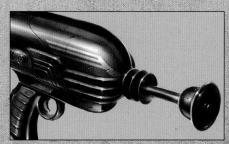

## 10 Background material

Next, I want to add a background. This can usually be done with a simple colour, or colour applied on a texture, perhaps. I open a new layer and place it under my raygun layer. I then use the Lasso tool and tightly capture the outline of my gun. Next, I go to Select/Inverse – my Lasso has now selected everything except the gun. I delete this negative space. Finally, I place my background image on the layer below the raygun.a

# ADDING DETAIL TO A RAYGUN

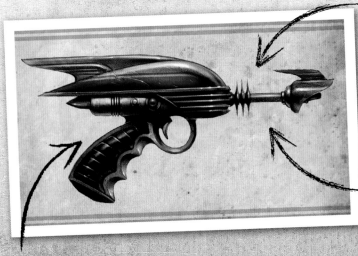

## Weathering makes it real

Looking at the first two guns, you can see some pitting, scratches and dents, along with a suggestion of rust stains. If you want to add weathering to brassy or copper-like metals, you could add some teal verdigris. The usual places to add rust and verdigris are around crevices, where components attach, or around rivets and screws. By adding these details it creates the illusion of a heavily used object.

## Iconic touches

What would a raygun be without the discs on the barrel? The barrels of vintage-style rayguns often have an iconic and instantly recognisable look. This usually consists of three or four discs in a row, which make up a heatsink-type device located somewhere on the barrel. I want to add this familiar feature, so I create a row of horizontally stacked disks along the base of the barrel. What these discs are for I don't exactly know, but they're probably designed to regulate the temperature of the beam passing through the barrel. Whatever they are, I still think they look classy.

## Varying your references

Starting with a similar process to the previous gun, I decide to go with the odd-looking machine from the reference photos as inspiration for the outline. Aside from the sloped top, the machine has a powerful workhorse feel that I really like. I begin sketching my new design, but decide once again to start with some horizontal guidelines. This enables me to view the gun from the front as well as the side, and makes for a more interesting illustration. I keep the sloped top and fin, while mixing in other Art Deco and streamline elements.

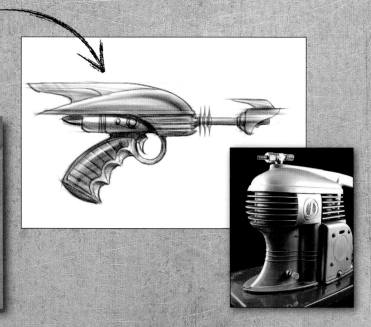

## PRO SECRETS

### SAVE, SAVE AND SAVE AGAIN!

You can never save too often when creating digital art. The worst thing that can happen is having your program crash after you've spent hours on a piece. It's also a good idea to save multiple versions of your work as you progress through your project. Occasionally, files become corrupted, so it's always good to have one project saved in several stages.

## Vintage car-style design lines

Using the same colouring method mentioned earlier, I take the vintage 50s car as inspiration and opt for the bright red colouring on the stripe design. Keeping in mind the fluid lines of the car, I follow along with smooth strokes. If I have a hard time getting the lines to flow smoothly when working freehand, I can easily use the Capture tool to create a stencil and just airbrush the red inside.

## Turn-of-the-century gun

With this gun on the left, I decide to try a more vintage design, inspired by the bicycle lamp reference photo. Not as smooth or fluid as the streamlined Deco items, this object exposes more of its functioning parts, while still adhering to applied arts to a lesser degree. The seams where the components connect are more obvious and they don't flow into each other as smoothly as the Deco designs. Keeping this in mind, I work around these rules to capture the turn-of-the-century era.

## PROSECRETS

### LOOKING WITH FRESH EYES

Often I'll be working on an image for an extended period of time and I might notice that something's wrong with it, but may not know exactly what it is. When this happens, I usually take a break for a while then come back later and look at the image with fresh eyes. This often helps me when it comes to discovering flawed details within the illustration.

## Different era, different colours

When I'm satisfied with my pencil sketch, I move on to the colouring. Since this design is from an older era, I'm going to have to drop the metallic greys and opt for the colours used on the machinery of the time. As the reference images (above right) show, the vintage brass or copper seems to work well in translating the time period of this weapon. I also add a deep red for the leathery handle grip pads and finally decide to toss in some cool teal for the chemical tubes on top.

# VEHICLES

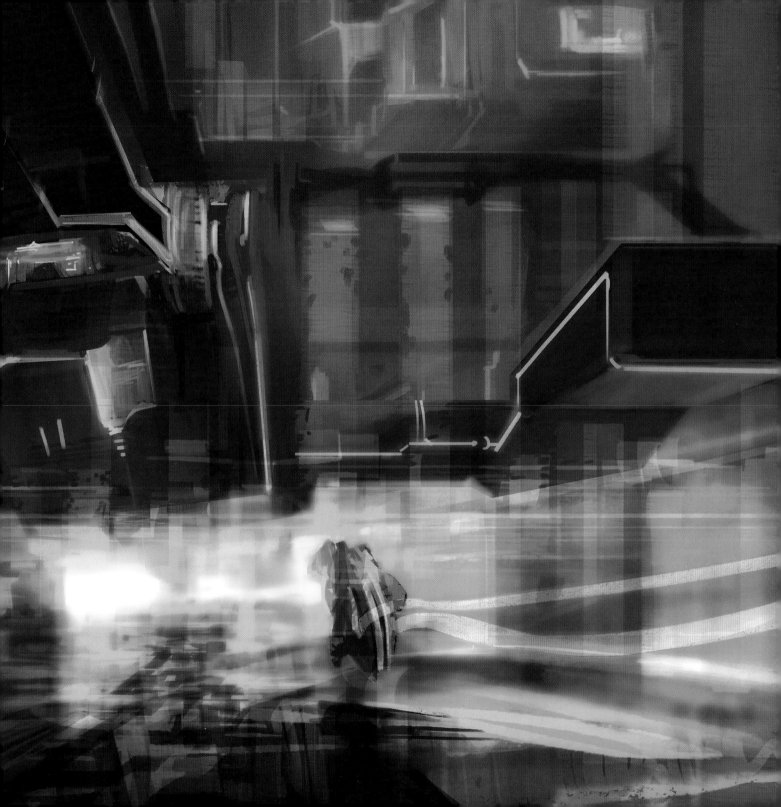

## ARTISTPROFILE
### Chee Ming Wong

**COUNTRY:** England

Chee has over 11 years of creative visualisation and pre-production experience, and, as Koshime, hosts free digital workshops.

**WEB:** www.koshime.com

# PAINT A LIGHT CYCLE

## Learn to develop your own TRON-inspired light cycle and illustrate a key frame action shot with Chee Ming Wong

Developing a vehicle that instantly occupies a place in the upper echelons of sci-fi history is actually pretty easy – when you know how. The key is to make it clear to the viewer what the vehicle's core technology is. Thus, whether it be a magical potion-powered broomstick or a streamlined block of nano-carbine that becomes a single-seater vehicle, it's all in the manner of your description.

Transferring this description into a tangible, visual asset that appears workable is what makes a successful designer and, ultimately, a well-loved iconic product. In this workshop, which looks to TRON for inspiration, I'll try to explain the process in two parts, by tackling the visual design element, followed by a key art illustration.

As concept artists our job is to generate designs for the entertainment industry. Each piece of art should have a purpose, and tread a fine line between aesthetic form and function. To lend further credence to this maxim, imagine that with any piece of art each asset can be realised, should the technology exist.

Ultimately, these aspects are distilled into either a two-dimensional line schematic or pseudo three-dimensional form. How this is then interpreted by a third party relies on both abstract and detailed suggestion. If all goes to plan, the end result is a heady mix of something approaching wonderment and excitement, which appeals to the innate sense of imagination that's present within us all.

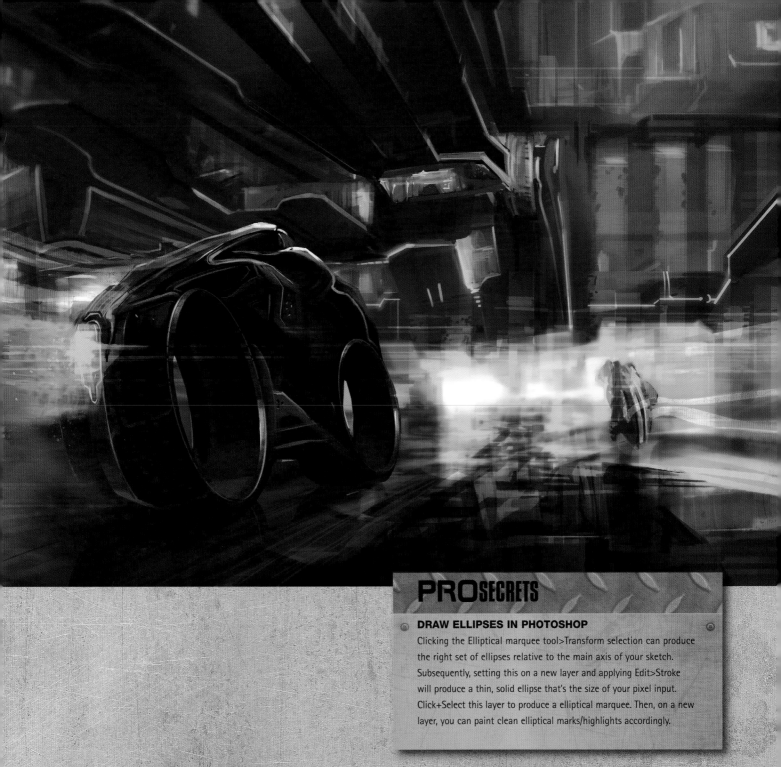

## PROSECRETS

### DRAW ELLIPSES IN PHOTOSHOP

Clicking the Elliptical marquee tool>Transform selection can produce
the right set of ellipses relative to the main axis of your sketch.
Subsequently, setting this on a new layer and applying Edit>Stroke
will produce a thin, solid ellipse that's the size of your pixel input.
Click+Select this layer to produce a elliptical marquee. Then, on a new
layer, you can paint clean elliptical marks/highlights accordingly.

 **Visual design**

Developing the light cycle involves a process of repetitive idea generation. The first 10 or so sketches help exorcise existing preconceptions and known clichés, and the subsequent thumbnails help develop a more honest process of development. These sketches need not be large, and can be produced fairly rapidly. However, I'll need to be fairly disciplined to make each one unique, rather than simply changing one component, shape or texture, and this difficulty is compounded by certain designs that share either similar or the same component parts.

 **A collection of cycles**

I've picked five light cycle sketches to show the client, and included a short description to explain my design.

**TYPE A**
Twin dumbbell ball-joints with twin-forked vertical suspension arms.

**TYPE B**
Unibody chassis and central propulsion block with hollow wheels.

**TYPE C**
Partially exposed chassis of magnesium alloy, with integrated engine block.

**TYPE D**
Fixed central wheels and combined body chassis.

**TYPE E**
Barebones suspension-type plated chassis.

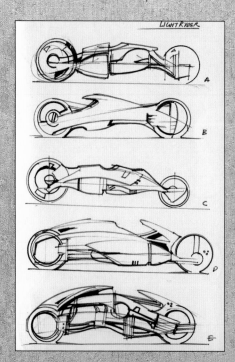

 **Propulsion concerns**

I think about the vehicle's propulsion system. One idea involves a particle-emitting discharge, with or without a diffuser to control propulsion. This power unit would be controlled through a compact set of directional thrusters. Such a propulsion system should be installed within a rig that enables lateral and forward movements. This may involve low-pressure spheres in place of standard wheel technology, or an advanced array of compartmentalised ribbon technology. For this workshop, I'll utilise a conventional, rear-powered arrangement. These propulsion elements are then incorporated within a modified Type E design. This features a central strip of nanite-coated materials in place of wheels, configured as a front spheroid and a rear torus.

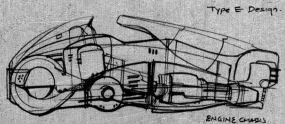

Type E Design.

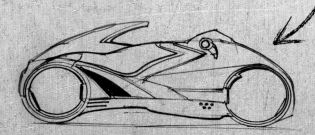

ENGINE CHASSIS

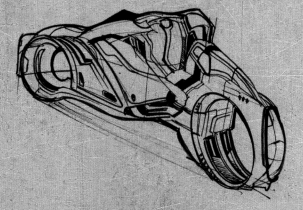

## ❹ Further development

Once I've decided on the base model design,
I explore possible variations, because I'll invariably come up with a
range of aesthetics and functionality options that might not have been
considered previously. Utilising different viewing angles often helps. The
amount of possible visual exploration depends on the time available,
but will prove invaluable
should you be asked to
present your design to the
client in person, because
then you'll be totally
familiar with the form and
aesthetics of the vehicle.

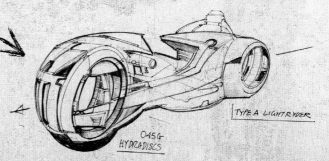

TYPE A LIGHTRYDER

045G
HYDRADISCS

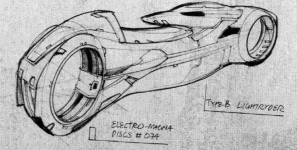

TYPE B LIGHTRYDER

ELECTRO-MAGNA
DISCS # 074

### SHORTCUTS

**BIND THE KEYS
FUNCTION KEYS (PC & MAC)**
Within Photoshop and Painter, bind
common tasks to function keys to
speed up your workflow by 15-20
per cent.

## ❺ Presentation sketches

Eventually, your development sketches need to be unified within a set
of presentation sketches. In terms of materials, one should be fairly
flexible. As long as the message is successfully conveyed you can use
whatever media suits the project. Here I produce a layered sketch in
Photoshop, because it has good layer management, and the standard
brush set of a hard brush and soft airbrush is all you need to produce
most of your everyday work. Elliptical shapes are easier to achieve using
SketchBook Pro; however, you can do the same within Photoshop with
some lateral thinking – see the Pro Secrets box (see p. 147).

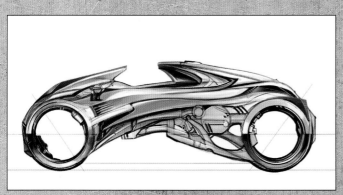

## ❻ Managing my Photoshop layers

I use the following layer structure to organise my work during the
painting process. Ghost layer: sketch the preliminary outlines and then
reduce Opacity to 15 per cent. Layer 1: sketch the main axis. Layer 2:
sketch the main forms and partition lines. Layer 3: sketch in subforms
and main details. Layer 4: set to Multiply (lower the Opacity as
required), then paint with grey at 10 per cent Opacity. Layer 5: paint
with grey at 30 per cent Opacity, then darken areas where edges meet
and where the horizon line is reflected, to suggest the ground plane.
Layer 6: add highlights. Layer 7: utilise strips or reinforcing shapes and
details to suggest curvature of hard and soft forms.

 **Generating a key frame illustration**

The second part of this workshop involves developing the scene as key frame art. This type of illustration depicts the design at a critical moment, such as during an action scene. For this stage I create a black and white storyboard. Limiting yourself to just two values means you can explore elements of composition and lighting in a graphic manner, and easily adjust elements of hard and soft edges. Sometimes the original storyboard can be even better than the finished version because of its simplified composition.

 **Painting a colour moodboard**

Having established elements of a chase scene within the initial storyboard sketches, I paint in the key illustration's main forms and tones, with the result being two colour moodboards. These are fairly rapid colour shape studies that help present me with options of how to take the illustration to the next stage. Ultimately, I prefer the top image simply because of the feeling of dynamism, rather than any preconceived elements of formal artistic composition.

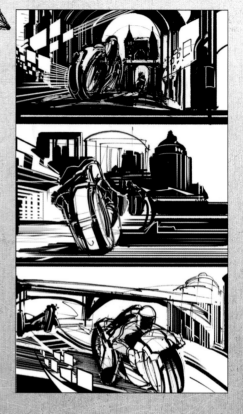

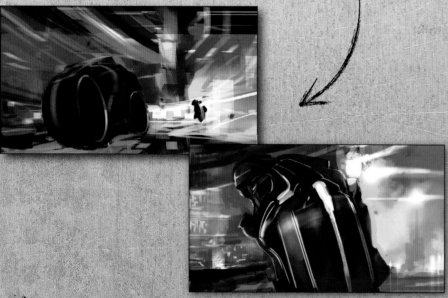

 **Embellishing without detracting**

I try to depict the shapes of the main background forms and establish various sub-forms. These are smaller supporting vertical or horizontal shapes relative to the main light sources. If you're not careful, adding more layers of paint may diminish the image's true essence. Indeed, the vibrancy of a initial sketch can be lost during this stage. Thus intelligent painting is crucial, without overthinking every stroke.

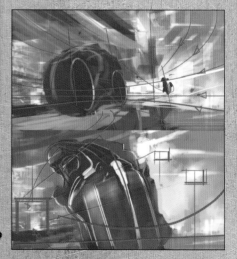

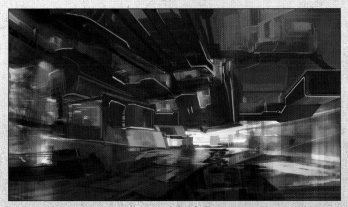

 **Background considerations**

Utilising the base colour sketch, I put the cycles on a new layer and start to detail them. The next task is to tackle the background. This involves establishing the main lighting, then the main core shadows and values. I then push some elements in the background even further back to provide a feeling of spatial distance and awareness. I do this for the entire backdrop, with the roof space remaining the final challenge.

 **Distant details**

The roof space presents a challenge. The vertical slice of lighting and shapes bisects the image. To counteract this I create reinforced roofs and distant tower blocks using flat washes of paint, and add supporting streamlined shapes. I introduce digital storm drains and mechanical piping, and establish various 45 degree bends to unify the overall art direction.

 **Colour grading**

The final 10-15 per cent of the process involves colour grading and unifying some errant shapes and values. The Channel Mixer layer can be useful for removing or adding colour elements to homogenise the scene. Use of the slider should be fairly subtle however, and the layer option should be set on Color only.

 **Introducing a sense of speed**

Adding particles such as smoke and dust, motion blur, Gaussian blur and depth of field should be the last thing you do. This step can take as long as the rest of the painting process, and is a good time to fix any small details and polish the image as much as possible. In this image I wanted to convey the sense of the two light cycles racing into a horizon that's dissolving into pixels, in keeping with the TRON-inspired theme. To do this I introduce various detailed elements and light streaks (akin to slow-motion photography of city traffic) as my final flourishes.

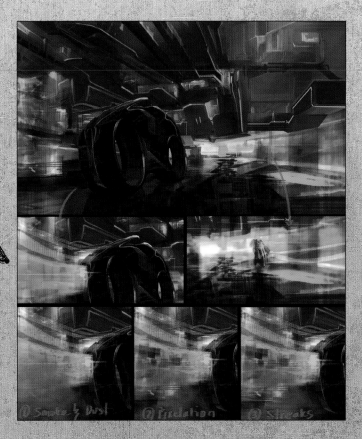

## ARTIST PROFILE
### Thomas Pringle

**COUNTRY:** Canada

Thomas was born in Copenhagen, Denmark. He has worked on high-profile projects for the likes of Vectorcell, Avalanche Studios and THQ. Thomas now lives in Canada.

**WEB:** www.pringleart.com

# IMPLYING DETAIL

**Learn how to block in overall shapes and lighting while implying details, with Thomas Pringle**

Creating implied detail in a painting is a handy skill. In this exercise I'll show you the importance of arrangements of shapes and value contrast, as well as colour and overall design.

When creating implied detail I simplify the shapes and figure out what elements are the most important and what can be left out. Since what little is left will carry the image, it will have to keep a consideration for form, lighting and composition and read well to the viewer. It's important to keep the painting loose. If I want to take the painting in a new direction I can try things out on a new layer. Broad confident strokes are key. Even though this is a quick painting style it doesn't mean it has to be rushed. Find

out what is important to tell the story and leave the rest out!

Keep an eye on perspective and space. Everything in the space I define has to relate to the perspective or it will seem awkward or badly drawn. Even if the vanishing point isn't shown, I should always have an idea of where it is. Also look out for your values – they should be arranged so that they draw attention to the subject. Take care to keep them separated. I usually start out with a middle, dark, and light value; the painting will benefit from a clearer expression and a better read.

Finally, the really important part – think about the underlying structure of the picture. Figure out how things work and how things relate to one another.

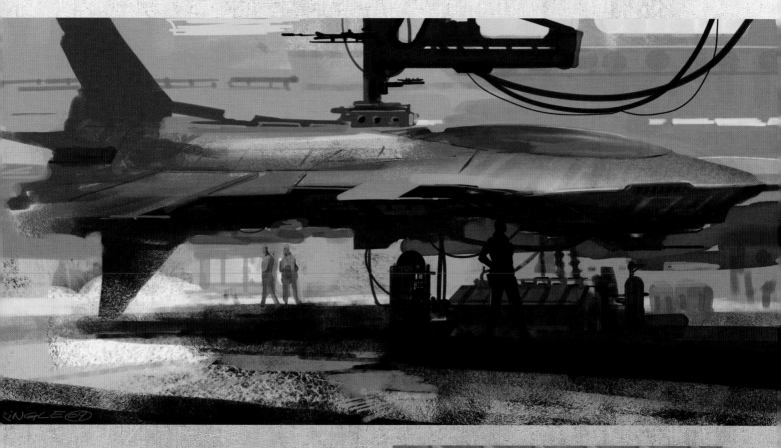

## PROSECRETS

### OVERALL DESIGN

Always consider the overall picture without going into detail too fast. Don't noodle in one corner. Make sure you have your composition and value range down on the canvas. This gives you a good idea of where you're heading with the picture and helps you see any issues before investing too much time in the image.

## 1 Dabbling around

My first step for this image is to rough in the palette I'm going to use. I load an old image of mine and paint over it so all that remains are abstract blobs of colour. At this stage I haven't got a clear direction, but I know I want a sci-fi image set in some kind of environment. I try not to commit too quickly while looking for that happy accident that will trigger a direction for the painting.

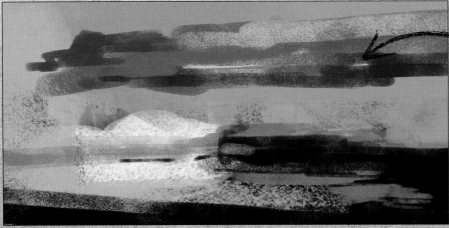

## 2 Roughing it out

I decide I'm going to paint a grounded spaceship, and I start working out the basic shapes and composition of the piece. At this stage my focus is more on the abstract quality and the composition than anything else. I try to come up with an interesting distribution of values to emphasise this. Also, I'm looking for something that reads well and looks dynamic. I extend the canvas to the right as I want to present the ship in its whole.

## 3 Defining, lighting and contrast

Once I have my basic composition and values laid out I focus on a lighting direction. I want to present the ship in an interesting way. I commit to a light source from above; this way I can have interesting shadows on the ground and underside of the ship, with potential for play in contrast against the brighter background.

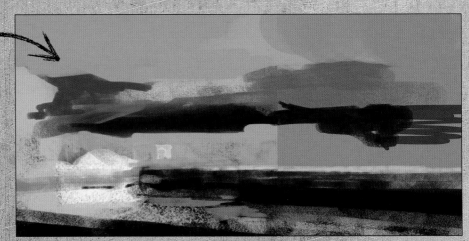

## Basic ship design

So far I've roughed out the basic distribution of values and I now shift my focus towards defining the ship. Since I've got my values figured out I can play up the shapes against the background. I define the shape of the tail and cockpit. I want the ship to look slick and aerodynamic so I streamline the shape of the front and give it small wings close to the fuselage. In order to achieve a crisp look I paint on a new layer and erase the excess paint. This makes for sharp contrasty lines.

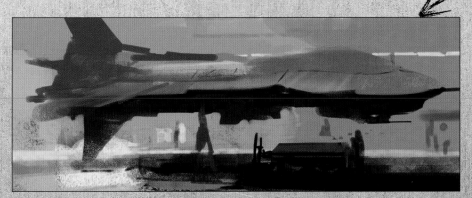

## Area around the fuselage

In order to give greater dimension to the fuselage, I draw a few lines to define the direction of the forms. To sell the idea of a grounded plane I add some kind of maintenance object on the ground, as well as a character. This adds scale and shape contrast from the sleek look of the aircraft, keeping the eye from wandering.

## More surrounding area detail

I work on the background without concern for detail, roughing in the shapes of windows or air ducts. I want to show the rough shape of other objects in the background, possibly another ship, so I pick a value in between the darker foreground and the lighter background and rough in the object on the far left. Also I add a crane mechanism at the top so the ship isn't floating freely.

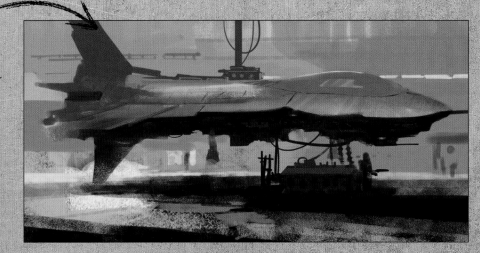

## 7 Background elaboration

I work on the background, coming up with shapes that will keep the eye interested. I don't want the sole focus to be on the ship alone, I also want it on the background. At the same time, I don't want the background to compete with the foreground, so I keep the shapes simple. I paint the shadow on the underside of the background shape.

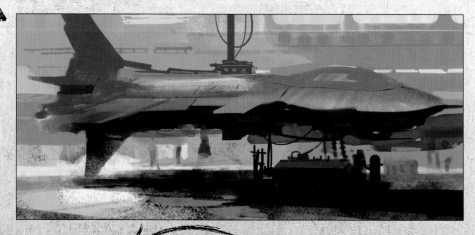

## 8 Ship design and controlling focus

As I want the ship to look sleek and fairly aerodynamic, I cut down the shape of the front and the cockpit. As the picture is coming along I still try to be as loose in my approach as I can get away with. It's important not to begin noodling as I reach the final stages of the painting. I've added a couple of guys standing in the background. They help with pulling the viewer into the picture and will complement the foreground character once I paint him.

## 9 Docking machine

I decide to flesh out the rig at the top a bit more to balance the image a bit. Also, this gives me an excuse to add some hanging cables, which makes for some nice silhouettes against the lighter background. I add a touch of dark blue from the reflection of the rig in the cockpit window, keeping my colours within the same basic palette I've established.

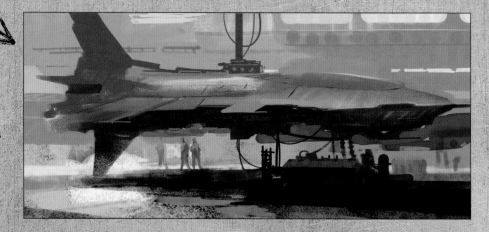

## Foreground character

Adding a character to the image really shows off the scale, so I paint the foreground guy in beneath the ship, draped in shadows. I start out in a dark blue with a lighter value on the planes that will receive the dim reflected light of the surroundings. I place the character a bit to the right as it gives a dynamic relation to the ship and the two guys in the background. It keeps your eyes on the page moving back and forth between these three main elements.

## PROSECRETS

### STRIKE A POSE

When painting characters, draw the skeleton first with emphasis on the pose. Detailing is fine, but if the underlying pose or proportions aren't working, no amount of detail will help you, it will just draw attention to the problems.

## Final touches

Nearly there, and I still haven't succumbed to the urge to add ever more detail. To emphasise the focal point I add a couple of highlight and dark lines to the underside of the ship, define the machinery a bit more and add a touch of reflected light on the character. I hope you'll agree that the final image implies much, but is actually relatively sparse.

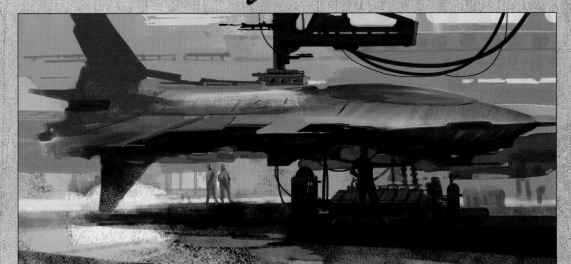

## ARTISTPROFILE
### Kevin Cunningham

**COUNTRY:** USA

Kevin is a designer for Savage Games, but he began his career in a different field – working for Honda. He has worked for many clients in the game industry and now principally concentrates on concept design.

**WEB:** www.kevincu.com

# DESIGNING ORION

Kevin Cunningham invites you to get on your bike as he shows you how to create a futuristic motorcycle

There are a variety of factors to consider when designing motorcycles – for me, the whole process usually starts off with a question. Will it actually be built into a real object that exists in the real world, or is it going to be a design that is wholly from the imagination and completely fictional?

In my experience with designing vehicles for both Honda (the real world), and EA (entirely fictional), my starting points are completely different. With Honda I'm given a detailed mechanical layout created by engineers that shows me where the engine resides, and gives me frame geometry points for the steering head and rear swing arm as well as the wheelbase. These factors are critical to how a bike will handle, and are very important for safety reasons. For a fictional world like one you'd find in a video game, the importance is not so much how the

bike will handle as how cool the design looks. Regardless of which scenario you're designing for, both will usually require a fair amount of research.

This research usually consists of looking through hundreds of images that will help me with design inspiration, the mechanical details, and the accurate depictions of shapes, forms, materials and lighting. At the same time, I'm also considering the environment into which I will be placing my design – be it an outdoor setting or a photo studio – because each has its own distinct look. In this instance I'm using an outdoor setting because I prefer to showcase this design into a much more realistic environment.

This workshop will take you from a rough sketch to the refining of the completed design, and will largely focus on techniques to render your line drawing into a believable product.

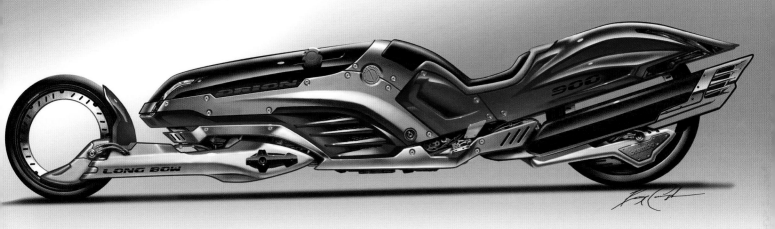

 Concepts

Here is the progression from the first ideation sketch to the final line drawing. Sketch A was created with the idea of doing a bike that drew inspiration from old cafe race bikes, with long tanks where the rider sits close to the rear tyre. In sketch B I'm finding the main character lines and refining the design of the first sketch. Here I start to see the frame becoming more of a visual design element and not just a structural frame that has been hidden beneath some plastic.

The final sketch and line drawing, sketch C, is ready for rendering. The frame is now a major element of the design and it separates the bike into three sections: the top of the cowl, the lower faring section and the rear seat.

## 2 The journey begins

I begin the whole rendering process by taking the Line Drawing layer and changing it from Normal to Multiply. This layer remains on top of the layer stack so I can always see my line drawing during the painting process. All subsequent layers will remain under this layer.

I quickly render the tyres with only two layers – one for the outside of the tyre where it makes contact with the road, and one for the inside of the tyre where it meets the rim. This way I can easily shade one tyre with the Dodge and Burn tool without affecting the other. The wheels and brake disc are on their own layers as well. I also know that once I have one tyre and wheel finished, all I have to do is copy those layers and scale it up for the rear. I also quickly block in the rest of the bike, and for the first time I see how it will all look graphically. Putting the Frame layer on top of the bodywork layers means I don't have to worry about how clean the Bodywork layer is when it meets the frame, because it's underneath it. I don't really mask much, so I try to get my layer ordered in a way that helps facilitate that. Be sure to never paint on these blocked-in layers, as you will need to come back to them a few times during the rendering process, so it's good to always have them just in case.

## 3 Orion's belt: Rendering the frame

I start rendering the frame first because it's a pretty flush fit to the upper cowling and rear seat area. I duplicate the frame layer that I will be painting on, and lock the transparency of the layer so that I only affect the painted area. I use a larger brush with the Hardness turned all the way down, and I start by Dodging and Burning in my light and dark areas as I start to develop the form of the frame. Once it starts to look pretty close, I move to the front swingarm and use the same techniques that I used to render the frame, because it's made out of the same material. If the shape isn't quite right at this point, keep tweaking it until it looks just as you want it and refer to your reference photos if you need to.

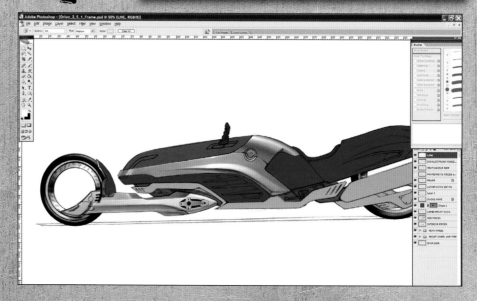

## 4 Glossy surfaces

For the core, I start with the upper grey tank area first. I copy the base grey layer that I'll use as my core, which will be the sky reflection area where the sides of the tank roll over to the top surface. Instead of trying to airbrush that shape in I wanted more control, so I darken that duplicated layer and I erase out what I don't want. I use the 30 brush with no hardness and my Opacity set to 20. Once I have the core that I want, I duplicate that layer and use Hue/Saturation with Colorize checked and shift it to a blue sky tone. I copy the first black core layer again and repeat the steps to change the colour to purple. I erase out a little of the bottom of the blue core to show some of the purple, and the top of the purple to show some of the blue. I use blue on top, as it will reflect the sky on the top surface of the tank, and I go with purple to warm up the core a little to help make the surface turn from the top of the tank to the sides. I take the black core that I created earlier and place it on top of the blue and purple layer, and I now have my core so I can get to the reflection.

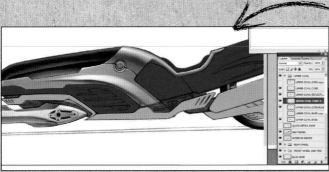

## 5 Reflection

To create the reflection, copy the base grey layer again and place it below the core layers. I use the Polygon Lasso Tool to carefully select my reflection, then I hit Ctrl+J (PC)/Cmd+J (Mac), and Merge via Layer to take my selection and duplicate it into a new layer. I want the reflection to go from dark on top to lighter on bottom, so I use Dodge and Burn to achieve this.

### SHORTCUTS

**LAYER VIA MERGE CTRL+J (PC)/CMD+J (MAC)**
I use this to paste my elements into a new layer. You can duplicate the entire layer by hitting Ctrl/Cmd+J.

## 6 Add the shine

To make something look shiny, leave some white between your core and reflection, and between your core and the very top of the tank. To do this I copy the base layer again and, with the Dodge tool range set to Midtones, I put in my white areas. It now looks a lot shinier and I can call this area done.

## ⑦ Seeing red

The red parts of the bodywork are created in the same way as the black part, but I flopped the sequence by tending to the reflection first, then the core and then the white areas. The surfaces are a lot more complex in this area, so I need to make sure they are reading correctly, and the reflection will show me that. I also use the Pen tool and create a path where I don't want the red, then right-click with the pen tool still selected, which brings up a menu selection. I choose Make Selection and hit Delete to get rid of it. Make sure you close your path before making a selection.

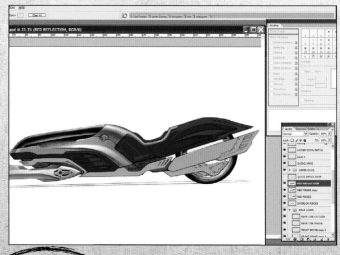

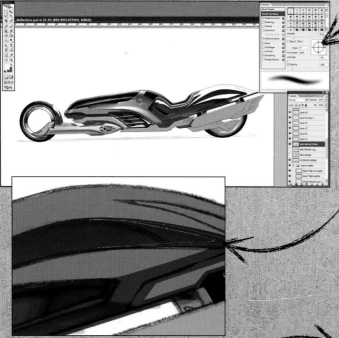

## ⑧ Further details

I add in some detail to the reflection by selecting areas with the Pen tool, duplicating them on to another layer, and then darkening them with Levels. I also Dodge the bottom of the reflection to lighten it and create a dark-to-light fade – and the reflection is done.

### SHORTCUTS

**MERGING LAYERS CTRL+E (PC)/CMD+E (MAC)**
Merge layers by selecting the layers that you want and then simply press Ctrl/Cmd+E to merge them.

## ⑨ More redness

I now repeat the steps that I used to create the core for the black tank and upper cowl section, but eliminate the purple from the core to leave more red. Then I add my white in.

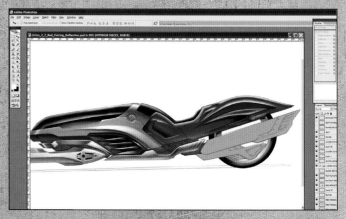

##  Exhausted

The final parts are coming together, and all the major surfaces and materials are reading correctly.

I finish up the exhaust quickly (Image A). Find an image of a carbon fibre weave online if you don't already have one. Free Transform the carbon fibre piece to get the weave to the right size. I render it in the same way as the red bodywork, using my carbon fibre weave as a base. I quickly design a chrome tip to cap off the exhaust. All the research I did earlier is going to come in very handy during the detailing phase. Detailing out a traditional drawing usually means just indicating some quick details, but now I can grab little pieces from images of motorcycles that I've taken over the years and start pasting them into my painting to give it that third read that keeps drawing the viewer into my design.

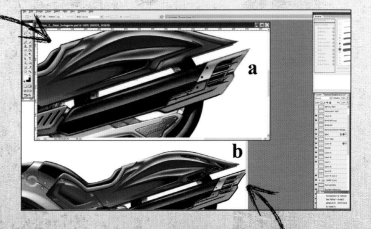

## PRO SECRETS

### TRANSFORMING A SELECTION

I use this a lot when I'm doing a circular selection for selecting a bolt or the tyres. Just drag out an Elliptical Marquee while holding down Shift to get a perfect circle selection. Go to the Select Menu and from the drop-down menu click on Transform Selection. Now adjust it just as you would with the Free Transform tool.

## Final line work

I use the Pen tool to add my final line work in (Image B) and set my brush to a Hard brush with the Shape Dynamics box checked. I stroke the path with the Simulate Pressure box checked to get the line to fade at the ends. I use this for surfaces that face upward and I uncheck it for lines that face downward to thicken it up. Sometimes you have to stroke it once or twice to get the right thickness, and hiding your path by hitting Ctrl+H (PC)/Cmd+H (Mac) can help you see it easier. This works really well for selection masks as well, but don't forget that you have it hidden because sometimes it can get frustrating wondering why your brush isn't working when you have your selection hidden.

## Background highlights

I can see the light at the end of tunnel now, and it's time for the highlights. In your brush selection menu, click on Brush Tip Shapes to bring up all your brush settings. I make the brush into an oval shape, manually rotate it to the angle I need, and paint in highlights where they hit the bike. Be careful not to overdo it or it will look like your bike has been dive- bombed by birds. The background is created using the Gradient tool, which is very straightforward to use. I go with a cooler background to help push it back and help pull my design forward. Keep the background simple because you don't want it to compete with your design. After adding in some graphics with the Text tool, I name the bike, sign it, and call it done.

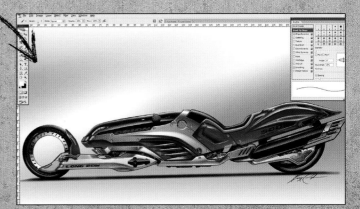

## ARTISTPROFILE
### Christian Bravery

**COUNTRY:** England

Christian runs Leading Light, an art and design agency that provides both character and environment designs for the video game and entertainment industries.

**WEB:** www.leadinglightdesign.com

# MAKING FANTASTIC FLYING MACHINES

BAFTA award-winning concept designer Christian Bravery creates a bug-based assault copter from scratch

For this workshop I thought that I'd do a piece of speculative industrial design – a futuristic flying machine. That sounds like fun, right? So how do we go about it? We start with the brief. Since I'm writing my own brief, that's easy. I'm fascinated by insect body composition, so I'm going to design a flying machine based on an insect – a wasp or dragonfly perhaps. When I was a kid, I saw a painting of a miniature robot that looked like a housefly by the sci-fi illustrator Tim White. I loved that piece, it really struck a chord. So I'm going to use its concept as a reference for my new creation.

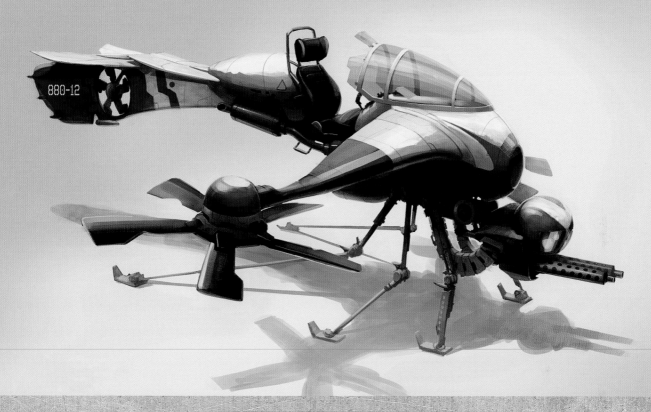

## 1 Reference points

To help me paint insects and machinery, I need to find some reference imagery. A quick hunt around my personal library of shots I've collected provides me with some useful images.

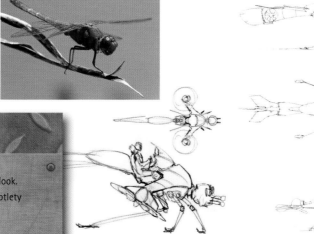

## PRO SECRETS

### MAKING YOUR DESIGNS CRISP

Use the Unsharp Mask filter to give work a nice tight, crisp look. Try to resist using it mid flow, or overdoing the effect, as subtlety is the key.

##  Thumbnail sketches

Now I draw. Using the images as inspiration, but not simply copying them, I work out some simple thumbnail drawings on paper, based on my dragonfly reference. I want the machine to be small and agile, like a real dragonfly, but large enough to carry a pilot. I mess around with a few options for the pilot position, eventually rejecting a seat in the head section for one placed just at the back of the thorax area, where the power plant and fuel tanks are positioned.

## 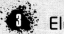 Elevations

Once I'm happy with the overall layout in thumbnail form, I go ahead and carefully draw up some elevations and work out a nice three quarter view of the vehicle. This is the one I'm going to paint. It's really useful to work out the elevations prior to attempting a perspective drawing, as they enable you to resolve the design simply, without worrying about perspective and also, in turn, in form your perspective drawing.

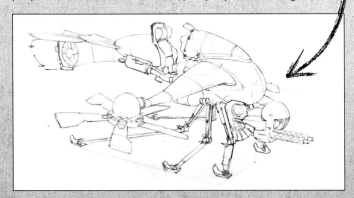

##  Material thinking

So now for the vehicle itself. What materials should I choose? Well, it's a futuristic flying machine, so I'm going to make it predominantly out of metal – and more specifically polished aluminium. This is mainly because I like that retro feel of old P51 Mustangs and Liberator bombers from WWII, and also because the material has interesting lighting properties that I can explore.

As ever, it's useful to have good reference, and as I'll be reproducing the complex lighting relationships inherent to the subject it's essential here. I choose a few relevant pieces of photo reference from my library, then using these photos as an impromptu palette, I can select appropriate colours from them as I work up the painting. A brief word on photo reference. I don't restrict my search to the subject at hand, but think beyond it to subjects that may be unrelated in the wider world, but whose material properties are similar. For instance, a can of Coke and an F-16 fighter are largely made of the same material, aluminium. Many movie spaceship interiors have that back end of a fridge look. In this case, why not take a photo of the back of your fridge and comp it into your scene? The results may surprise you. Or horrify. There's no guarantees when you throw caution to the wind like that.

##  Silhouettes

For this kind of painting I like to work dark to light on the subject and retain a plain, pale background. I make a copy of the pencil sketch in Photoshop, and set the Layer Blending mode to Multiply. Next I add a new layer under it, and fill it with dark, desaturated green. Then I paint the pale background in, leaving a dark silhouette of the vehicle.

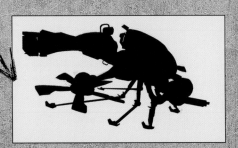
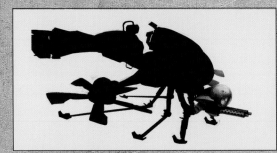

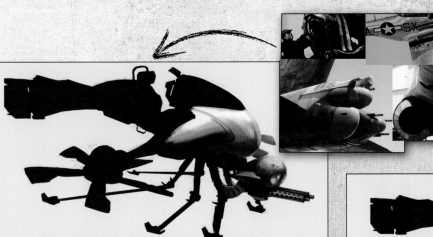

## 6 Simple thinking

Since this image is a design representation I don't need to worry about the complexities of mood, character elements, action or background detailing. I'm just concerned with material, colour and light.

## 7 Getting the light right

To achieve a good result, I just need to follow some simple rules. This shot is day lit, so a fairly uniform top-down lighting model works best. Surfaces facing up receive the most light, so these will appear brightest for their given local colour (the colour of the material under neutral light). Vertical surfaces will give a medium tone, so it follows that downward facing surfaces should obviously be the darkest. But wait, these areas are receiving bounce light from the ground plane. So the actual darkest area on a given convex surface is at the point which receives the least light from the main light source and the reflected light of the ground plane combined. Make sense? It's pretty simple really. Think about this formula and you're on your way to painting convincing convex bodies.

### SHORTCUTS

**PASTE ALL LAYERS**
**CTRL/CMD+V**
Select all and copy merged, then use this to paste your whole image as a single layer.

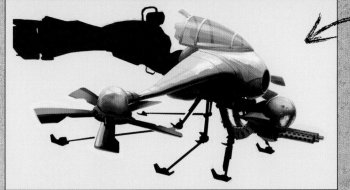

## 8 Brushed glass

So that's the basics, but I also need to render glass for the cockpit fore-canopy. No problem. Create a new layer, then using a brush with pressure-sensitive opacity control and a tone slightly darker than the background plane, paint the canopy in a few long quick strokes, then erase to the correct shape. Work in the highlights with some more quick strokes and paint in the metal framework using our nice simple lighting formula.

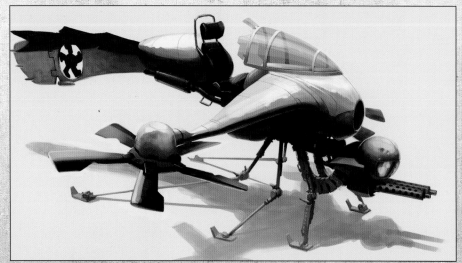

 ## Highlights

At this point I'm looking at the painting and thinking that the material specularity is off. It lacks the signature hard-edged shine of polished aluminium. That's easy to fix. I just harden up the lower edge of the highlighted area of the surface and we're there. The basic rule is this – the more reflective the object, the harder the highlight. The less reflective the object, the softer the highlight.

 ## Casting shadows

Now I drop in the ground plane shadow, just to make the vehicle feel like it's situated in a real environment, rather than floating in space. This really helps with the solidity of the piece and how it's perceived. I just bosh it in loosely on a new layer and erase the parts I don't like, or that cover the object itself.

Returning to the lighting issue, it's useful to point out that crevices and holes will be the darkest parts of the object and also more saturated for their given local colour. We also need to consider shadows cast across the object.

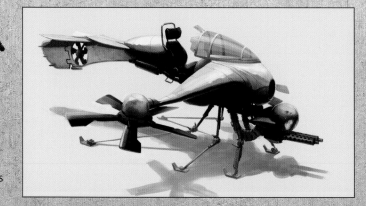

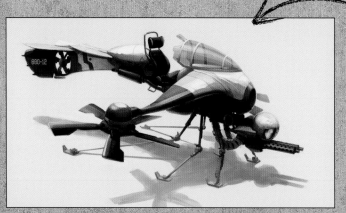

 ## A splash of colour

Okay, that's the base coat done, but it's looking a bit too uniform. All that unbroken, polished aluminium is starting to look bland, so I decide to give it a lick of paint – red paint. To do this without losing existing detail I create a new layer and set its Blending mode to Multiply, then choose a middle red and paint in the colour scheme. I try a few options, erasing those that don't work, adjusting and refining the ones that do, painting in slapdash strokes and using the eraser to tidy up later. Brighter, more saturated highlights are added on another layer in Normal mode.

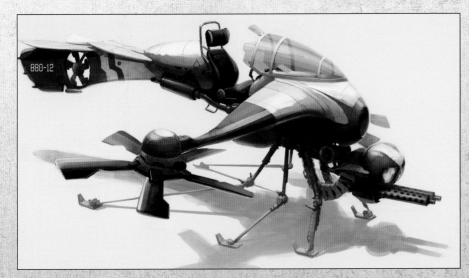

 **12** ## Devil is in the details

Nearly there. Now I add final details like decals, the identification number, warning tags and cockpit controls. Then I work around the whole piece with a homemade texture brush and some nice bright turquoise, adding highlights and rim lighting to soften the whole thing and make it feel less clinical. Play with this technique if you like it. I do.

 **13** ## Bringing to the fore

Here and there the bodywork of the machine is getting lost in the background. I make a copy of the collapsed image and make it darker using Curves, then erase back to the original to leave a subtle vignette look to the image.

Finally I give the whole thing a blast with the Unsharp Mask filter to harden it up. Play with the settings and you'll find a look that works for you.

 **14** ## The finished article

Okay, there we are, one vehicle, designed and rendered. I hope you like the result, and I hope you learned something along the way.

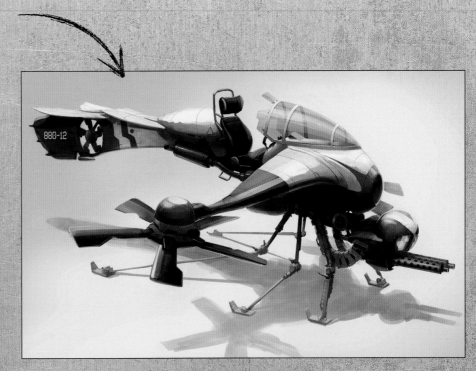

# ARTISTPROFILE

## David Levy

**COUNTRY:** Canada

David began as a concept artist for video game companies. He is now a senior concept artist and has recently set up Steambot Studios with his friend BARONTiERi.

**WEB:** www.vyle-art.com

# DRAMATIC CONCEPT ART

Leading concept artist David Levy shows how to paint a piece that's full of drama, using custom brushes to create a nuclear winter image

Creating dramatic concept art means capturing the correct mood for your piece. The mood that I'm going to try to achieve in this workshop is one of a nuclear winter, which still has a poetic atmosphere to it. Opposing or contrasting ideas always make for great painting subjects, and a saturated winter is not a very common way to approach an image. With that rough idea and direction, we will let chaos direct the first part of the painting, then slowly give it a meaning and a more concrete perspective, lighting and mood.

For this workshop, I'll start using the same brushes I created for an earlier project, but will also create new variations using the Dual Brush settings.

Before starting this kind of exercise, it's important to have a good knowledge of perspective, composition and lighting.

Without these basics speed painting can be frustrating, as speed and technique only come with practice. Nevertheless, there are rules that make the job easier, and atmospheric perspective is one of them. In most environments (aside from space) the atmosphere acts as a filter and creates a hierarchy in contrasts. I'll use that rule to emphasise the atmosphere in my painting. I'll try to imagine what a somewhat sad mood mixed with a futuristic space-situated design might look like.

The Dual Brush feature will help me create elegant shapes that will disappear in the depth of the fog. The tools used might seem complex, but their use is based on classical painting techniques. I'm going to overlay colours, starting from the background, slowly moving forward and finish close to the viewer's eye, as a painter using oils might do.

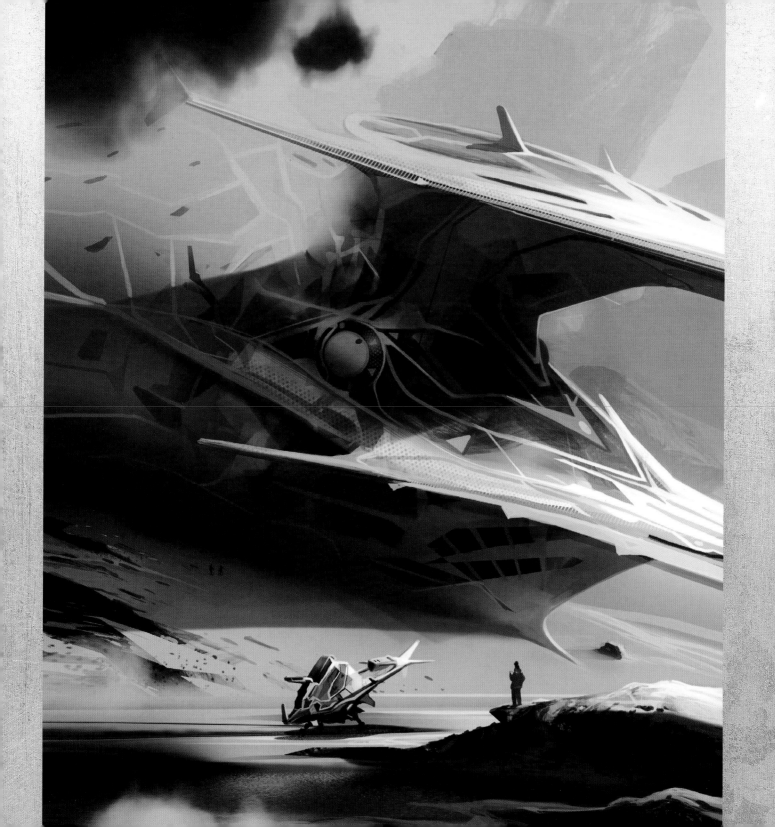

# 1 Background

Let's start with a medium green gradient from top to bottom of the image. I decide to keep the brightest area on the top, which influences the way light will appear in the final image. At this point I have no clue how that painting will unfold in front of my eyes. One thing is sure, though. With a vertical composition, I have the possibility to create a large building in the background. You shouldn't be afraid as you begin your image – be relaxed and enjoy yourself.

# 2 Basic shapes

I try to let the brushes go free as much as possible. I know that I need some rocks, a metal structure for the vessel and some soft gradients for the nuclear snow. I don't even look at the page during this process, just let myself be surprised by the shapes. When I look, I can already see a foreground and a background shaping up. This happens thanks to the variation of opacity and contrasts giving, the illusion of depth. I already sense that this off-axis composition could be something that plays to my advantage.

# 3 Shapes come to life

Using a Palette Knife brush I add two bold strokes of dark blue/green. Suddenly a large mass appears and textures are exaggerated during the shadowing process, giving a feeling that something high-tech might be lurking in the fog. The sharp edge on the right side reminds me of a vessel's prow.

# 4 Perspective

Using the Selection tool and the Rock brush from my set of custom brushes I decide to push the perspective by using rocks lying underneath the ice closer to the viewer. At the same time I make sure to exaggerate that off-axis composition by opening that embryo of perspective like a fan from left to right. These rocks will help the eye flow from foreground to background in a single and comfortable manner. I am starting to wonder how will I be able to balance this weird drop of composition to the right.

 ## Fun with fog

I decide to have a bit more fun with the fog, and get the sides of that silhouette to disappear in the mist. I find the best way to balance the whole image is by layering a nice, straight horizontal plane at the bottom of the picture. The composition now feels more balanced, and that sharp edge on the right keeps looking more and more like a prow. I think it is about time to give a wash of reality to the rough sketch.

 ## Connecting circle

I exaggerate that light coming from the right side by sculpting some white cap-like shapes, and by also adding a shine to that slab that I decide is going to be ice, thanks to a soft/sharp reflection. I toy with the idea that the connecting circle that I created in the middle of the more heavily textured area close to the centre might become the viewer's main focal point.

 ## Blowing snow

I add to those dark patches of texture, using the Selection tool and a newly created Dual Brush. I also decide to simulate radiosity underneath that mass with a soft but obvious dark airbrushed line. Close to the prow, I intensify the brightness as it gets closer to the bright snow. I decide to soften the snow and ice contact area using the Airbrush again, to give it a feeling of blowing snow.

 ## Adding scale

Time to give punch and scale to what is now seriously shaping up like some futuristic prow of a spacecraft carrier. I throw in some design markings on the top right part to give a sense of perspective, and straighten the line so it looks like it has been man (or alien!) made. I repeat the same operation on the level underneath, making the shadow line more obvious. At the bottom I add two characters that will give and indication for the ship's scale.

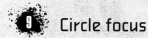

## 9 Circle focus

As I said in step 6, I think the connecting circle will make a great focus, so I work on the materials in the shadowy area. The lighting effects give the illusion of an eerie, unknown reflective material. That highly saturated yellowish green seems to work well, and will help develop the texture of the ship further. I really dig into the pixels in a close-up, revealing a lot of blurriness/sharpness variation. That will probably have to be fixed later on during the polishing phase.

## 10 Whale image

I exaggerate the back of the ship, by making it resemble a stranded whale on that strange green snow. I also have some fun designing a pattern on the back of the mechanical beast. That helps with reading the volume, and also makes the viewer believe that there might be much more there than what the eye can see. This is important – after all, if you detail everything, how can the viewer dream? I add clouds to the top left corner to play with the scale again, and also give a nice framing to the centre of the illustration.

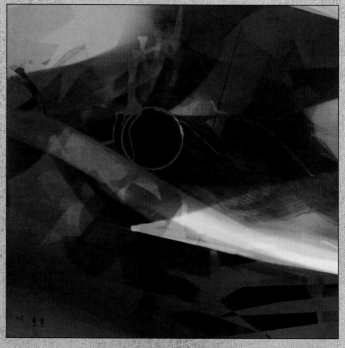

## 11 Texture

Working on the design of the texture feels different from the high adrenaline of trying to come up with shapes from chaos. The shapes come up by themselves, but I need to make sure I follow the overall volumes decided earlier on by the brushes and light gradients. I also have to be careful about the shadow-to-light shifts that affect the materials. The shapes again seem to take a life on their own, and the circle now resembles the eye of a mystical whale.

## 12 · Foreground in focus

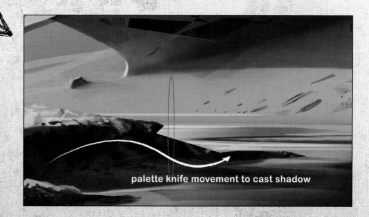

palette knife movement to cast shadow

It's time to think about the foreground. I need as much space as possible to eventually add some characters to my scene, and help the viewer jump into my image. A slab of snow-covered rock is an easy way to add depth and an instant foreground element. I also add some texturing designs at the front of that ship. Adding highlights where the ship and snow meet gives a nice indication of where the light falls. I flip the image over the vertical axis, and use the Palette Knife to gently cast a shadow on the side and underneath the rock.

## PROSECRETS

### THE IMPORTANCE OF BASICS

I have noticed on many occasions that many students tend to try to run before they can walk. Most of the digital tools that enable us to paint nowadays are extremely powerful, but one thing not to lose sight of is that a classical background will always make the difference. Even though you have a whole set of powerful digital tools, it is only by practising the basics that you will be able to use them to their full potential.

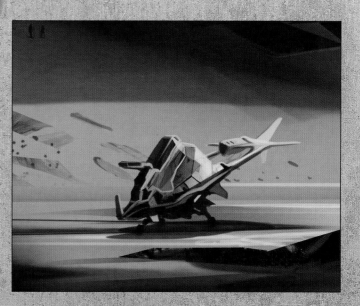

## 13 · Tiny ship

I decide to add another ship in the foreground as this craft's tiny proportions will emphasise the scale of the giant vessel even more. I use the colours already present in the painting with the colour picker, and I also add a very vibrant red so the image has a new point of focus – now slightly closer to us. I accentuate the light on the top right, and add in details including the landing gears and reactor. Then I cast the new ship's shadow on the ground.

## Fresh eyes

I zoom out to check that the composition is working with this new element and flip the image quite few times to keep my eyes fresh. This is probably a good time for me to take a break and go and get some coffee, as it's important to keep an objective view on your work – especially in a speed painting when things happen fast. Now the speed painting is pretty much done. From now on, it is going to be much more about polishing and sharpening the details. To give the piece more punch, I add a Multiply layer to the whole image. This enables me to slightly underexpose my image, without losing detail.

## Sculpting light

Now that the picture is darker, it's nice and easy to sculpt light on the sharp edges of the ship. The light coming from the top right, which cast shadows earlier on, helps me decide where to place those.

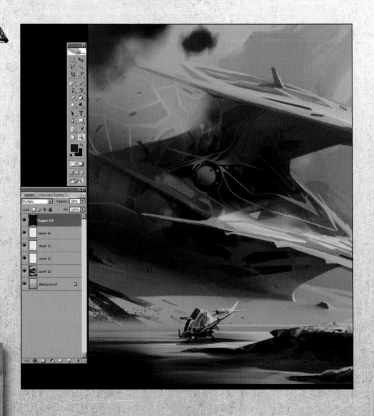

# PRO SECRETS

### CUSTOMISE YOUR SHORTCUTS

I like to customise my own shortcuts using Edit>Create Shortcuts, as well as the Actions option in Photoshop. Here are the few I have set up. Though there are shortcuts for these actions in Photoshop, I prefer to have them somewhere logical for me to use as I work. Clicking F9 creates a new document in one click. It gives me the size and format of a new file, and a basic name, but you could go even further by dropping in a basic background colour and so on. When I hit F5, it creates a new layer (Layer>New Layer). I like to organise common shortcuts at the most logical place for me to get at when working. You could also set them up on your Wacom.

## Add a figure

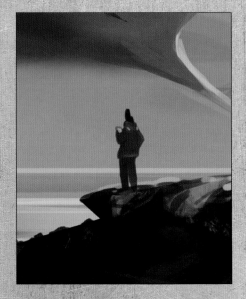

I add a character to the foreground to make sure the viewer's eye has a point of entrance to the picture, but also to keep that eye focused in the middle of the image. That rock ledge seems the best place. Maybe he is looking at some data on his computer or checking the view.

## 17  Add reflection

I zoom out a little bit to paint the icy shore, and add the water reflection close to the camera. It is a nice trick to make the image even more three dimensional. Even though I used a long focal lens for the image, adding those foreground elements is what gives a strong feeling of perspective contrast with the background.

## 18  Final polishing

Now all that's left to do is to polish the image and do the final tidying up. I clean up the foreground rock by zooming very close and softening anything that might distract the viewer. This is the time to smooth things up using the airbrush, or add even more detail using the round brush.

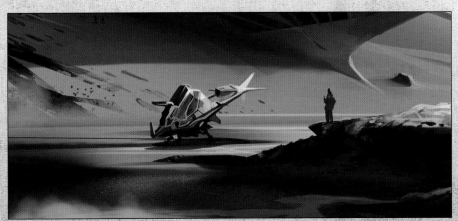

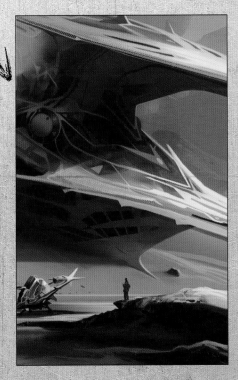

## 19  Finished image

The image is finished. I managed to get the result I wanted – a dramatic image with a strange mood that has an alien beauty to it. The fact that the characters do not look like they have any sense of urgency helps confirm to the viewer that the scene is calm – if it was not for the gusts of wind that raise, from time to time, a cloud of toxic snow.

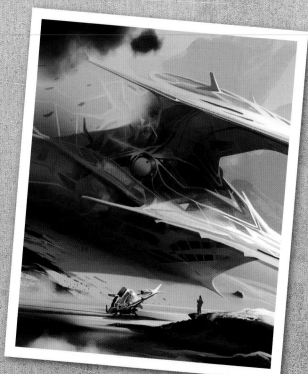

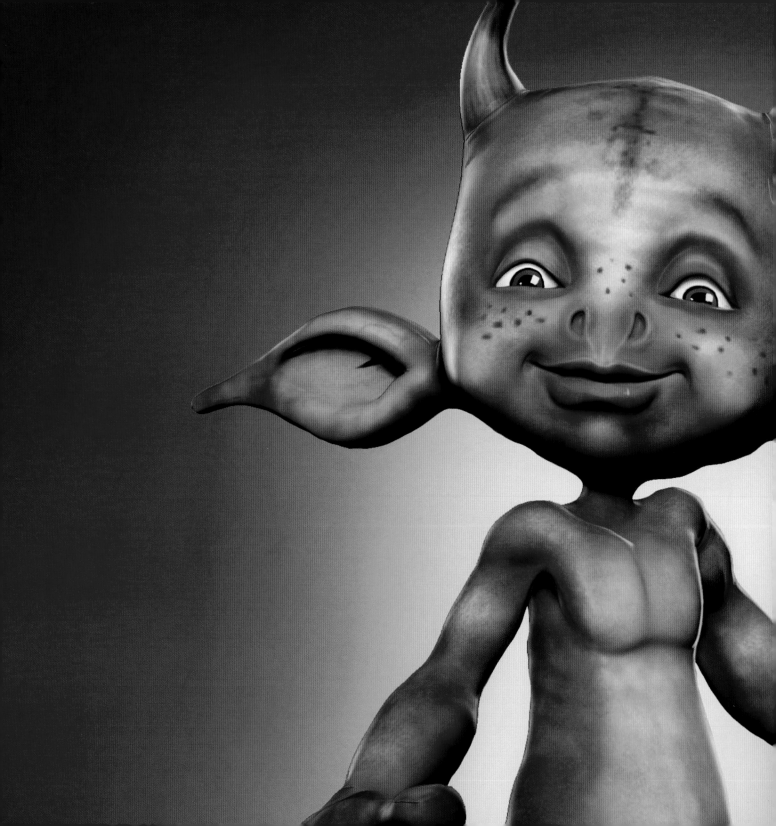

# 3D ART SKILLS

## ARTIST PROFILE

### Sunil Pant

**COUNTRY:** USA

After gaining a quantum physics degree in Mumbai, Sunil enrolled in an art school. He then moved to San Francisco, where he's a freelance 3D artist who's worked on high-profile projects that include Iron Man 2 and Megamind.

**WEB:** www.dgbrain.carbonmade.com

# CREATE 3D MODELS

## Sunil Pant designs a Steampunk-era military airship with the help of Google's 3D modelling program

I use Google SketchUp to help me quickly block out my shapes and get a design that I can look at from all angles. This helps me judge what scale and proportional changes I need to make before I get too deep into the 3D modelling of the design. I think the most important thing to nail in a design are good proportions and perfect scale. I use Google's SketchUp Pro 7.1 here.

As an artist, it's important to lay down parameters for your work before you start to draw them out on paper. I have some initial thoughts on the image. What's the theme of this design? Is it a modern or retro airship? Does it comprise nice bevels and clean edges, or gritty and heavy metal parts? How heavy is it? These, in a way, are all the assumptions a viewer makes when they see a design. Asking these questions helps make a good start. In this instance, I've gone for an old-fashioned look as opposed to something modern.

 **Do your groundwork**

I do as much research as possible on the subject. This phase of design is one of the most important – it gets me in the right frame of mind for the project. I put my reference images of combat vehicles, aircraft, blimps and propellers in front of me before I tackle the airship design.

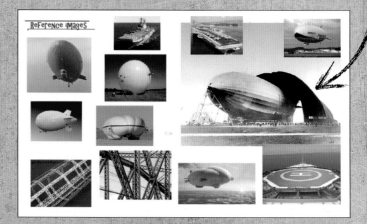

REFERENCE IMAGES

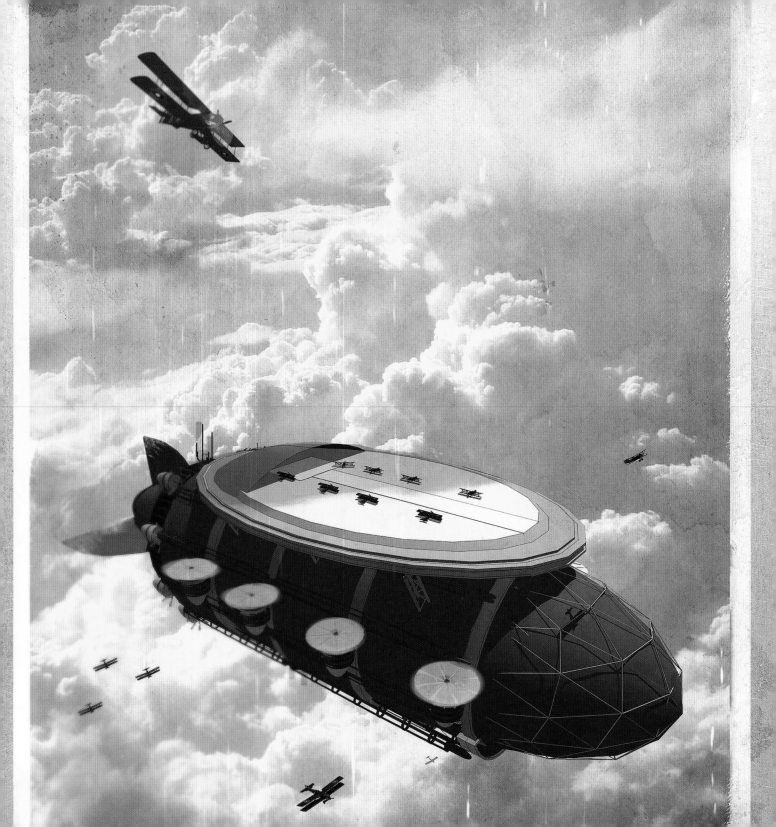

## ② Use thumbnail sketches

I like getting my ideas down on paper as quickly as possible. While coming up with a collection of thumbnails I make sure that there's variety in my shapes and forms. It's quite liberating to sketch as many options as I can without spending more than five minutes on each one. At this point, I also have all my photo references to hand, just to give some context to all my doodles.

## ③ Refine your choice

I do a layout drawing of the thumbnail that I find the most interesting: it has a simple yet strong look. These ones were done over basic 3D models from SketchUp to maintain the correct perspective. I'm not too concerned with all the details yet, and I approach this part almost as though it were an oil painting, using a few strokes to give a rough idea of the refinements to follow. I'm concerned with the overall shape, proportion and scale of the airship, and how it relates to the forms along its surface.

## ④ Use SketchUp

You can see here how I start to block out the airship in simple shapes. This phase in the design process is where I deviate from the approach usually taken by most of my peers. I like using SketchUp as a tool to further figure out any proportion and scale issues. Here, I've started with a primitive sphere and scaled it to fit the airship body. I block out the main shape of the vessel first and add directional fins to distinguish the front from the back.

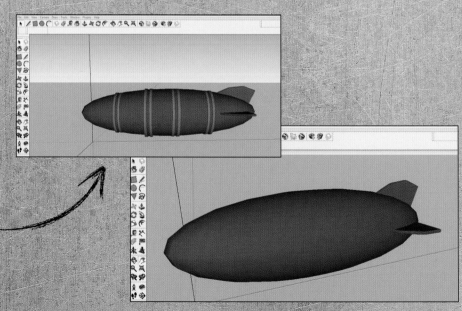

## Keep parts separate

Building areas in SketchUp is all about cutting and extruding forms. I designate features such as the landing pad and propeller blades as separate files, using the Circle, Scale and Extrude tools. I also introduce four rings over the body surface. These are on tracks that enable the propellers to slide and tilt while the airship is in motion. As a design element, the tracks around the surface also help break up the body of the ship.

## Build propellers

I now go in and build the propeller blades, using my real-world reference photos and matching the overall shape as closely to the real thing as possible without adding any details. You can do this by first creating a curve on a plane with the Curve tool. Then create a circle in 3D space using the Circle tool. Highlight the outer ring. Select the Follow Me tool and click the curve surface that you've just created.

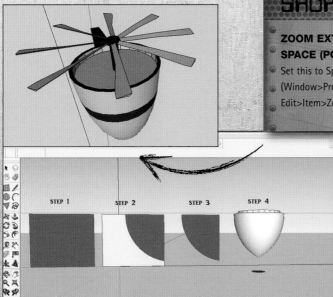

## SHORTCUTS

**ZOOM EXTENT**
**SPACE (PC & MAC)**
Set this to Space to explore your model (Window>Preferences>Shortcuts> Edit>Item>Zoom Extents).

## PROSECRETS

**USE OTHER PROGRAMS**
SketchUp enables you to import several types of 2D and 3D files using File>Import. This makes it possible to convert my .skp file into an .obj one and then import it to other programs that can handle the format, before further tweaking and editing the model.

## Add details

I'm satisfied with the overall shape and start to add in girders and pipes. This gives the airship some scale. The finer the details I put in, the bigger this vessel appears to be. Notice that even though the design already looks detailed, there are still repeating shapes and forms. As such, a viewer can recognise what a shape or form is, rather than trying to make sense of arbitrary elements.

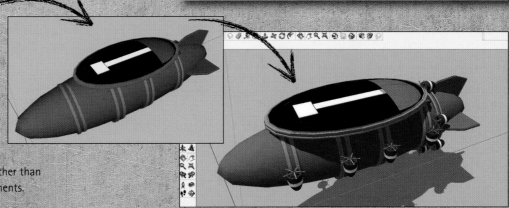

## 8 Introduce shadows

Adding shadows in SketchUp is straightforward because it's all done in real time. Go to Window>Shadow>Shadow Settings. Here, you can play around with the time and date settings and see what works best for your designs. The only advice I'd give here is make sure that your design isn't swamped in shadows, or else it'll end up looking flat.

# SHORTCUTS

- **DUPLICATE ITEMS**
- **CTRL+MOVE TOOL (PC)**
- **CMD+MOVE TOOL (MAC)**
- Use this combination to replicate objects quickly in SketchUp.

## 9 Use fog to add a degree of realism

Introducing fog is a quick way to add some atmospheric depth to an object. In this case, it offers a way for the airship to be painted into a suitable environment without having to leave SketchUp. Go to Window>Fog>Display Fog. You can place the fog as close to or as far away from the camera as you like. I normally play around with these settings to blur out the horizon line in the distance.

## 10 Pick a style

Go to Window>Styles and choose your preference. Sometimes, I use sketchy edges over my layouts to keep them looking fresh. They're also a way to get away from the stiff look that a 3D model can suffer from thanks to default shaders. Note that you might not want to build your model with sketchy edges applied, because that could slow your computer down considerably.

## Enter the 3D Warehouse

After I'm satisfied with the design and shadow layout of the airship, I bring in a few World War I biplanes from the SketchUp Warehouse. You could also incorporate pieces created outside SketchUp that you've created in the past into the scene to add scale and context. Acceptable 2D formats include .jpg, .tif, .png and .bmp, while compatible 3D formats include .3ds, .dwg and .dem.

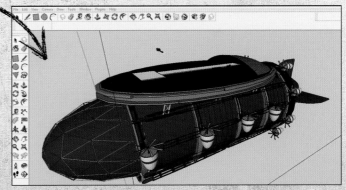

## Import and integrate

I now import the finished piece into Photoshop as a .jpg image. The best way to do this is to go to File>Export>2D Graphic. This helps you save your file out as a .jpg and then work on it further in Photoshop. You could also use other painting software that supports the format.

## Think about presentation

After I've taken all the screengrabs I need of the airship design in SketchUp in .jpg format, I use Photoshop as a tool for presenting the design clearly. Here, I overlay a graph paper texture first, then arrange my work on top of it on a Multiply layer.

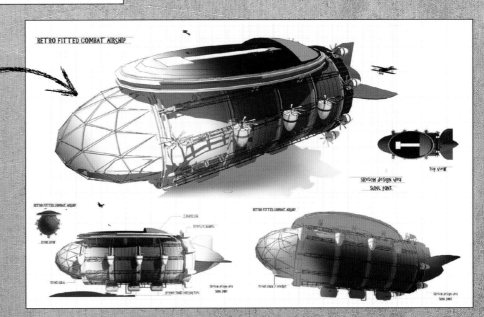

## ARTIST PROFILE
### Glen Southern

**COUNTRY:** England

Freelance 3D modeller Glen is also the creative director and partner at SParleVFX, based in Liverpool.

**WEB:** www.southerngfx.co.uk

# TAKE YOUR FIRST STEPS IN 3D

## Discover how to model your 2D creature design for animation, print or even your very own game, with Glen Southern's expert advice

At some point most artists wonder what it would be like to see their characters or creations translated into 3D. That 3D model might be for a game, to be animated or for some form of rapid prototyping. You may even just want to create a 3D model to help you improve your own concepts. Being able to rotate a model and see it from all sides will also help you decide if the design is working and if it'll suit its intended purpose.

While it's always a pleasure to see what other artists can do with your ideas, it's an even greater pleasure to do the translation yourself. But where do you start? Hitting the ground

running in the 3D world can be a daunting task. What software should you use? Should you learn the basics of box modelling or begin building a model point by point? Should you use a more modern method of modelling like digital sculpting with ZBrush or Mudbox?

This workshop will take some of the pressure off and give you an insight into Silo, a low-cost modelling package that's easy to learn, used in lots of production environments and is also a package that has all the tools you'll need to create a 3D creature. You can find out more about Silo by downloading the trial from their website (www.nevercenter.com/silo/).

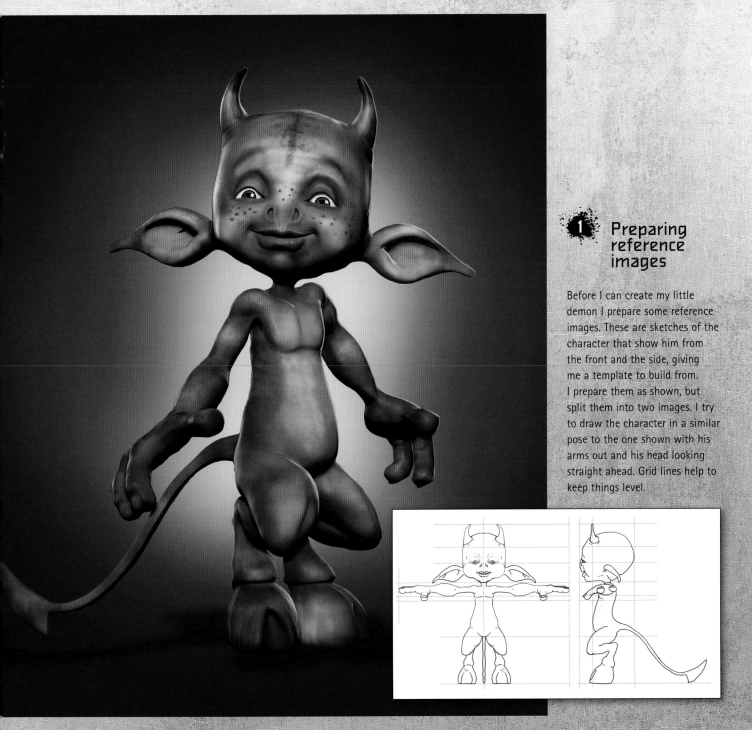

# 1 Preparing reference images

Before I can create my little demon I prepare some reference images. These are sketches of the character that show him from the front and the side, giving me a template to build from. I prepare them as shown, but split them into two images. I try to draw the character in a similar pose to the one shown with his arms out and his head looking straight ahead. Grid lines help to keep things level.

## 2 Importing the images

I save the two images and then launch Silo. Press Space to go from a single view to a quad view. I add the images by clicking into the front view (press 2), then use Display> Set view port image to navigate to the 'front' image. I click into another view, then go to Right view (press 6) and do the same to import the side view. You can add a cube to the scene to help you get the layout right.

## 3 Edit tools

Silo needs very little configuring, but one thing I always set up is the ability to smooth your model with a mouse wheel roll. To do this, select Editors/Options>Mouse settings and click Scroll. Look down for Ctrl+Shift and set that to Smooth. Save the settings to have a smooth tool slaved to your middle mouse button.

## 4 Starting from a cube

All box modelling starts from a basic primitive shape. I'll be using a cube. I right-click and load a basic cube, before going into Edge mode (S) and clicking a front horizontal edge. Shift+X will split the cube in half. I go to Face mode (D), and select and delete the whole left-hand side of the cube.

### SHORTCUTS

**EXTRUDE**
**Z (PC & MAC)**

The core of this creature workshop is done using the Extrude command to create new geometry.

## 5 Mirror techniques

There are two types of mirroring in Silo. Instance mirror (Modify>Mirror>Instance mirror toggle) gives you a reflected version of your mesh across the X-axis. You can't edit this reflected half, but you can turn it off and on. The other way is mirror geometry (Modify>Mirroring>Mirror geometry) that flips the mesh across the axis and welds it together. This can be edited on either side. I'll be using Mirrored geometry from now on.

## 6 Display modes

You can view your model in several ways. To model, and for most jobs, I use Flat mode (Display>Object display mode>Flat shade). While box modelling I sometimes need to see through the mesh, so I switch to Ghosted mode from the same panel. While in there I can switch to Smooth shade and turn the wireframe on and off as required.

## 7 Head and body

Using the mirrored cube I make the head and body. I split the head a couple of time vertically and horizontally (go into Edge mode, click the edge and then press Shift+X to split), before selecting the whole head (F). The smooth function tightens the head. Now I make another cube, select the top face and extrude upwards (Z) a few times. I smooth that mesh a little to tighten it and round it off.

## PRO SECRETS

**LEARN TO REFINE YOUR MODEL**

Become a master of Tweak and Smooth. The secret to organic modelling is the ability to make believable creatures and characters by creating accurate anatomy. If you can tweak your mesh quickly and accurately and have access to a powerful smooth tool, you can refine your models in no time at all. Get to grips with creating good topology and then keep your models smooth and tight.

## 8 Apply Soft selection

To see the mesh smoothed I can temporally subdivide it (C); to reverse this step press V. When in Sub-d mode I can match the model to the reference in the front and right views. To do this you may need to switch on soft selection (Selection>Soft selection), which acts as a magnet and has an area of effect. Make sure you're in Ghosted mode to make the model transparent.

 ### Extruding the arms

I select two polygons at the shoulder, extrude out once and tweak the points to form the shape of the arm. I keep extruding out to form the elbow and forearm, and do the same to create two fingers and a thumb. I then tweak the shape to match the reference images. I press C to look at the model subdivided and match the reference in this mode.

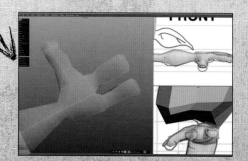

 ### Extruding the legs

I select polygons on the lower body and begin to extrude downwards. Once I reach the knee area I turn the polygons back on themselves (press E to rotate) and extrude backwards to the ankle joint. Then I extrude and turn these down and onto the hoof area. To make the hoof I extrude down a scale to match reference. I tweak the model and switch Soft selection on and off as required, while pushing points into the mesh.

 ### Creating the ear

I select the head model (F), then switch into Face mode (D) and select polygons roughly where the ear will be. If the head needs more polygons I split around a few times first. I extrude the ear outwards several times following the front reference images, while moving, scaling and rotating as necessary. I extrude all the way to the end. Selecting the front polygons and extruding, I scale these down then before extruding again inwards into the ear.

 ### Making the eyes

To make the eyes I create a new object by right-clicking to generate a sphere. I rotate it forwards and scale it to fit the head. On the head model I select the polygons where the eye will be and extrude inwards once. I then scale down and extrude again several times. Now I place the eyeball into the socket and by tweaking and using a combination of soft selection and smooth, I'm able to shape the eyelid. This step is a little tricky to get right.

 ### The mouth and nose

The key thing with the mouth and nose is to keep the polygon flow around these areas. For the mouth I select the central polygons and extrude in and scale a few times. I tweak the lip shape to match the reference image and tighten the edge of the mouth to form a crease. For the nasal cavity I simply extrude in and tweak as necessary, remembering to use Smooth to tighten areas.

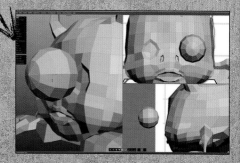

### SHORTCUTS

**MOVE, SCALE AND ROTATE
W, E AND R (PC & MAC)**
- Always follow an extrude
  with a Move, Scale or Rotate
  command.

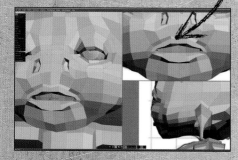

## ⑭ Cutting and splitting

The model needs to be 100 per cent quads if possible. Sometimes you need more geometry in a certain areas. Cut new edges into the mesh by pressing X and delete edges as needed. Never leave an N-Gon in your mesh (a polygon with more than four sides) because they don't work in all software. Get into the habit of testing your mesh regularly by pressing C and reverting back with V.

## ⑮ Joining objects

I select and delete half of the body and head. I enter Object mode (F), select both objects (Shift), and right-click to combine the two. I delete two polygons on the top of the neck and two on the bottom of the head, before selecting two points on the head and two on the body. Then I press P. I repeat this around the neck. I then re-mirror the body across.

## ⑯ Creating a tail

The tail needs to be extruded out from the base of the body, so I select the polygons at the bottom of the back and start to extrude outwards. I continue extruding and moving while keeping an eye on the side view. Once I reach the end I go back to where the arrow head begins and extrude downwards. Using a combination of cut, split and smooth I match the tail tip to my reference.

## PROSECRETS

**THINK IN THREE DIMENSIONS**

To understand 3D modelling you have to become comfortable moving around in 3D space. Learn how to zoom in and out, how to pan left and right in a scene and how to rotate your point of view and move around your objects. If you can navigate around the modelling area effectively then you'll be able to create models quicker and more efficiently, because you're not spending time navigating the space.

## ⑰ Posing

When a model is created in the classic T-pose it can look sterile. The solution is to pose the mesh and break the symmetry, so that you see the figure in action. This can be done by selecting parts of the mesh and rotating them. Using Soft selection helps to get the joints positioned correctly. The base mesh is now ready to be UV'd and then onto ZBrush for texturing and sculpting if required.

# SCI-FI GALLERY

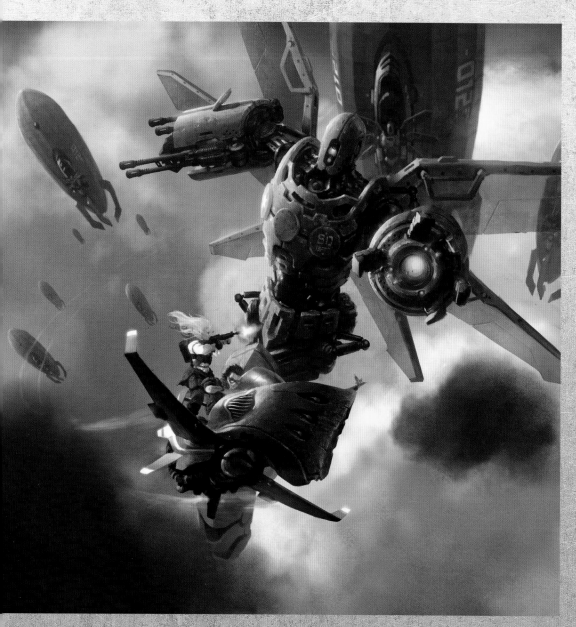

# Marek Okon

**COUNTRY:** Poland

Marek was a web designer until a couple of years ago, when he decided to do some more serious digital painting. Now he's doing book covers and illustrations for various publishers, and really enjoys mixing sci-fi and fantasy into his work.

**WEB:**
www.omen2501.deviantart.com

# James Paick

**COUNTRY:** USA

James picked up a pencil at an early age and copied anything that he thought was intriguing. 'My art became a voice for me to communicate, to just let loose and have fun,' he remembers. In terms of subject matter, he just did whatever art came naturally. Now he works full-time as an illustrator and art director in entertainment advertising, working on many game titles and films. But James is not one to let the grass grow under his feet. 'I also juggle many freelance projects, ranging from video game concept designs to graphic novels.'

**WEB:** www.scribblepadstudios.com

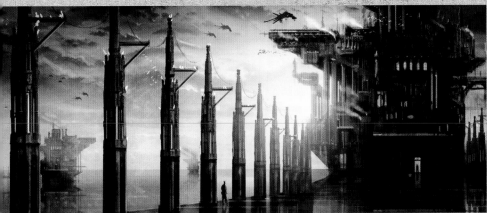

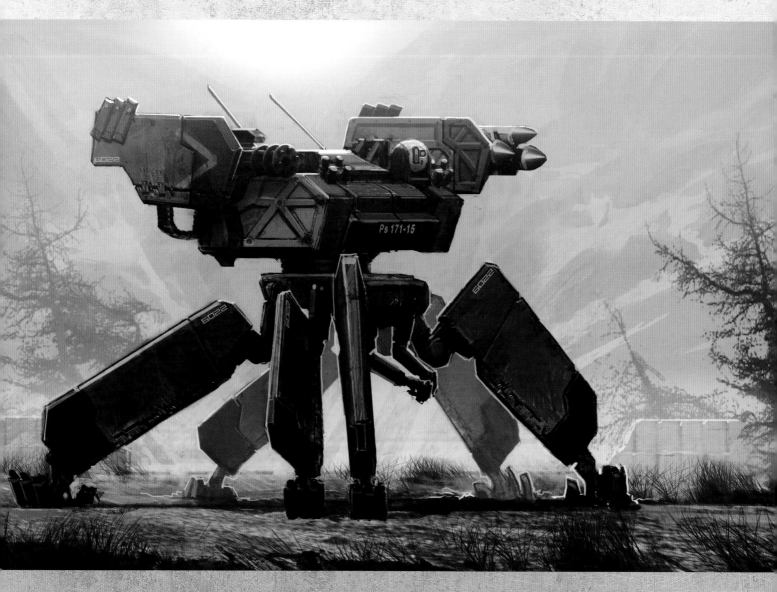

# Ben Mauro

**COUNTRY:** USA

Ben studied industrial design in California, and is now a
concept designer at Weta Workshop.

**WEB:** www.artofben.com

# Mike McCain

**COUNTRY:** USA

Mike caught the art bug in college, somehow escaping with a computer science degree, while spending most of his time drawing or buried in Photoshop and Maya. He graduated in 2007 and currently works as a designer in Seattle. He's also slightly obsessed with *Star Wars*.

**WEB:** www.mikebot.net

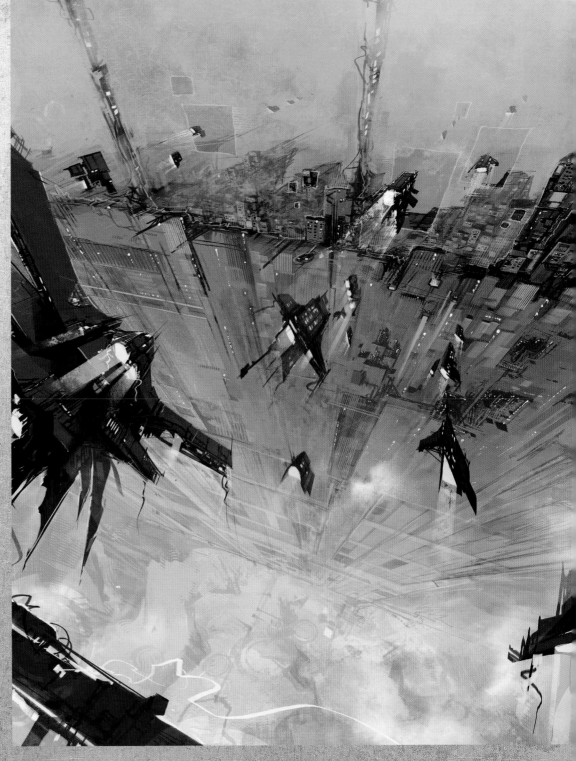

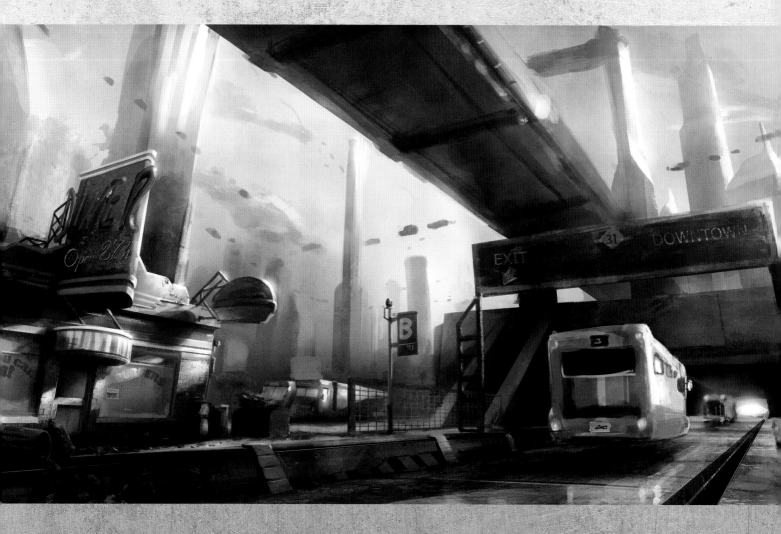

# Alex Broeckel

**COUNTRY:** Germany

With over 12 years' experience as a professional 3D artist, Alex specialises in building and lighting digital environments for the entertainment industry. He's worked as a lighting Technical Director on films including *Harry Potter and the Prisoner and Azkaban* and *Oliver Twist*.

**WEB:** www.alexbroeckel.com

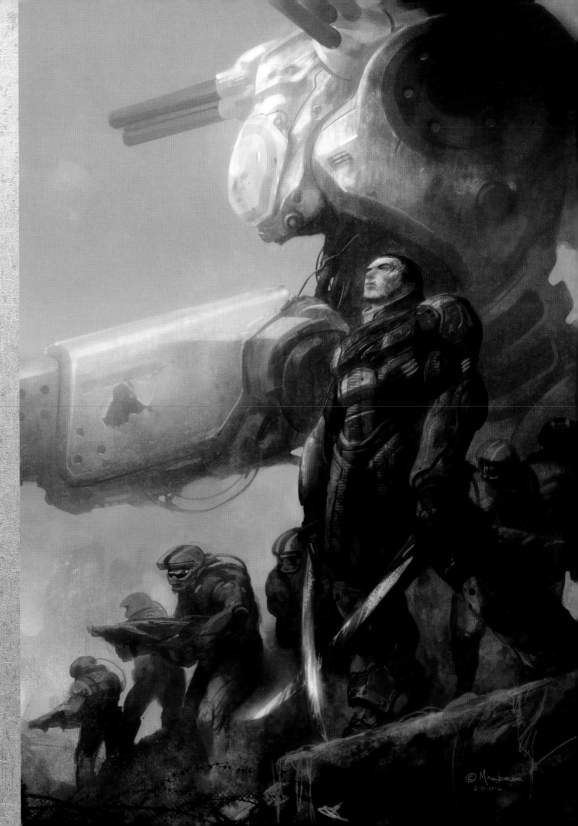

# Daryl Mandryk

**COUNTRY:**
Canada

Daryl is a digital artist living in Vancouver, Canada. He is currently working for Disney Interactive designing concepts for video games. Prior to this he had stints at Propaganda Games and Electronic Arts.

**WEB:** www.mandrykart.com

# Monsit Jangariyawong

**LOCATION** Thailand

Monsit graduated with a BA in architecture, but since then he's been working as a digital artist. His first loves are fantasy and sci-fi art. 'They've always been my favourite themes,' says Monsit. 'It's fun to create things from your imagination, whether it's a monster or a space ship.' His beautifully realised images draw on myth, film and Japanese manga.

**WEB** www.monsitj.cgsociety.org

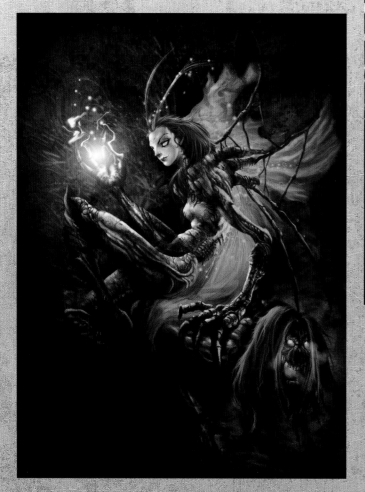

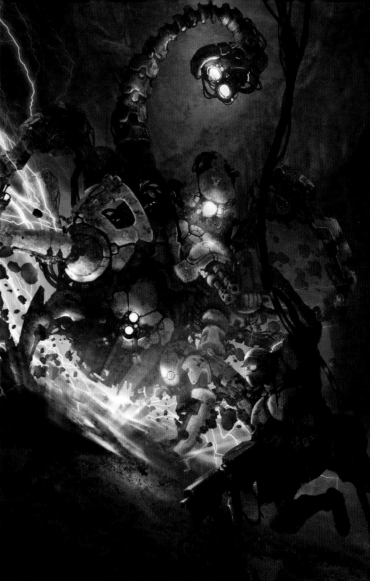

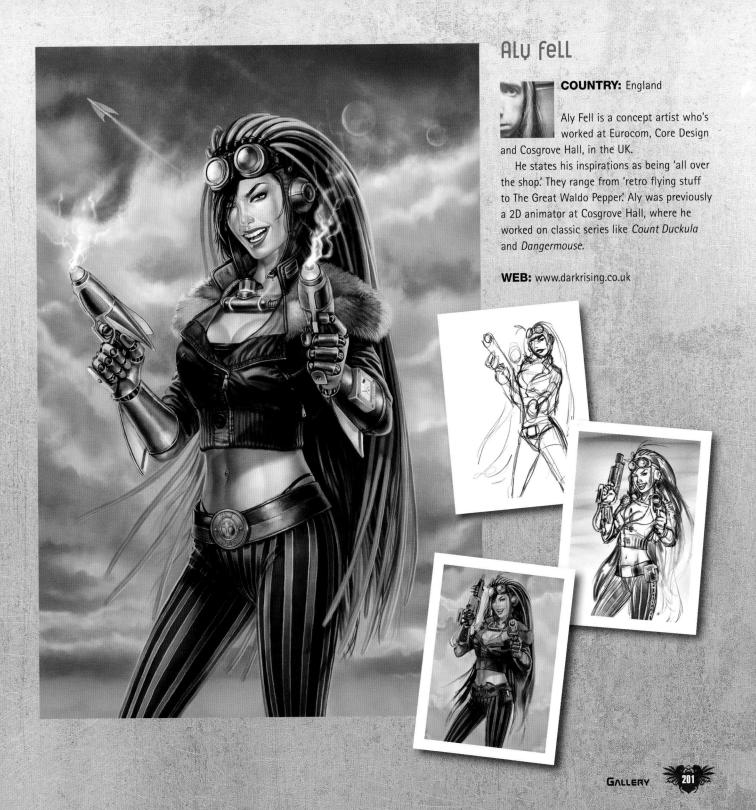

# ALY FELL

**COUNTRY:** England

Aly Fell is a concept artist who's worked at Eurocom, Core Design and Cosgrove Hall, in the UK.

He states his inspirations as being 'all over the shop'. They range from 'retro flying stuff to The Great Waldo Pepper'. Aly was previously a 2D animator at Cosgrove Hall, where he worked on classic series like *Count Duckula* and *Dangermouse*.

**WEB:** www.darkrising.co.uk

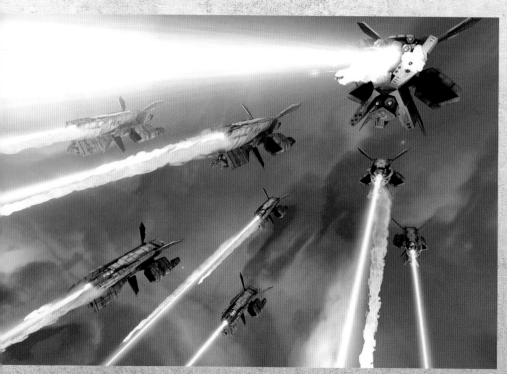

# Josh Grafton

**LOCATION** England

Otherwise known as Strangelet, Josh has been a composer and producer working in film and advertising for a long time. 'But I've always been an artist since I learned to make the screen border change colour on my ZX Spectrum,' he says. An undying love of sci-fi films like *Starship Troopers*, *Dune*, *Star Wars* and *Aliens*, and the timeless art of people like Chris Foss and David A Hardy have roused Josh.

Nowadays the inspiration comes from game development teams. It's long been a dream for Josh to art direct games. 'To this end I joined the dev team at Angels Fall First and we're well under way with a space-war sim, *Planetstorm*,' he says.

**WEB** www.strangelet.deviantart.com

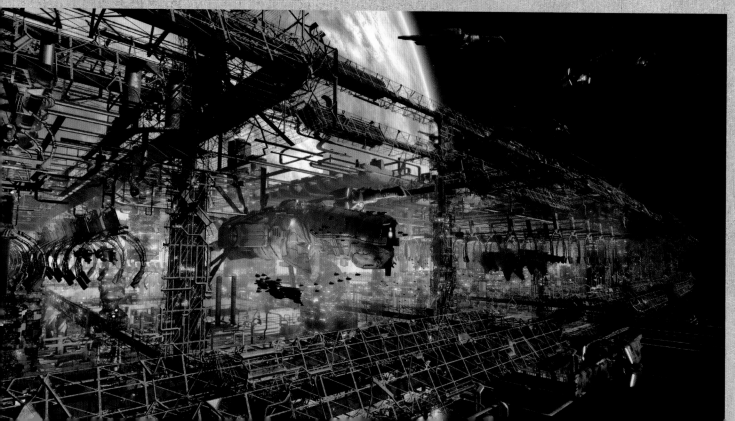

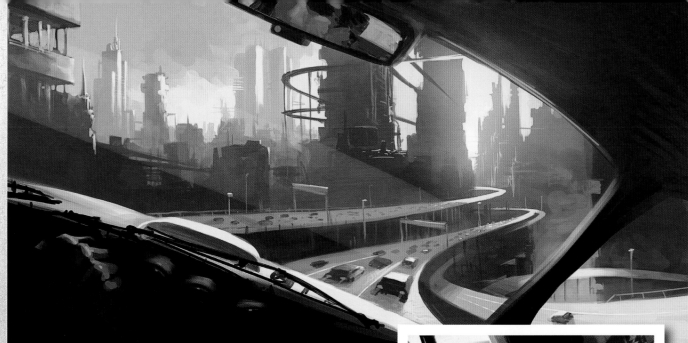

# Christian Bravery

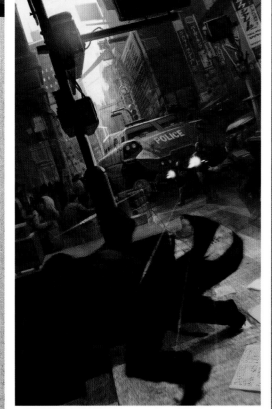

**LOCATION:** England

After the strip he was illustrating for the *2000 AD Megazine* got canned in favour of reprints of *Preacher*, Christian came to a logical but painful conclusion: 'Drawing comics was no way to make a living!'

He decided to try his hand at video games. 'I applied to various companies and last on the list was a new start-up called Lionhead Studios.' Lionhead was looking for 'the best 3D artist in the world.' Undaunted by never having used a 3D package, Christian applied. 'I spent 48 hours solid learning 3ds Max 1.2 on a friend's machine and somehow got the job,' he says.

For the next nine years he worked on a number of titles and was art director on *Black & White 2*. Since leaving Lionhead and setting up Leading Light Conceptual Design he's stayed busy. 'I've created concept art and design solutions with EA Criterion, Sony and Stormfront, and am currently working with EA Canada on the next iteration of a best-selling, triple-A franchise.'

**WEB:** www.leadinglightdesign.com

# Skan Srisuwan

**LOCATION:** Thailand

Thai-born Skan first came to our attention when he won a spate of online challenges with his stunning image The Conductor, seen above He has since moved to Singapore, where he his is a freelance concept, character and vehicle designer, as well as doing art instruction work at a number of local Universities.

**WEB:** www.fiduciose.net

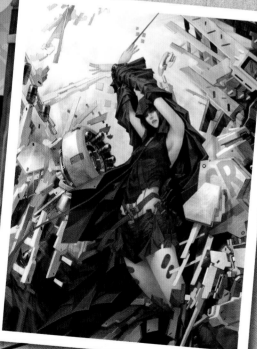

# Wei Ming

**LOCATION** China

Ming was 10 years old when he first dreamt of becoming an artist. 'Just draw what you like to draw', my mother told me. Thereupon I used my pen to create something new and build my world. My mum encouraged my passion.'

When at high school, Ming received very formal and systematic training in modern industrial design. 'I studied 3D animation by myself with solid painting skills, both of which intrigued me, though my understanding of design was still vague.'

Studying abroad changed this, helping Ming see the real charm of this field. 'Seeing so many high standard concept designers amazed me!'

**WEB** www.allenwei.com

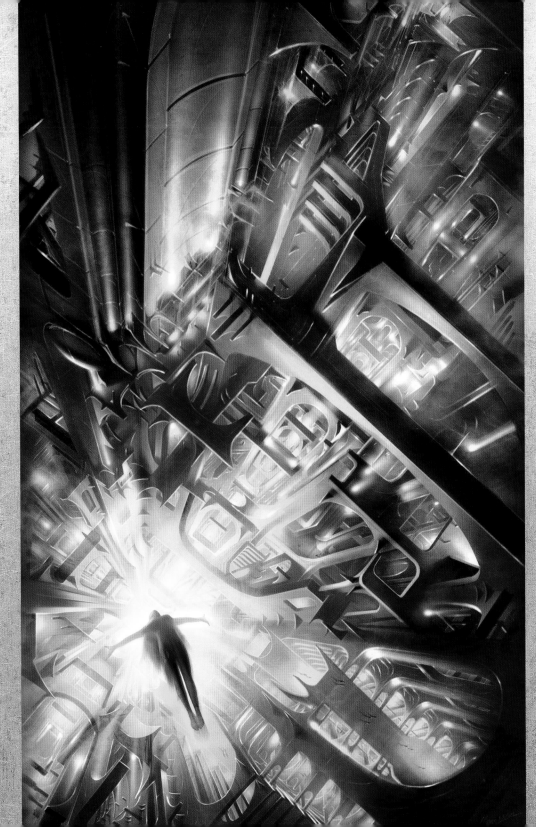

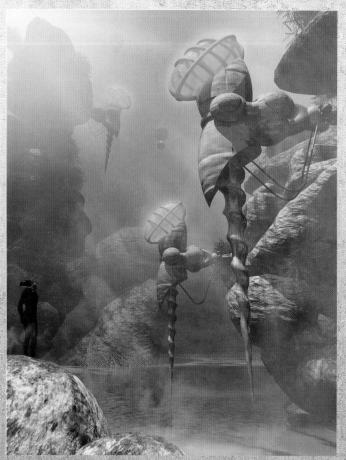

# Joe Uinton

**LOCATION** England

Joe (aka Orbital) got into using Bryce about five years ago. 'From the start it became a pretty obsessive hobby.' A window cleaner by day, he says: 'It isn't the most exciting job in the world, so it's nice to be able to focus on doing something creative in my spare time.' Joe modestly still considers himself a hobbyist, despite the quality of his work and having worked for AutoFX and DAZ. Mostly, he creates fantasy worlds. 'I find this enjoyable as I can push my imagination as far as possible. I like to create scenes with atmosphere and perhaps a little bit of magic.'

**WEB** www.futurerealms.net

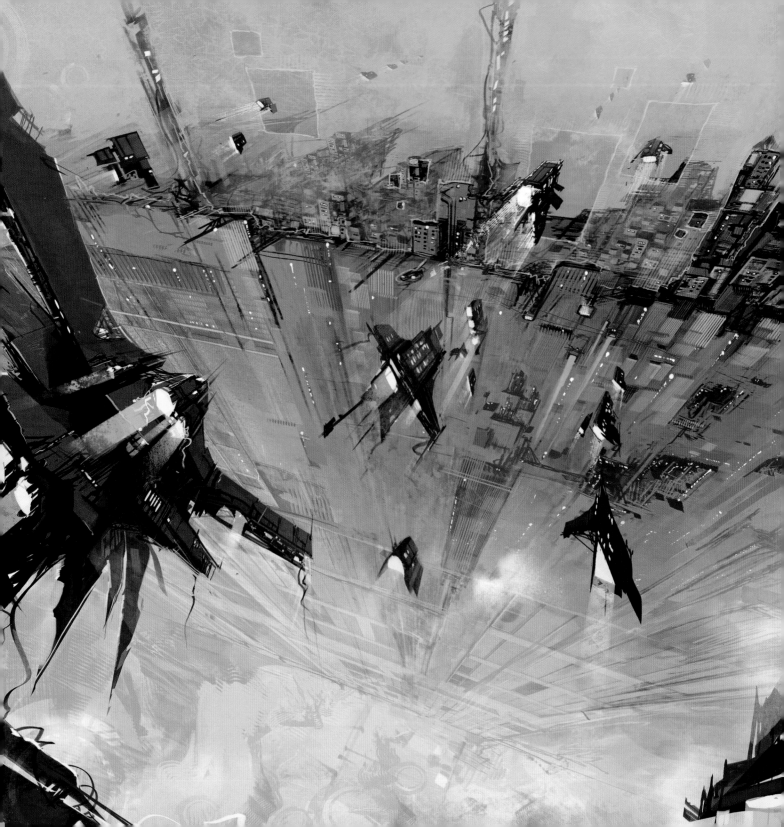